	7	
		*
	÷	
		<u>.</u>
		X
		•

STEP BY STEP ART SCHOOL DRAWING

						*
	1					
			•			
				•		
				7		

STEP BY STEP ART SCHOOL

DRAWING

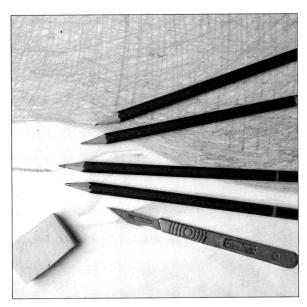

BY JENNY RODWELL

Published in 1987 by Guild Publishing by arrangement with The Hamlyn Publishing Group Limited a division of The Octopus Publishing Group, Michelin House, 81 Fulham Road, London SW3 6RB

Copyright © First Editions/Jenny Rodwell 1987

Second impression 1989

All rights reserved. No part of this publication may be reproduced, stored in a retrieval system, or transmitted in any form or by any means, electronic, mechanical, photocopying, recording or otherwise, without the permission of the copyright holders.

Designed, edited and produced by First Editions (Rambletree Limited) 27 Palmeira Mansions Church Road, Hove East Sussex, BN3 2FA

Produced by Mandarin Offset Printed and bound in Hong Kong

Contents

Chapter 1	Introduction	10
Chapter 2	Equipment	22
Chapter 3	Charcoal and Chalk Materials Techniques Drawing Form Sheep's Skull	32 34 36 38 42
Chapter 4	Colour Sticks Materials Techniques Still-life with Drapery Lobster on a Plate	46 48 50 54 58
Chapter 5	Pen, Brush and Ink Materials Techniques Studio Still-life Circus Scene Quayside Sketch	64 66 68 70 72 76
Chapter 6	Pastel Materials Techniques Red Cabbage Swimming Pool Potted Primroses Still-life with Vegetables	78 80 82 86 90 94
Chapter 7	Pencil and Graphite Materials Techniques Gorilla Female Nude	102 104 106 110 114
Chapter 8	Coloured Pencil Materials Techniques Palm Trees Girl on the Beach	118 120 122 126 130
Chapter 9	Markers and Fibre Pens Materials Techniques Orange Lily Deserted Beach City Street	134 136 138 142 146 150
	Glossary Index	154 155

Chapter 1

Introduction

Everything in the world is a subject for a drawing; yet what you draw is not important. That you enjoy drawing, and feel you are learning more about the visual world as a result, is of the utmost importance. This chapter explains simply and clearly some of the underlying principles of drawing. It helps you to see every subject with a fresh eye and, above all, it aims to remove the mystique which, sadly, surrounds this fascinating and rewarding activity.

There is nothing magical, for example, about understanding perspective, about 'measuring' the subject, or about drawing negative space. They are all 'learnable' principles which, once mastered, will help you tackle any type of subject with confidence and enthusiasm. Although such fundamentals are important, try not to treat them as 'musts', to be slavishly followed. This chapter is designed to help you, and to remove some of the frustrations of learning to draw – it should not be treated as a textbook,

with hard and fast rules, to be first learned and then obeyed!

Drawing is a subjective occupation. The best artist is the one who understands the principles and rules, but who interprets rather than copies them. Composition is a prime example of this. Convention dictates that a pictorial composition must be harmonious; should not contain any discordant elements, such as a figure looking toward the edge of the picture; and should avoid absolute symmetry at all costs. Yet, we only have to look at some of the Old Masters to know that such rules can certainly be bent, if not broken.

This book is largely about materials, about the marks and effects which can be achieved with a whole variety of drawing media. But, without a basic understanding of drawing, the most sophisticated tools in the world will not enable you to produce a good drawing or, more importantly, the drawing you want to produce.

Introduction

STARTING TO DRAW

Making the first mark on a pristine sheet of paper is rather like being the first person to trample across a perfect patch of freshly fallen snow – it seems such a shame to spoil it! When learning to draw, the problem is even worse, because most of us have such grand and preconceived ideas of what the finished picture will look like that we are almost doomed to disappointment, even before we begin.

It is therefore a good idea to regard drawing as a process, a way of thinking and recording rather than a means of producing a perfectly rendered picture at every attempt. If getting going becomes a real stumbling block, and the thought of marking the paper is actually inhibiting, then try warming up with a few quick, throw-away sketches of the subject. This is a tried and tested method for overcoming tension and inhibition, and an excellent way of getting into the right mood.

The secret of successful drawing depends upon careful observation and the ability to put down on paper what you can see. So before starting, take a good look at what is in front of you. Decide how you are going to approach the subject, and where it will be placed on the paper.

No two artists approach a subject in exactly the same way. The sequences on this page show two different approaches. In the first, the artist develops the whole subject concurrently, starting with a rough outline, then working across the image, gradually bringing up the whole drawing at the same pace. The second sequence shows a different approach. Having decided on the scale and position of the subject on the paper, the artist starts drawing in one place and works across the image, bringing each area to a state of completion before moving on to the next.

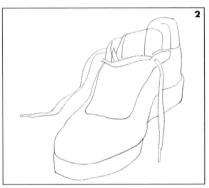

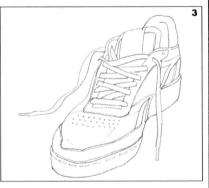

The 'Growing' Drawing

- 1 Here the artist starts in one place in this case the top of the shoe, making sure this is in the correct position on the paper, and leaving plenty of space for the rest of the subject.
- 2 From here, the lines are extended to show more of the shoe the finished drawing 'grows' outwards from its starting point.
- 3 The artist completes the work by putting in remaining undrawn areas and details.

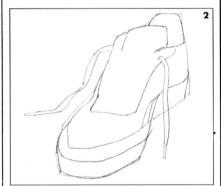

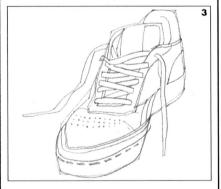

Developing the Subject

- 1 For this traditional approach, the artist starts by establishing the main lines of the subject. At this stage, the drawing is kept fairly sketchy and loose to allow for redrawing and correction as the image develops.
- 2 From the initial sketchy construction lines, the artist works into the subject, using the line to describe the form of the shoe.
- **3** Finally, the drawing is completed with further line and detail.

INTRODUCTION

Outline and Internal Contours

Unless we are familiar with an object, an outline drawing of that object will not necessarily tell us what we are looking at. In the outline drawing (below left), we only recognize the subject as being a model of a hand because we know what a hand looks like, and we know that such an outline is likely to be that of a hand. But we need the added information of the second drawing to really know and understand what we are looking at.

The first drawing contains a flat shape; the second drawing describes a three-dimensional form. By drawing into the subject, the artist has turned a silhouette into a solid object.

These internal lines are similar to the contour lines we see on maps. Just as geographical contours describe the form of a hill by mapping out the relief pattern of its surface, so an artist draws contours to describe the form of a subject. The artist, however, must look at the subject to decide where the internal lines should be; they cannot be placed scientifically, at regular intervals, as with maps and diagrams. The hand, for example, has natural contours the finger and wrist joints, and the wood grain which runs lengthwise down the fingers, hand and arm.

Internal lines are as important as the outline. So don't automatically

start by drawing the outline and then filling in the rest. Ideally, you should try to develop the two together, looking carefully at the subject to see how the inside lines and outside lines combine to describe the form. However, there is no reason why you should not try to draw from the inside, and leave the outline to last.

Light and shade can also be exploited in a drawing to give a sense of form to an object (see page 14), changing it from a flat shape into something real and solid. But remember, the areas of light and shade are not independent of the internal contours. They are directly related to them.

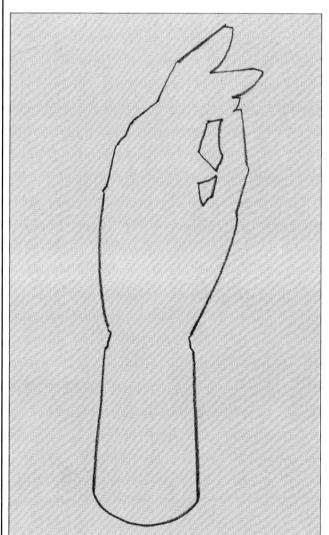

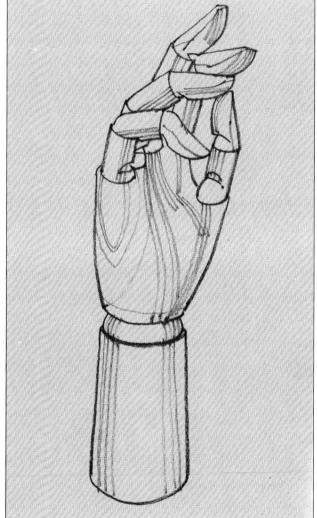

LIGHT AND SHADE

We are able to see three-dimensional objects because of the light which falls on them. Without light, and the shadows it creates, all objects would be seen as flat shapes. Strong, directional light casts harsh, defined shadows on and around the objects; it also creates bright highlights and reflections. The effect of diffused light is more subtle. The apple illustrated here was drawn in the artist's studio, with a strong window light falling from the top left-hand side, hence the highlights on the top, and the dark shadow across the right-hand side of the fruit.

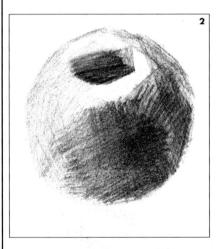

Tone

To indicate light and shadow on an object means picking out the pale and dark areas. These darks and pales are known as 'tones'. The tonal range runs from black to white, and includes all the grevs in between. To pick out the tones, or values, you should ignore the local colour as much as possible, and this can be difficult especially if the subject is complex or highly patterned. This apple was actually red and green, but the artist was concerned only with the tonal, monochrome effect of the light and shadows, and chose to illustrate this in black and white. Any other single colour could have been chosen.

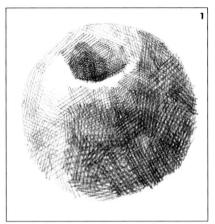

Types of Shading

These are various techniques for blocking-in shadows. Probably the most common way is to build up a shaded area with a series of parallel lines, a technique known as hatching. When the lines are drawn close together, the tone is dark; widely spaced hatching produces lighter tone. Whichever method you use, it must have this flexibility – you must be able to vary the tone.

- 1 Cross-hatching. Shading built up in patches of tiny crisscross hatching. The cross-hatching becomes finer and more spaced towards the lighter areas.
- 2 Scribbled hatching. Regular parallel lines are unsuitable for the rounded form of the apple, so the artist adopted a looser type of hatching.

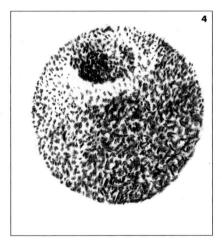

- **3 Blending.** Soft shadows, blended with the finger, eraser or cloth, are only possible with soft drawing materials. These include charcoal, pastel, conté and soft pencil.
- 4 Stippling. Tiny dots can be built up to depict shadows the denser the dots the deeper the shading.

Colour and Surface Texture

Texture and local colour are factors to be considered when assessing the tonal values of an object. For example, a matt surface will have less tonal contrast than a shiny surface, which often contains bright reflected highlights. Local colour too, affects

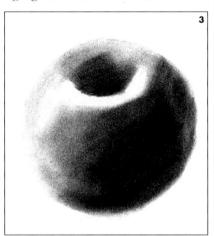

tone. Two identical objects, one light and one dark, will not be the same in a monochrome drawing – the lights and shades on the darker object will be tonally darker than those on the lighter.

Describing Form

When rendering shadows, you can often give a further feeling of three-dimensional form to the subject by paying close attention to the direction of the strokes as well as to the tones which the strokes represent. In other words, be logical about the direction of the shading – draw with the form, not against it. For example, the hatched lines on the apples are taken round the curved shape of the fruit.

INTRODUCTION

Planes

Objects with gradually curving sides, such as spheres and cylinders, are simple to draw: the shapes are regular, and light and shade are evenly distributed, making it easy to both recognize and describe the form.

Not all subjects, however, are so straightforward. Natural forms have always been favourites of the artist, but they are inevitably irregular and often complicated. Plants, flowers, animals, birds and human figures are fascinating and challenging subjects, but they are notoriously complex and irregular when it comes to drawing them. Light falls on their surface in an unpredictable way, making it difficult to see, let alone draw, the subtle

areas of light and shadow.

The best approach is to find a way of simplifying what you see. Try to ignore distracting detail and small surface irregularities, and to break the subject down into basic areas of light and shade. These simplified areas are called 'planes'.

The illustrations here show a cylinder and a human face, simplified into planes of light and shade. The lightest planes are those areas which receive direct light; the darkest are those turned away from the light. The greys, or mid-tones, describe other planes in varying degrees of light and shade. On the face, the light is falling from the top left, catching the forehead, cheek, nose, the convex area between the nose and mouth,

and the lower lip. These are the lightest areas in the drawing, and the artist depicted them with the bright, light tone of the paper. The darkest tones, down the right side of the head and neck, are drawn in black.

By simplifying the face in this way, the artist has tackled the problem of form and structure before attempting to create a realistic image. But, with this basic, solid structure established, the artist is then free to develop detail and to blend and break up these large, rather crude planes into softer, more blended areas. The technique can be adapted to any subject, and will help you to draw both simple and complicated forms.

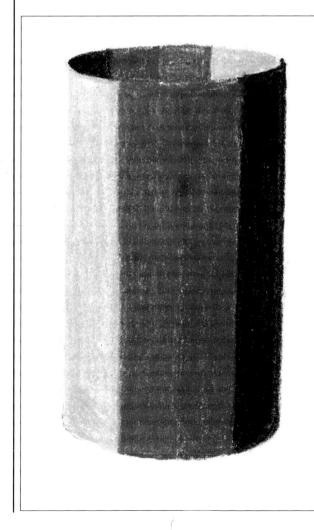

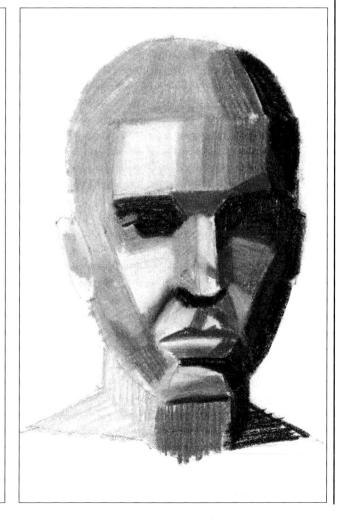

THE FIGURE

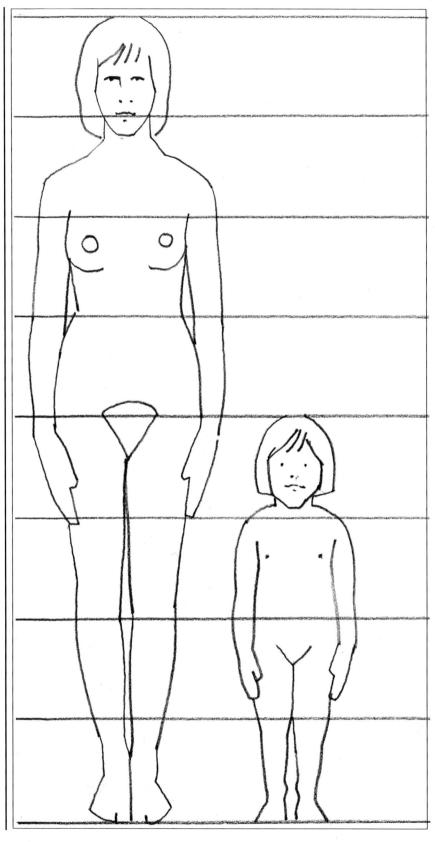

Proportion

Everyone subconsciously knows the proportions of the human figure, and consequently, if you get this wrong, the mistakes will be glaringly obvious. If the proportions are not right, if you have drawn a figure with a too-large head or a too-long arm, no amount of careful rendering and detail will disguise the monster you have created! And it is a sad fact that the longer you work on a drawing, the easier it is to get used to an error in proportion, and carry on in happy oblivion. It is usually somebody else, coming fresh to the drawing, who notices that something is wrong.

One way to avoid this problem is to frequently stand back from your work to check that all is well. Prop the drawing upright to avoid a foreshortened or distorted view.

Generally speaking, the head of a standing adult fits into the height of the rest of the body about seven times; a child's head is considerably larger in proportion to the body, depending on the age of the child. Obviously, this guide is variable, but it is a good general principle to follow.

Arms are always longer than one imagines. An adult standing with arms outstretched measures approximately the same from fingertip to fingertip, as from the top of the head to the soles of the feet. When the arms are relaxed, as in the drawing here, the hands hang a considerable way down the thighs.

A seated figure is more of an unknown quantity. Before starting work, imagine a line drawn across the picture from the top of the head to a point parallel to the feet. As a rough guideline, the head takes up about a quarter of the line. Naturally this proportion varies considerably according to different postures and chair heights, so check the proportions of your particular subject, taking the head as the basic measuring unit (see page 21).

Another artist might analyze the

forms in a completely different way,

perhaps splitting the torso into two

cylindrical forms – one to represent

the chest cavity, the other the

abdomen - and so on.

Mass and Volume

The human figure is a solid, single form. But it is also a complex form. The head, torso and limbs can all be seen as separate elements, and each of these is made up of several forms. By analyzing the subject and breaking the figure down into a series of simple cylindrical forms, as the artist has done here, you will make the task of figure drawing much easier.

For this initial stage, forget about line, surface rendering and whether or not your drawing looks like the subject. The main thing is to establish the figure as an arrangement of solid cylindrical forms, with each cylinder representing a mass or volume of the body.

The torso is the largest volume in the figure. In this illustration the torso is upright, the weight of the figure being borne squarely by the chair. Often, however, the torso is at an angle – this is especially the case with standing positions when one leg carries most of the weight of the body. When the weight of the figure is unevenly distributed in this way, the torso leans to correct the imbalance and to prevent the figure from falling over. The head will tend to tilt in the opposite direction.

Stand in the front of a long mirror and watch the effect on your body as you shift your weight from one leg to the other. Any change in one part of your body is reflected elsewhere. Observe yourself in a number of positions, and notice how a simple, and seemingly local, act of lifting an arm affects the slant of the shoulders and the angle of the torso. Imagine each of the body's cylinders has an axis, a centre rod, and try to determine how the direction of each axis is affected by your change of position.

The 'cylinder' approach is an excellent way of starting a figure drawing. When you have established the main volumes in this way, the

robot-like construction can be rubbed down so that it does not necessarily impinge on your finished drawing. You are then free to concentrate on the visible aspects of the subject, converting the broad masses and volumes to a living, recognizable human being. Without understanding the volumes and three-dimensional composition of the figure, there is always a danger of merely copying the surface.

Although useful, the approach is not a rigidly formal one. It is designed to encourage an understanding of the basic volumes and structure of the figure, not to hamper the drawing by imposing rules. Drawing is not a science. The method outlined here is helpful, but should not be regarded as a technical exercise. The cylindrical diagram may look scientific and unchallengable, but it is just one artist's interpretation of the subject.

COMPOSITION

Planning the Picture

When we talk of 'composition' we are really referring to the way the subject is arranged on the paper. This may be a single object – a vase of flowers, or a figure. Or it might be an arrangement of objects, or a complete scene.

Whatever you are drawing, it is important to give some thought to the composition before you start.

These still-life drawings illustrate just four possible arrangements of the same subject, and there are an infinite number of other possibilities. Notice how the background plays an important part in each one. The basic division of the drawing into the blue and brown shapes is just as important as how the mugs and coffee pot are arranged. The artist has avoided a

horizontal division, preferring a more interesting and unusual solution in this case.

No subject fits conveniently into a rectangle or square – the shapes we generally work on. When we look at the subject, what we actually see is an amorphous shape with an indistinct outline – and our eyes can only focus on one part of that shape at a time. The rest of the image is blurred.

The most immediate problem, therefore, is defining the edges of the composition, finding the most suitable shape for the subject and fitting the subject into that shape. This applies even with a figure study, an isolated drawing which does not actually touch the edges of the paper. It is still necessary to place the subject properly on the paper, leaving enough

space around the figure to prevent it looking cramped, but not so much that the subject looks small and lost.

An excellent way of looking at the subject through 'rectangular eyes' is to cut the shape from a piece of card. This can then be moved around until you find exactly the composition you want. In this way you can actually see the shapes of the space around your subject – the blue wall and brown table in the case of the illustrations on this page.

Scale too, is an important consideration. Variation of scale within a compositon is usually more interesting than one which has no contrast between distance and foreground. This is especially true of landscapes, which can be very dull if everything is small and distant.

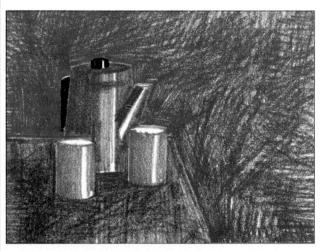

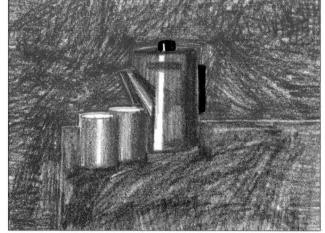

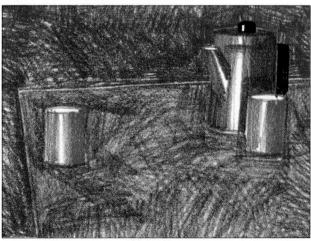

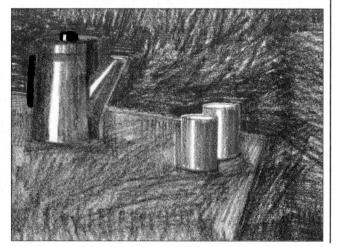

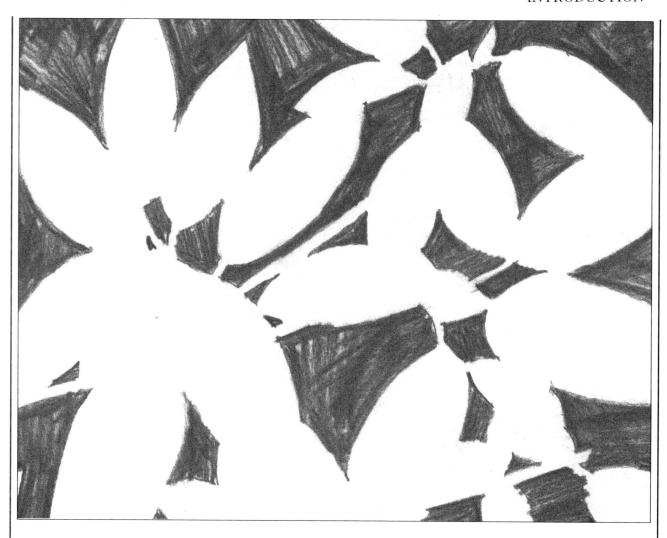

Negative Shapes

When planning a composition, remember to include in your calculations the spaces around and between the subject. If these are not taken into account, your drawing will, at best, lack cohesion and a sense of design. At worst, it will be wrong, because if the 'negative' shapes are inaccurate, this will be reflected in the rest of the drawing.

The leafy twig illustrated here was done, not by drawing the shapes of the leaves, but by drawing the shapes of the spaces between the leaves – the negative shapes. By working in this way, the artist has successfully created a satisfying composition, with every area carefully considered and

brought into the overall design. Notice how the subject is extended to the edges of the paper, the straight edges of the support thus forming part of some of these outer shapes.

Drawing the negative shapes forces an awareness of the composition as a whole. It also discourages a tendency to draw what we know rather than what we see. For example, we know what a leaf looks like, so why bother to check that we have drawn it right? However, because we have no such preconceived idea about the shape of a space, it becomes necessary to look very carefully at what we are drawing. The purpose of the exercise is not to produce a drawing in which

the negative shapes are as important as the positive ones – in this case the leaves. Rather it is a device for drawing the positive shapes correctly in relation to each other by drawing the spaces between them correctly.

Practice the technique. You will be surprised how much easier it is to make correct drawings once you become aware of negative shapes. Chairs, tables and stools are ideal for this type of exercise, because their legs and crossbars create a variety of geometric patterns of empty space. Other good subjects are winter trees, with their twisted and splayed branches and spindly twigs; household objects; and groups of figures.

PERSPECTIVE

Linear Perspective

Imagine standing in the middle of a completely straight road, looking into the distance. You will notice that the edges of the road appear to come together and disappear at a spot on the horizon. The scene demonstrates perfectly the principle of linear perspective – that all such parallel lines on the same plane appear to get closer as they recede into the distance. The point at which they appear to meet is called the 'vanishing point'. The practical applications of linear perspective are important,

because if the perspective of a drawing is wrong, this distorts the whole composition.

If two sides of an object are visible, two vanishing points are necessary; more rarely, three sides of an object can sometimes be seen, in which case three vanishing points are required. In the drawing below, two 'sides' of the ship are visible, and the artist has plotted the two vanishing points.

Aerial Perspective

Objects appear to get fainter as they recede into the distance.

For example, hills and mountains look bluer and paler, the further away they are. This is because the intervening atmosphere interferes with our perception of them.

For the artist, aerial perspective can provide a useful means of indicating space. By making distant objects fainter, and by drawing with finer lines, it is possible to create an illusion of recession. In the bridge drawing below, the artist used a soft pencil for the heavy foreground lines; for the distant objects, a hard pencil was chosen to create thin, pale lines.

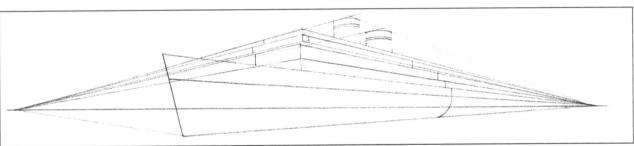

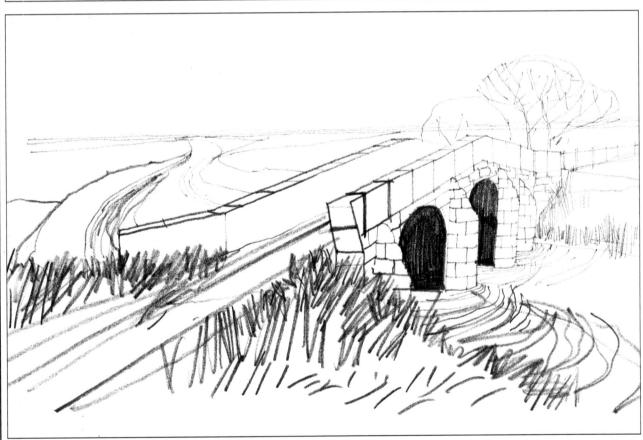

INTRODUCTION

Measured Drawing

By holding the pencil upright at arm's length, you can use it as a measuring device to help you to establish the correct proportions of the subject. Start by choosing one 'distance' on the subject as your measuring unit. Use the top of the pencil to mark one end of this unit, and your thumb to mark the other end. Everything else can then be plotted accurately in relation to this one measurement.

For the tulip drawing below, the artist first took the measurement of one bloom, and worked out the

position and size of the vase and the other flowers in relation to this chosen unit. For example, the height of the bunch of flowers was exactly six times that of the measured tulip head, and this was duly plotted in. Before drawing a single line, the composition was thus plotted out in some detail – the position of each element was indicated with a series of marks. In this particular drawing, the artist worked in coloured pencils, so each mark was plotted in an appropriate colour – red flowers, green leaves, and so on.

When drawing the figure, the obvious measurement to start with is the height of the head. Generally, however, it does not matter which part of the subject you choose, as long as it is consistent and easily visible.

Of course, the literal measurement of the chosen unit has no bearing on the size it is on the paper. If this was the case, you would have no choice at all in the size of your drawing! It is the relative size which is important.

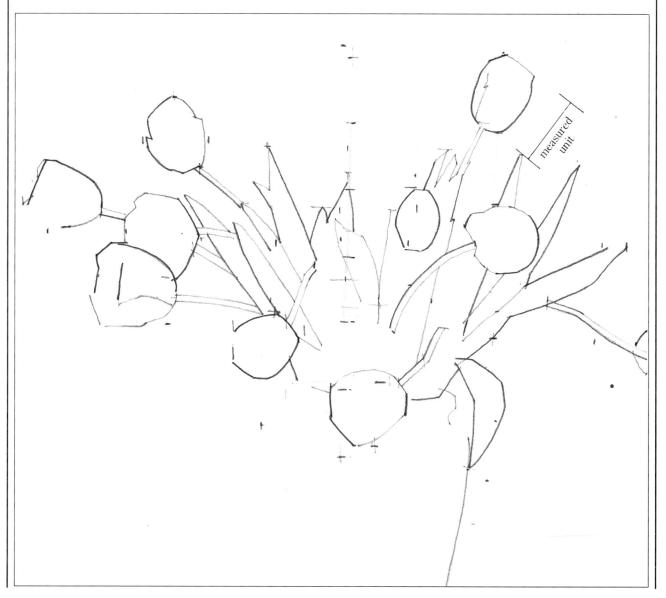

Chapter 2

Equipment

Learning to draw is very much a matter of learning how to exploit the materials. In the practical sections of this book, the materials – the actual drawing media – are described and discussed in detail. Pencils, pastels and charcoal, for example, are clearly illustrated, with demonstrations of the marks they make and the techniques to which they are best suited. There are, however, certain materials and items of equipment which are common to all, or many, of these groups. This chapter takes a look at a few of these – some are helpful, some useful, and some essential.

Choosing the right paper for a particular material can be confusing and time-consuming. In this chapter we suggest suitable supports for the various media. This is done gently, usually without too many absolute prohibitions – although obviously there are a few 'definitely nots'!

Erasers, pencil sharpeners, and easels are also discussed here. Generally, the recommendation is to resist the temptation to go out and spend money on equipment before you really know what you want. Easels, for example, are a relatively expensive item. Although undoubtedly useful, an easel is not essential (the step-by-step drawings in this book were actually done without an easel). By all means buy an easel, but wait until you know what your requirements are – whether you like working small or large, indoors or outdoors, and so on.

Sketching and drawing are compact, portable activities—that is one of the great attractions. But work mounts up, and pieces of paper accumulate at an alarming rate. It is useful to have storage space for your drawings and sketches—plan chests, folders and filing systems, are all practical possibilities and well worth thinking about.

Indoor drawing calls for good lighting. Not only should you have adequate illumination for the subject, but the paper too should be well lit. Whether you are working by daylight or artificial lighting, try to avoid the light falling in such a way that your hand casts shadows on the paper.

Equipment

All you actually need to make a drawing is a piece of paper and something to draw with. The basic requirements are that simple. Of course, most artists possess a far wider selection of materials and equipment, many of which were bought for a particular job, and which have accumulated over a period of time.

It is almost always a mistake to go out and buy masses of materials in one go, especially for the beginner. Far better to start off with the minimum, adding to this gradually as you become more involved and confident. An art shop is rather like an Aladdin's cave, full of colourful and tempting things. But not all of these are suitable, and some are very expensive. So start off with a few basics. Some of these, such as fixative and erasers, are essentials. Others, like easels, a ruler and sticky tape, can make life much easier.

Sketchbooks

These come in a wide range of sizes and types. The most useful size is one which fits into a pocket or bag and can be carried around. Sizes start at around $7 \text{in} \times 5 \text{in}$ (17.8 cm \times 12.7 cm), going up to $25 \text{in} \times 20 \text{in}$ (63.5 cm \times 50.8 cm), and larger.

Hardback sketchbooks are durable and easy to keep and file away (they have a spine, so can be labelled and stacked on a shelf for easy reference). Daler hardback sketchbooks have 80 pages, perforated for easy removal. Spiral bound pads with a stiff card backing are useful for outdoor sketching: used sheets can be flicked over quickly, ready for the next drawing.

Type and quality of paper varies. Most drawing pads and sketchbooks are made from cartridge paper, but other papers are available. These are made and sold mainly for watercolour work, containing Bockingford, Saunders and other types of quality paper. But they can also be used for drawing. For pastel and other colour work, Ingres drawing pads are made with an assortment of coloured papers.

Knives, Blades and Sharpeners

For the best results, all pencils should be kept well sharpened. Artists who work a lot with pencils use electric sharpeners to save time, otherwise a standard sharpener will do. Some pencil products are the wrong size or shape to fit a normal pencil sharpener – these include rectangular studio pencils, which have to be sharpened with a knife or blade; and the new, chunky water soluble coloured pencils (featured on page 126) which come with their own sharpener.

Craft knives and surgical scalpels, with interchangeable blades, and shielded razor blades are all ideal for pencil sharpening.

Drawing Board

A board to rest paper on really is an essential. This can be bought from an art shop – these are usually wood or laminated wood; some boards are reinforced with metal ends. Alternatively, you can make your own from offcuts, providing you choose an absolutely smooth surface. The size

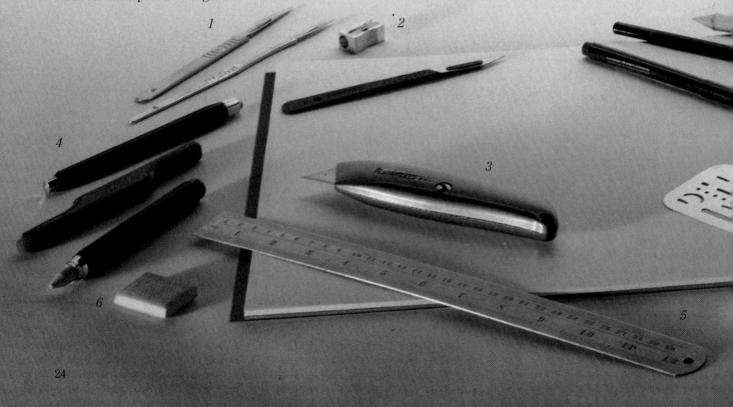

obviously depends on how large you are likely to work, but a practical size and weight would allow you to carry the board around with you easily.

Erasers and Eraser Shields

Ideally, do as little erasing as possible. Continual rubbing out can become a bad habit, undermining your confidence and hindering any possible improvement. As your dependence on rubbing out increases, a line ceases to be a committed mark. It becomes merely a tentative suggestion, a mark which can be easily rubbed out if it is wrong. This 'let out' is not good for the beginner, who should experiment extensively, learning to observe as well as trying out new ideas and materials rather than being concerned with the final, perfect mark.

Some erasing, however, is inevitable, and sometimes erasing is necessary to achieve a certain effect. The drawing on page 110 is a good example of what can be achieved with creative rubbing out!

The soft kneadable eraser is the most useful type. It can be moulded to any shape, and does not mark the paper. Especially effective with graphite and charcoal materials, the kneadable eraser is ideal for rubbing back and lightening initial construction lines of a drawing. It is also widely used for creating sharp highlights in an otherwise dark or tonal drawing.

Both the traditional India eraser and the plastic eraser are harder than the kneadable type, but they are fine for removing lighter pencil marks. The plastic eraser is excellent on tracing and layout papers.

Removing ink is rarely entirely satisfactory, but the specially designed plastic ink rubber contains oil, and this makes it possible to remove specks and small areas.

An eraser shield can be invaluable for fine, detailed drawings. The tiny cut-out shapes can be neatly erased; the metal or plastic template protects the rest of the drawing. By moving the template around, it is possible to create any shape you require.

- 1 Scalpels
- 2 Pencil sharpener
- 3 Craft knife
- 4 Eraser, lead and strip holders
- 5 Ruler
- 6 Putty eraser
- 7 Erasing shield

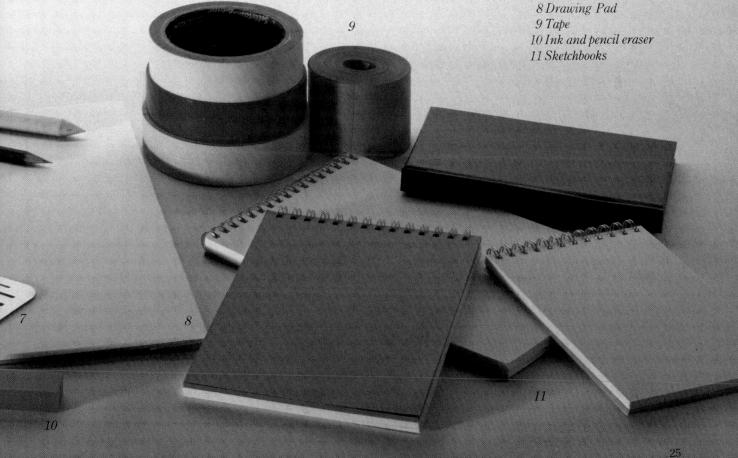

Fixative

Any drawing which is liable to smudging should be given a spray of fixative to preserve the sharpness and crispness of the image. Pastels, conté, charcoal and other soft, crumbly materials should always be fixed as soon as the drawing is finished. Often it is a good idea to apply a light spray of fixative at certain stages during the work – this minimizes the chances of accidently smudging the unfinished drawing with your sleeve or hand.

Fixative is supplied in aerosol cans, which are easy to use and store.

Otherwise it can be bought in glass or

plastic bottles. This is a cheaper alternative, but you do need a metal blower to spray the fixative on to the drawing. Both methods are equally satisfactory.

Fixative does tend to darken the colours of the drawing, sometimes quite severely. Pastels are particularly vulnerable, because the light, bright colours absorb the thin varnish and this can affect the tonal values of the whole drawing. Many pastel artists spray their work from

the back for this reason – this method is slightly less effective because it can leave loose particles on the surface of the picture, but there is far less risk of altering the work.

To fix a drawing, hold the can or bottle at right angles to the paper, at a distance of about 12 inches (30 cm). Spray lightly, moving backwards and forwards across the paper as you spray. Do this until the whole drawing area has been fixed. If you spray in one spot too long, the fixative can run or stain the drawing.

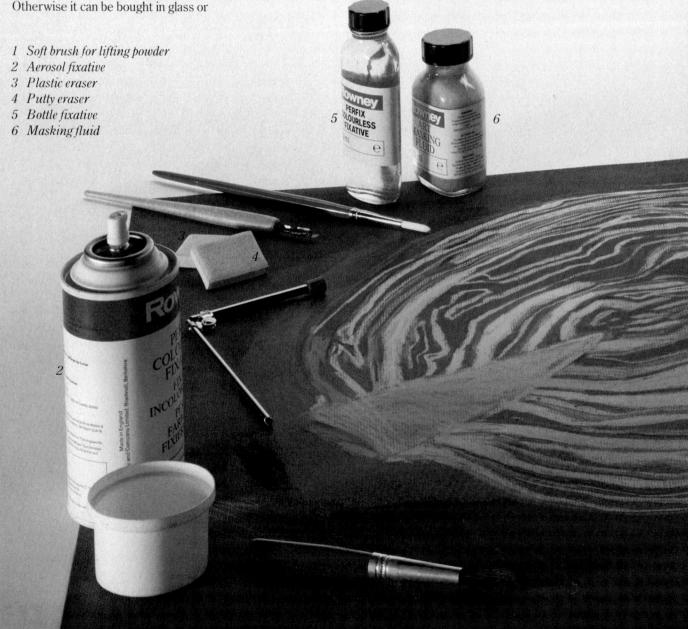

Easels

Drawing and sketching easels are essentially lightweight, designed to hold your board or pad at a convenient height and angle as you work. They are collapsible and portable, making them ideal for outdoor work.

A watercolour easel can be tilted to a horizontal position – this is useful for mixed media work, or if you plan to add washes of colour to your drawings. The horizontal position prevents the ink or paint from running. Lightweight box easels are also good – ideal for drawing expeditions because they have a box or drawer for materials. For working

at home, a table easel, which stands on any flat surface, is useful and takes up very little space when not in use.

It should be said, however, that an easel is not obligatory – certainly not the first item of equipment you should rush out and buy. It is obviously easier to see what you are doing if the support is propped up, and the majority of artists prefer to work in this way because it allows them a full and undistorted view of the drawing as it progresses. But other artists work quite happily with the drawing board rested on their knees or propped at a slight angle on the table. For instance, the step-by-step

projects in the last chapters of this book were done on a drawing board on a flat table top. The artist propped this upright at intervals in order to stand back and assess the work.

Nor should the lack of an easel prevent you from working outdoors; you can quite easily fix a strip of fabric tape to a drawing board (pin each end of the strip to the centre of the short sides of the board) and wear the board around your neck for support. A folding canvas stool is another excellent piece of equipment for outdoor sketching.

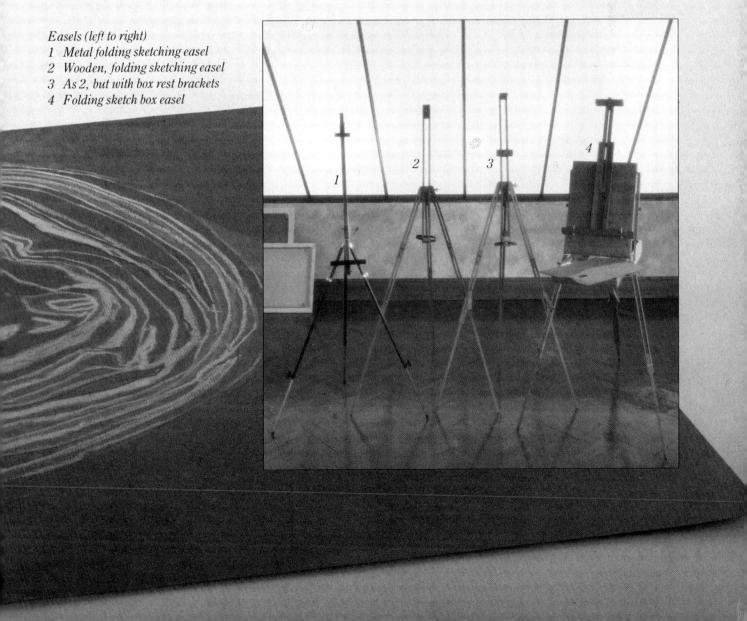

SUPPORTS/PAPER

The paper you choose for your drawing plays an important role in the success of the finished work. Not only is choice of colour and tone crucial when using coloured drawing materials such as pastel, but the texture and surface of the paper dictate the character and appearance of the marks made upon it.

Traditionally, drawing papers are white or off-white but, as you will find in the practical demonstrations in the final chapters of this book, the barriers are not rigid and there are no hard-and-fast rules. Common sense is the governing factor as far as colour is concerned. Obviously, a deeply toned paper is unsuitable for delicate pencil drawing; similarly, pastels and other coloured media often look better if the paper tone is chosen to match the colours in the subject.

How to choose a support for a particular drawing material is discussed in more detail overleaf. machine-made and hand-made.

Most papers are machine-made. These can either be 'hot-pressed' (HP), 'not' (meaning 'not' hot-pressed), and 'rough'. Hot-pressed papers are generally fairly smooth, whereas 'not' papers have a definite texture, or 'tooth'. Rough, as the name suggests, is extremely coarse and generally used by watercolour painters, but it is good for certain types of drawing, such as brush with ink, and mixed media.

Hand-made papers are expensive and are usually made from pure linen rag. One side of the paper is given a coat of size, and this is the side to draw on. If you cannot recognize the correct side by its slightly smoother texture, it can easily be identified by the manufacturer's watermark.

Cartridge paper is the most widely used drawing paper, but Bockingford, Saunders, Arches, Cotman, Kent and Hollingworth are among the quality papers to look out for.

The 'weight' of an artists' paper refers to its thickness. A 60 or 70 pound paper is fairly thin; a 140 pound paper is thick (this figure actually refers to the weight of a ream, 480 sheets). Lightweight papers will buckle when wet, and will remain buckled even after they dry. This is worth remembering if you want to use washes of colour on your drawing, or if you are working with water soluble pencils and intend to

5

discussed in more detail overleaf.

Choosing Your Paper
Artists' papers are confusingly named, but the categories are actually quite simple.
Basically, they fall into two groups,

3

dissolve the colour with a quantity of water (small areas of water or wet colour will not normally affect the paper). Choose a heavy, good quality paper – preferably in a gummed pad – to avoid this disappointing problem.

Toned and Tinted Paper

Coloured and toned drawing papers are widely available and usually come in an extensive range of colours and neutral tints. Quality names include Canson, Ingres and Fabriano, but there are many more. Each paper type is characterized by its particular surface texture. Some have a fine, regular 'tooth'; other papers can be

identified by barely discernible grooves.

Cheaper tinted papers include sugar paper, available in grey and other neutral colours. This is a longtime favourite with art students and beginners. Its popularity is due partly to its low price, and partly because its sympathetic mid-tones are ideal for many techniques and materials.

'Tooth' and Texture

The texture of your paper – how rough or smooth it is – is important. Crumbly materials, such as charcoal and pastel, need a support with enough surface texture to hold the colour. Pen and ink, technical pens and other delicate drawing tools are best on smooth paper or board.

Special Purpose Papers

In addition to the standard drawing papers, there are several specialist products on the market. Many of these, such as the exotically textured Japanese papers, are not suitable for the inexperienced artist. But others are more functional.

Smooth board, including Ivorex and Bristol board used mainly by graphic and technical artists, are ideal for drawing when an even, precise finish is required. Other types of board are simply drawing papers glued to a stiff card. Being rigid and easy to handle, these are convenient for outdoor work.

Special papers for charcoal and pastel are also available (see overleaf).

1 Sugar paper

2 Sugar paper

3 Bockingford Medium 140 lbs

4 Hollingworth Rough 140 lbs

5 Whatman Rough 140 lbs

6 Whatman HP

7 Bristol board

8 Cartridge paper

9 Pergamenata (vellum type)

10 Hollingworth Smooth

11 Pergamenata (vellum type)

8 5 W 6 W 7 E 8 C 9 P 10 F 11 F 9

10

11

SUPPORTS/PAPER

The supports used in the projects in the final chapters of this book were the choice of the artist, selected in order to demonstrate techniques and materials as clearly as possible. You will probably find it helpful to follow our artist's example, but do not let this deter you from making your own experiments later on. Even when learning to draw, the task can be made more exciting and adventurous by trying out different surfaces and comparing the results.

Charcoal and chalk

When using charcoal and chalk, the paper should be matt and have a slight 'tooth' or key, otherwise the dry, powdery medium will not adhere to the surface of the paper. Very smooth or shiny supports are unsuitable because the charcoal and chalk slide around.

When working with charcoal and chalk – using the charcoal for the dark, shaded areas, and the chalk to depict illuminated planes and highlights – choose a tinted paper. Ideally, this should be a medium or middle tone, so that both lights and darks show up well. Canson, Ingres, Fabriano, Montgolfier and the inexpensive sugar papers are all good for charcoal and chalk. A special 'charcoal' paper is also available. This

is heavy with a coarse texture and toned or coloured finish.

When working with charcoal alone, choose a paper of any colour provided it is pale enough to enable the dark lines to show up.

Colour Sticks

This broad category includes traditional conté as well as the waxier studio sticks and crayons. Again, a slightly textured paper is required if the various sticks of colour are not to skid around. For traditional conté colours – sanguine, grey, bistre and brown – choose a medium toned, neutral coloured support, such as sugar paper or one of the more subdued tinted papers. When using the full range of conté colours, use tinted, white or off-white paper. Studio sticks and wax crayons are best on light-toned or white paper.

Pen, brush and ink

Ink can be used on any paper surface, depending on the effect required. This can either be very smooth or shiny, or extremely coarse. Pens are best used on fairly smooth surfaces; the technical pen should never be used on coarse or textured papers because these clog the fine tubular nibs. When drawing with a brush, however, the possibilities are wider. Try using very textured handmade watercolour papers – supports not normally favoured for drawing. These produce unusual and exciting textures, including areas of flecked colour and broken lines.

Pastel

Soft pastels are at their best on good quality tinted paper. Choose one to match the subject. Light pastel tones on a dark neutral paper can be most effective. Special pastel papers, similar to fine sandpaper, can be bought at art shops. Alternatively, try the finest graded sandpaper available at your local hardware store. The advantage of these gritty surfaces is their capacity for holding dense quantities of pastel, and this makes for exceptionally intense colours.

Pencil and Graphite

Choice of paper here is wide, depending on the scale of work and the effect required. Generally, a smoother paper is good for small, detailed drawing; coarser surfaces for large-scale work. Otherwise almost any medium textured drawing or watercolour paper is suitable. Exceptionally smooth and shiny surfaces are not recommended.

Coloured Pencil

Again, a medium textured paper is desirable when using coloured pencils. The water soluble variety call for a heavy, good quality support to withstand wetting. Coloured and dark toned papers are generally unsuitable because the pencil tones have neither the strength nor the opacity to stand

out. Light-toned papers, however, are worth experimenting with and should be selected with the subject in mind.

Markers and Fibre Tip Pens

Hundreds of these modern, disposable writing and drawing tools are now available in stationers, artists' supply shops and high street stores. Some are waterproof, others water soluble. Choose the surface to suit the product – trial and error is probably the best way. Generally, medium textured drawing paper is the best bet.

Wedge-tipped markers and certain felt-tipped pens bleed when used on ordinary, absorbent drawing paper. To avoid this, use special marker paper available from graphic and fine art supplies. This is sealed, either on one or both sides, thus preventing the colour from seeping through.

- 1 Ingres
- 2 Ingres
- 3 Canson
- 4 Canson
- 5 Pastel paper
- 6 Canson
- 7 Canson
- 8 Canson
- 9 Turner Grey
- 10 Greens 'Camber Sand'
- 11 Ingres

1/

1

Chapter 3

Charcoal and Chalk

This is the perfect medium for beginners. It is much better to start drawing with charcoal and chalk than with a normal pencil. The medium is popular in many art schools for initial drawing lessons because it encourages students to think about the whole subject and not to become lost in detail. In the same way, it will help you to think big, to concentrate on main features, to treat subjects in broad terms, and to think about lights and darks from the moment you make your first marks on the paper. Why not pin up a jumbo-sized piece of paper to the wall, right now, take up charcoal and chalk, and sweep some broad marks on to the surface, perhaps sketching out an arrangement of large, simple objects on a life-size scale...

Without worrying about detail or over-specific outline, try to indicate – straight away – where shading appears on the objects, contrasting this with lighter patches. Then draw in some outlines later, using the shading as the starting point. You do not necessarily have to start with an outline sketch.

You may have discovered by now that the medium is messy! Smudges are almost inevitable, but do not worry about this; in fact it discourages another initial fault of beginners – to rely totally on an eraser to make their drawing absolutely neat. Work that is too neat becomes dead, especially if it is overworked. Charcoal, or charcoal with chalk, is essentially a lively way of operating.

You should think positively about what choice of paper to work on. Black and white on toned paper makes you look for the lights and darks of the subject. These are important. A drawing without tonal contrast looks flat and uninteresting. Tones are something we have to learn to look for; they will not appear automatically as you draw (for instance, there may be more than one shade in a shaded area). The local colours or tones of familiar objects are what our eyes see without 'thinking'. Tone is something which we look for only if we have to make an interesting, contrasting picture. Therefore it is advisable to get into the habit of 'tonal thinking', looking for lights and darks rather than detail and colour. You do not even have to make recognizable forms at first - turn your subject or composition into an arrangement of flat shapes of greys, black and white as a good initial exercise.

Charcoal and chalk can be used, of course, for linear drawing as well as for shading.

Materials

CHARCOAL AND CHALK

Charcoal, made for centuries by the controlled and partial burning of wood, is one of the oldest drawing materials in history. It makes bold, black marks which can then be lightened if necessary by erasers. The longer the process of carbonization of wood, the softer the charcoal is. Charcoal for artists comes mainly from the vine – producing the

finest quality – and the willow, which is the more common. The products are marketed usually in a form known as stick charcoal – sticks about six inches long, boxed in sets. You can buy sets of thin, medium or thick sticks, and some can be purchased individually. The sticks can be sharpened to a point by rubbing on fine sandpaper. Charcoal pencils, where a strip of reconstituted charcoal is encased in wood like a

normal pencil, are also available on the market. Although they are cleaner to use, they have to be continually sharpened to reveal the charcoal point.

Compressed Charcoal

You can also obtain compressed charcoal, made from charcoal powder pressed with binding medium, which breaks less easily. This usually comes in shorter sticks. They are suitable for blocking in more definite areas of tone. Their marks are bolder, and less easy to tone down or rub out.

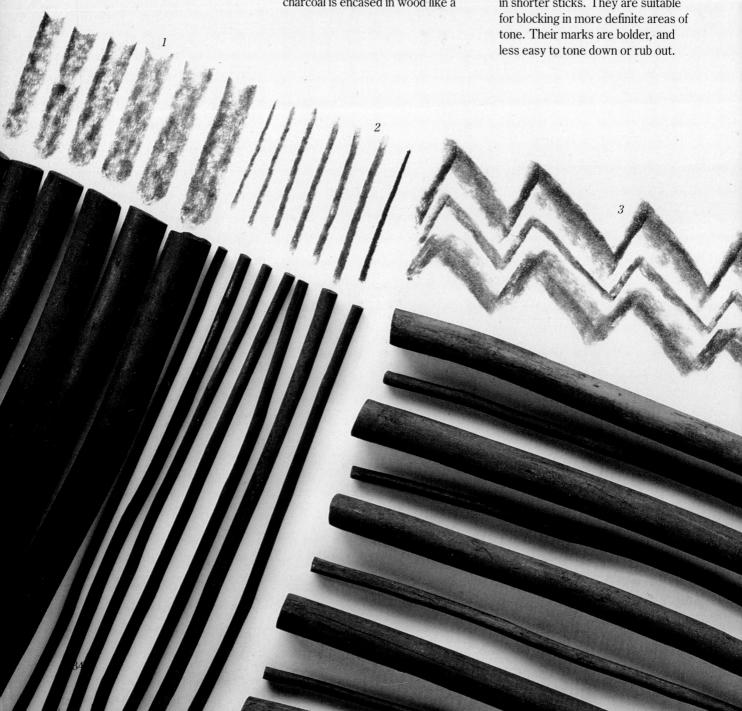

Chalked Highlights

Chalk (calcium carbonate) is often used with charcoal, and the cheap blackboard variety is perfectly suitable. White pastel, conté, or pastel pencils can also be used, but many artists stick to chalk as a traditional way of picking out highlights in a charcoal drawing, or for mixing with charcoal to establish a mid-tone.

Paper Choices

To get the best use of the light and dark tones of white and black drawing materials, you should choose tinted paper. Our artist has done this in the chalk and charcoal drawing on page 38. Several types of tinted paper are available. Canson or Ingres come in a

good range of colours, have good quality and also possess a matt surface suitable for the medium. Sugar paper, which also has a matt surface, comes in warm and cool grey, and is inexpensive. As a general rule, avoid smooth, shiny surfaces. Your chalk and charcoal will just slip around and not adhere to the surface at all. When using charcoal alone - for a line drawing rather than a tonal picture – any fairly textured surface will do, and you will find white and off-white suitable. Charcoal is sympathetic to the textures and grains of paper, allowing them to show through. For this reason, watercolour papers are good supports - their pitted surfaces create a lively textured drawing. For the beginner,

however, this can be difficult to deal with; it might be better to avoid very textured papers. But experiments will pay off. Because charcoal is good for large scale work, rolls of cheap newsprint or lining paper can be useful as supports.

Blending Tools

Charcoal tones can be blended or lightened by erasers. A kneadable eraser is ideal because it is softer and picks up the charcoal powder, producing a cleaner mark. Torchons, brushes, pieces of tissue, rags – all of these can be used to create lightened effects on charcoal.

It is absolutely essential to fix a charcoal drawing. If you fail to do this, the lines and tones will become blurred.

- 1 Thick charcoal
- 2 Thin charcoal

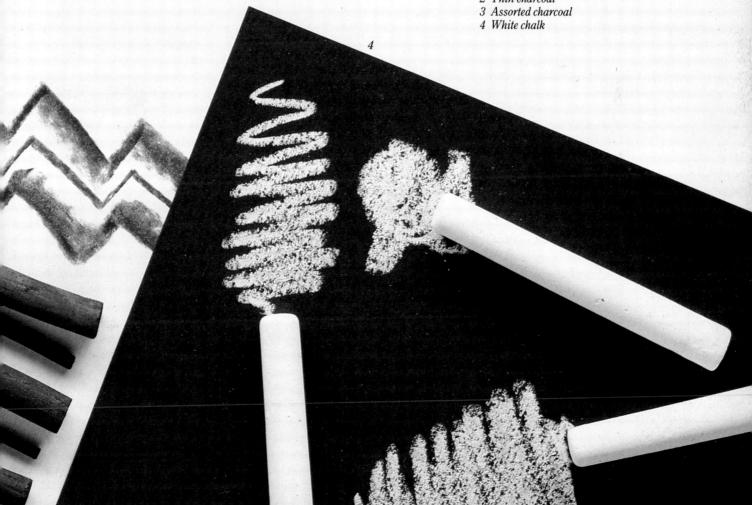

Techniques CHARCOAL AND CHALK

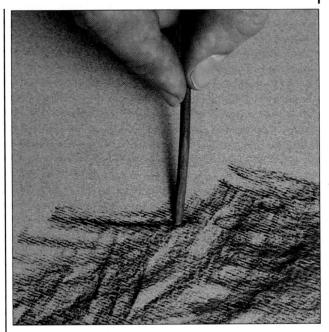

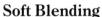

Charcoal is one of the most adaptable of all drawing media. With it you can make lines of any thickness and density. You can create areas of heavy shading, and you can also describe form by means of delicate, graded tone. Charcoal, however, is naturally grainy and makes an uneven, textured mark or line, especially when used on coarse paper. If you want a flatter or smoother finish it is necessary to blend the charcoal – usually with the finger, a torchon, or a piece of tissue or cloth. Before embarking on a drawing, it is worth devoting a little time to practising this technique, and to discovering the sort of effects which can be achieved.

To create an expanse of blended tone, first build up an area of lightly scribbled marks, making these as even and consistent as possible (1). Do not press too hard with the charcoal – if the mark is too ingrained, it will be difficult to blend. Use the tip of your finger, lightly rubbing the surface of the drawing to blend the marks together (2). The finished effect (3) is a deep, soft shadow which can be made darker by repeating the process until the required depth of tone is achieved, or lightened with further blending.

Remember, blending simply means smoothing or rubbing and need not be confined to large areas – you can be selective, picking out small patches and details, or even blending a single line if this is the effect you want. Chalk and charcoal with chalk can be blended in exactly the same way.

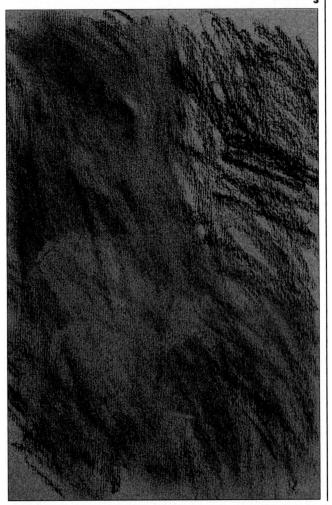

TECHNIQUES

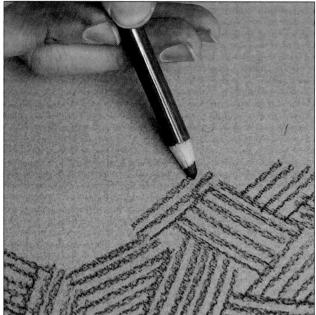

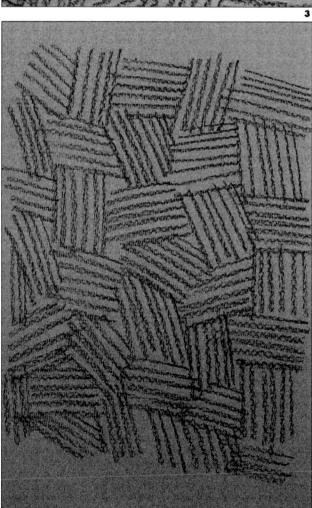

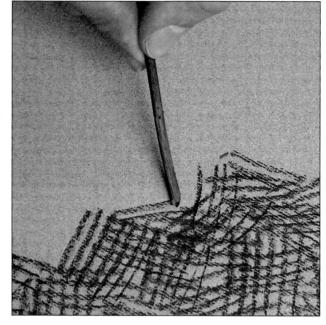

Hatching and Cross-Hatching

Drawing is essentially about line, about creating form and movement with charcoal, charcoal pencil, chalk, or any other drawing instrument – all of which produce a line. With soft materials it is possible to blend lines to achieve a solid area of tone, as the artist demonstrates on the opposite page. But it is also possible to create tone with line alone, using the traditional method of hatching and cross-hatching. By building up a series of hatched lines on a selected area you can suggest solid tone and colour, making this darker or lighter by varying the closeness of the lines. For a formal, graphic effect, keep the hatching regular and even; use free, scribbled lines for a looser, more sketchy look.

The pictures here show the artist creating hatched effects using both charcoal and charcoal pencil. Charcoal pencil (1) produces a harder line than charcoal, making it possible to control the tone to a large extent. Here the artist is using adjoining patches of neat parallel lines, allowing the amount of light-tinted paper showing between the black marks to dictate the shade of the final tone (2). The thick, soft line of stick charcoal is less suited to controlled hatching and here the artist adapts the marks accordingly. Instead of a regular pattern, the strokes are laid freely in loose hatched and cross-hatched areas, creating a slightly patchy mesh of tone (3). The colour of the paper affects the final tone, so experiment on both white and tinted supports.

Drawing Form

CHARCOAL AND CHALK

We know what a sphere, a cylinder or a box is supposed to look like, but we 'see' these objects only with the help of light and shade. Otherwise they would appear as flat shapes. In other words, we see form in terms of tone. This is not a problem in everyday life; we have expectations of what familiar objects should look like, but the artist has to 'create' form on the flat paper – one of the fundamental problems of drawing.

The objects here have been chosen for their simplicity – even though they are the key to much of what you will eventually draw. You may not have all these precise objects to hand but you should be able to find something similar from around the house.

Chalk and charcoal are excellent drawing materials to start with. They cover the entire range of tone; the charcoal can be used heavily to represent deep black, and the chalk similarly for the white end of the spectrum. Because they are a broad, chunky medium, they will encourage you to deal in broad terms – looking for the basics instead of getting carried away by irrelevant detail.

Grey or tinted paper, instead of white, is crucial for this type of drawing. From the midtone grey you simply need to make the darks darker and the lights lighter.

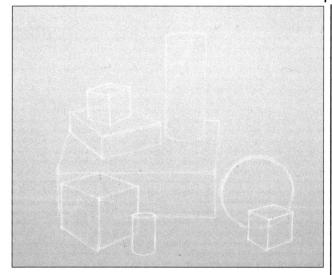

1 The artist uses white chalk to mark in the outlines of the objects. The lines are lightly drawn, so the final drawing will not be dominated by outlines. It is important to think about composition right from the start. The whole area of this grey Ingres paper, measuring 22in×30in (56cm×76cm), should be used; if the objects are too small, they will be dwarfed by surrounding space.

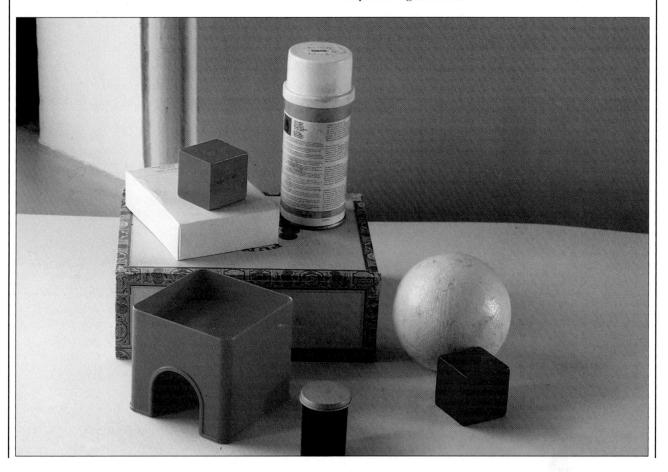

2 A stick of charcoal is used to block in the darkest shadow areas of the subject. When drawing objects which are different colours and contain patterns or letters, it is often difficult to discern areas of light and dark. Therefore, you will find it helpful to look at the subject through half-closed eyes. This blocks out some of the local colour, making the highlights and shadows more distinctive.

3 Here is an example of the torchon (described earlier) being used to blend the charcoal. The cylinder is dark on one side and light on the other, and is smoothly graded from its lightest to darkest areas. Therefore the shadow area must gradually fade, and the torchon is rubbed onto the charcoal to lighten it and help the blending.

4 At this stage the artist has established the main shadow areas. For the darker shadows the artist has used the charcoal relatively heavily to obtain black or dark grey. Because charcoal tends to crumble you might find it easier to build up the very deep tones gradually, when first drawing. The artist has used a second, slightly lighter, tone of grey for the mid, or 'in-between', shadows. This is done by using the charcoal lightly and occasionally applying the torchon to soften areas which look too dark.

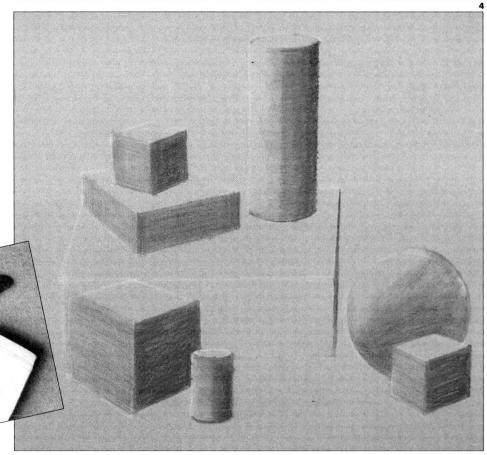

CHARCOAL AND CHALK/DRAWING FORM

5 The artist has given the blocked-in charcoal a light spray of fixative before moving on to this next stage.

A directional light is falling on the objects, which means that the top surfaces are light planes and the shadows are cast clearly to one side. The light therefore helps to describe the volume and form of the cubes, sphere, cylinders and boxes. In this illustration, the artist is picking out the most obvious highlights and blocking them in with fairly dense white. A chalk pencil is being used to obtain a good crisp line on the edge of one of the boxes, but do not worry if you do not possess one. By using the edge of a stick of ordinary chalk you will be able to achieve an equally precise mark.

6 All the white planes and highlights have now been established. The artist has used the chalk loosely to suggest the table top, deliberately seeking to achieve a broken tone by the free criss-cross of the marks. This has allowed the grey paper to modify the white, to avoid a densely bright table top which would have competed too much with the objects.

The treatment of the objects has reflected the nature of the objects themselves. They have very smooth surfaces, so the chalk and charcoal have been smoothly applied and blended when necessary with the torchon.

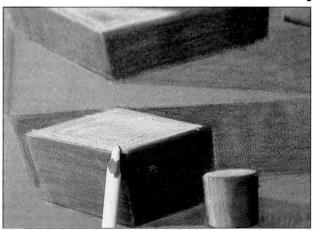

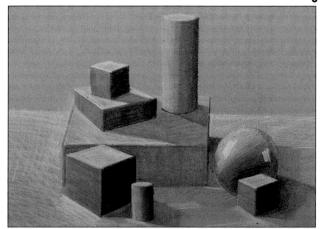

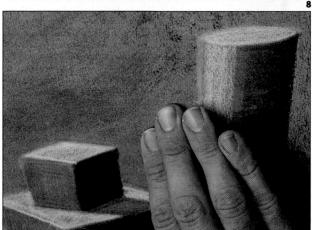

7 The artist blocks in the background. Because this is such a wide expanse and the artist does not want it to be too dark or dense, the area can be covered rapidly by using the side of a stick of charcoal. This method inevitably produces an uneven texture which can be blended later, but it has the advantage of enabling the artist to control

the tone – layers can be built up fairly quickly to obtain just the right degree of darkness. Cover the required area as quickly as possible even if it is too light, and then add second and third layers and so on. This way the result will be more even than by trying to establish the correct tone straight away.

8 The fingers are used to blend the background to a smooth finish. Again, the artist works quickly across the whole area, rubbing gently but briskly with the fingertips and causing the granular texture to give way to a flatter tone.

Textures can offer a choice between a picture which aims at harmony or one that seeks contrast. The background here did not necessarily have to be smoothly textured like the objects. The artist took a personal decision to aim for harmony. An alternative would have been to create contrast by allowing the slight coarseness of the initial background tone to remain – thus emphasizing the smoothness of the subject.

9 The forms in this finished picture are simple, abstract ones, but the treatment of them is exactly the same as it would have been for something more complicated. The rules are the same. After all, even the human body is in fact an arrangement of near-cylindrical volumes. An arm or a leg would require the same treatment of light and shade and similar blended

degrees of tone as the cylinder in the picture. The cubes and boxes, too, are the basic underlying forms which will need to be represented in many more complex pictures. A house, for instance, consists of a combination of these. The same principles apply to organic shapes such as flowers and plants – they have a definite structure and can be simplified into basic shapes and

forms in exactly the same way as the more obvious geometric objects. Dealing with amorphous shapes like foliage or clouds, human hair or animal fur – things which do not apparently possess precise form – can present what appears to be a daunting problem. If you can only get into the habit of looking at, and treating, these as arrangements of simple mass

and volume you will start to solve the difficulties.

One essential final touch for a drawing with charcoal and chalk: give the picture a spray of fixative and allow this to dry.

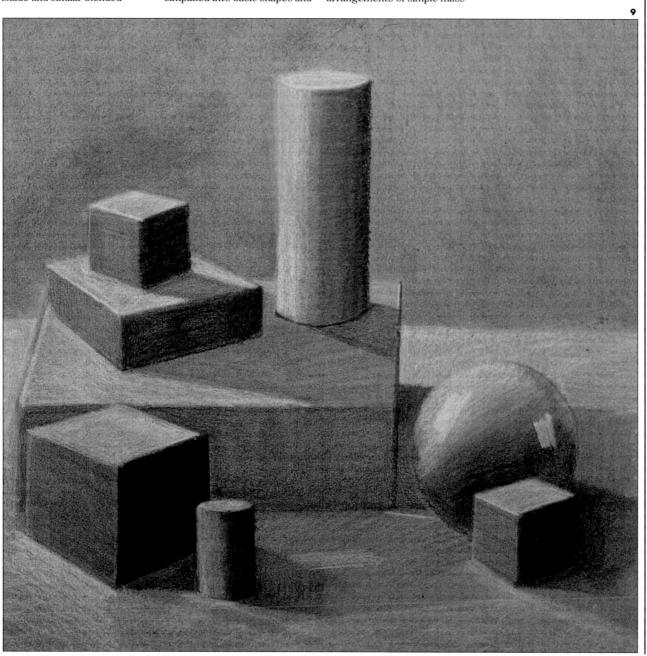

Sheep's Skull

CHARCOAL AND CHALK

The subject here is more complex than the previous geometric forms. But the approach is still simple, seeking out the basic elements of the image. The sheep's skull – placed in the barest of settings with a piece of curved paper forming a background free of clutter and horizon – provides a less rigid exercise than the previous project. It is a more complete enterprise, potentially more interesting, as there is more scope for personal interpretation.

You are invited to introduce new aspects now into your drawing. In this demonstration the artist looks for the graphic qualities of the subject – the effectiveness of the shapes themselves in an almost abstract sense. There is also an opportunity to be selective about areas of light and shade, rather than making an academic rendering of everything before you. The secret is to keep the selection to a minimum. Experience has taught the artist when to stop. The subject offers a challenging chance to try your hand at drawing line, exploiting all the different thicknesses and types of line, each doing a specific job. Here, for instance, the artist has used stronger line for the major shapes and outlines, tapering into a fine mark for the internal contours of the skull

The project involves an indication of local colour, and the use of texture, to enhance the nature of the subject and its bony substance. The lightest areas of the subject, the horn and the lower part of the skull, are appropriately lightened with white chalk in the drawing, as is the light-coloured background. The artist has deliberately made the shadow much darker than the reality, in order to improve the strength of the composition and emphasize the light-source, and thus the solidity, of the subject.

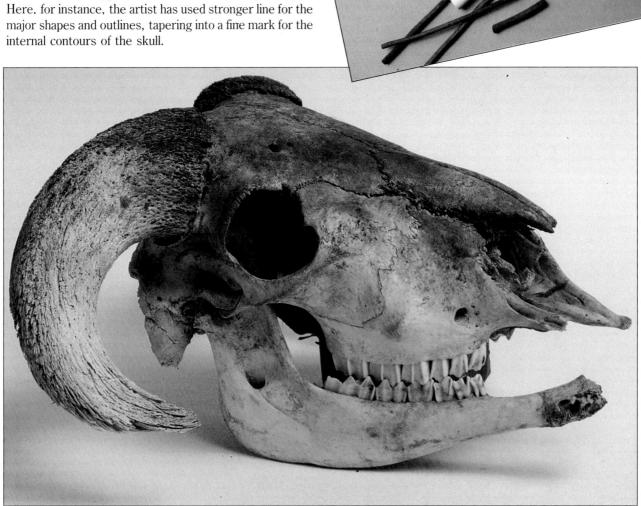

1 Working on grey Ingres paper measuring $22\text{in} \times 30\text{in}$ ($56\text{cm} \times 76\text{cm}$), the artist starts by making a line drawing of the subject in charcoal. The artist draws into the form' – outlining not only the outer shape of the skull, but also the forms that appear within it. For instance, in this case the outlines which make up the contours of a cheekbone are described.

When using line to depict a three-dimensional object, it is important to be sensitive to the subject as a whole. The line is therefore kept light but varied in strength and thickness. Remember that if the line is too regular and harsh, the subject will look flat, however accurate this line might be.

2 The outline continues, with the charcoal moving into the jaw and teeth. The artist draws the individual outlines of the teeth because in this case they are an integral part of the main structure. Again, the line is kept fairly light. The artist looks carefully at the subject, referring to it constantly before committing a mark to the paper, to retain a linear quality and keep adjustments

to a minimum. But this should not inhibit you into making an over-tight drawing. The line does not have to be absolutely perfect first time.

The necessary alterations here have been made by re-drawing rather than easing. For this picture, a clear image is required, and erasing would break-up the surface.

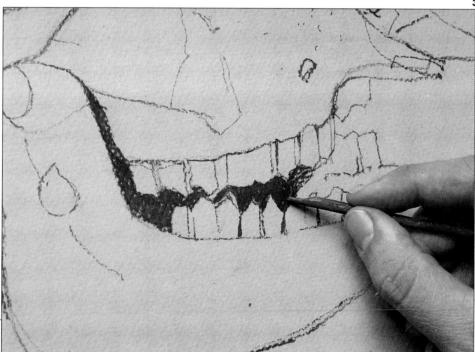

3 The space between the teeth is drawn in, to make a flat, black shape. The artist is trying to keep the light and shade to a simple minimum to preserve the linear aspects of the drawing. Just enough light and shade is required to suggest the form. The black shape is sufficient, immediately suggesting the depth that would exist behind the teeth and within the skull; the artist has not created any degrees of tone in this area. In blocking in this shape, the artist takes special care not to destroy the jagged, bony structures of the teeth.

CHARCOAL AND CHALK/SHEEP'S SKULL

4 The line drawing is complete. In effect, the lines on the contours resemble contoured hills on a map – they describe three-dimensional form on a flat diagram and they also build forms within forms. Now that the lines have been drawn it is easy to see how the artist has varied their thickness and strength to suit their purpose. The outlines are strong while the shapes of

the bones within the skull are lighter. Thus, the form has been described largely by means of line, without any strong directional light which would create the shadowy chasms that depict form. In fact a light did shine on the skull but the artist ignored it, relying on simplified shadow and line to create a solid image.

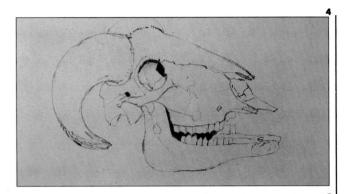

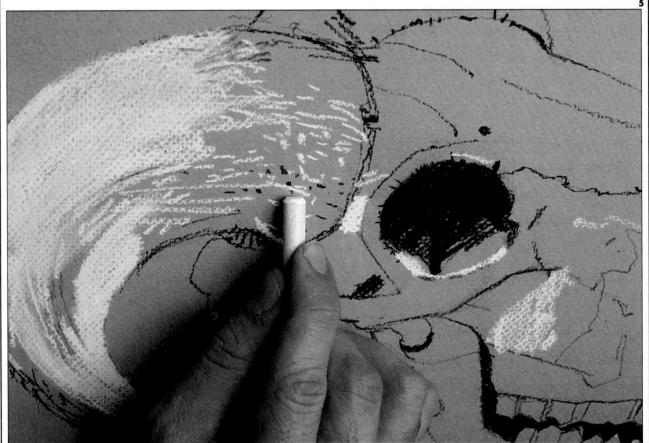

- 5 The white chalk is being used to pick out the highlights and obvious light planes on the skull, such as the raised edge of the eye socket and the tiny triangular planes on the face. Here a lot of white has been used on the horn, an important and striking characteristic of the subject. Flecks of white provide an effective way of depicting the horn's porous texture.
- 6 The light and dark tones are now in place, but in fact the image looks inevitably weak. This is because the skull is still predominantly composed of the grey-coloured paper and is therefore still very much part of the background. The picture as a whole has not yet taken on a three-dimensional aspect. The artist is ready to unify the image and develop the background.

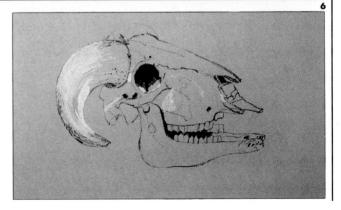

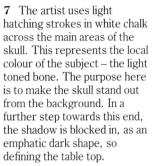

8 A final step has been taken to defeat the two-dimensional flatness of the paper and lift the picture into form and space. The artist has lightly scribbled in a texture with the side of the chalk. These areas of flat paper have therefore been broken up, suggesting substance rather than space – in this case a light-coloured backdrop to the skull.

Chapter 4

Colour Sticks

Now is the time to move on to colour, and to start with we shall keep our emphasis on a bold and broad approach. To help with this, we have chosen materials which can be brought together under the general term 'colour sticks'. These are chunky, broad materials which encourage an open approach and discourage overworking, rubbing out and detail. Conté, studio sticks and wax crayons belong to this category. Although they call for bold marks, they are easy to use. They require less expertise, for instance, than soft pastels and oil pastels – see Chapter 7.

Again, you are advised to work on a grand scale, on white or tinted paper, the bigger the better. Our artist operated on a large scale in both demonstrations, and there is no reason why you should not go even bigger, pinning the paper to a wall if your board isn't big enough – don't be restricted by standard-size equipment. Small supports and boards are fine for certain pictures, but remember that they tend to dictate the way you work. On a large scale, you can work freely, drawing from the elbow, keeping the lines flowing and uninhibited. For the same reason, give yourself plenty of room in your workplace.

Be adventurous with the outline, combining line and colour rather than outlining a shape with one colour and filling it in. The lessons learned about tone in the charcoal section also apply here – colours, too, have tones. It's great to have a lot of colours available – and most of these materials do come in wide ranges of colour. Remember to be selective, however. Choose the colours you need for your subject before you start. You can establish a harmonious colour theme in this way; and once you start, you won't want to stop and look for what you need – a habit which can all too often lead you to pick up a compromise colour.

These chunky materials encourage you to use the whole of the paper. Make use of this. Don't start in the middle and work on a fiddly scale, thus losing the benefit of the materials. Notice that the lobster, in one of the demonstrations, fills up almost the whole support. In the other illustration there is more space but it plays an active role in the composition. The still-life arrangement depends on the top half being fairly empty, with folds of material leading the eye down to the lower half, where the focal point is the statue head.

Materials **COLOUR STICKS**

The range of new and old materials in the form of sticks is so wide that terminology becomes difficult. There is a vast array available - crayons, studio sticks, conté, and so on. These are the simpler, chunkier sticks, as opposed to the pastels which occupy their own chapter.

Conté

These are small square sticks originally made from pigment compressed with clay and other ingredients. They are harder than charcoal and pastel. The traditional colours are black, white, sepia, sanguine and bistre. A range of greys has been added. Drawings done in these traditional colours often seem to have an antique look dictated simply by association. Leonardo da Vinci, for instance, used a red chalk similar to the sanguine conté.

Like charcoal and chalk, the limited range of these more traditional, subtle colours is good for tonedrawing on tinted paper. However, the development and refinement of artists' products never ceases, and conté sticks are now available in a full range of colours.

Conté can be bought in single sticks, in sets of the traditional 'Carrés' colours, or in the larger sets which contain a full colour range.

In a picture rendered in conté, the colours can be blended. When working with conté sticks, vou can use the sharp edge, the broad edge or the broad end, giving you the choice of three thicknesses of line. Conté colours need fixing. Use matt papers with a key - Ingres, Canson, cartridge, or watercolour paper.

Studio Sticks

Although they look similar, these modern materials are less manageable than conté because they are waxier, and they cannot be blended easily with the finger. They are more like coloured pencils without the wood. Studio sticks are good for the beginner because they defy a lot of detail, and their waxiness prevents them from being overlaid - the maximum is usually about three colours. You will achieve your best effects with studio sticks if you make

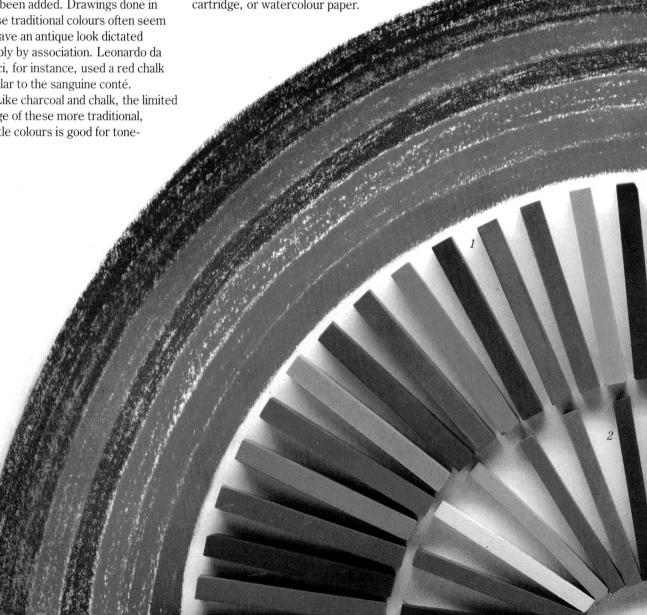

plenty of use of the white paper – see the illustration of the lobster. They can be used for three thicknesses of line, just like conté. Use smooth or textured papers, but remember that the papers should not be too rough.

Studio sticks do not rub out easily but they can be scratched back. They can also be dissolved with turpentine but it is difficult to control the tone and colour with this process, so experiment first. Unsuitable for small work, studio sticks are best for quick impressions. They break easily, so

build up colours in thin layers and don't press too hard. They are available from art shops in sets; on first use you might find them difficult because the outside of each stick has a waxy coating, so get rid of this by scribbling on rough paper.

Wax Crayons

The cheaper varieties of these – the kind you would buy in a normal stationery shop – tend to be less refined than those of top quality, and they are not the best materials for controlled work. But because they are inexpensive and easy to obtain, they are ideally suited for quick, or experimental, large-scale pictures.

Children's crayons are perfectly acceptable as tools for adult work; so, as well as searching the art shops for supplies, you could buy small sets of crayons from toy stores.

Water Soluble Crayons

These chunky sticks can be dissolved with water. Practice is required, and the use of water makes the colour darker and more difficult to control. This type of crayon is good when you want to combine a line drawing with areas of 'painted' quality. It is another material not really suited to detail, so work on a large scale. Good quality paper or card is needed, to withstand the wetting process.

- 1 Studio sticks 2 Conté crayons
- 3 Water soluble crayons

Techniques

COLOUR STICKS

Conté Crayons: Overlaying Colour

Less powdery than chalk and charcoal, conté colours can be mixed by laying one colour over another, allowing the underneath colours to show through. The sticks are square, which means you can obtain very fine hatched lines by drawing with the sharp edge of the end of the crayon, building up the colours in as many separate layers of cross-hatching as you need and allowing the colours underneath to show through.

In the illustrations on this page, the artist is using traditional conté colours – sanguine, black and white. The first colour, sanguine, is laid in neat cross-hatched patches on a tinted paper to obtain an even tone (1). To darken this, the artist works over the sanguine in black, using the sharp edge of the stick to make thin, controllable lines (2).

This combination can be worked into with other colours to alter the overall tone and colour as required. In the third picture (3) white is being added to lighten the final effect.

Conté Crayons: Blending Colour

Conté is soft enough to blend colours by rubbing them together. This technique is especially useful if you want a small area of smoothly blended tone, such as the gently graded shadow and light on a shiny, rounded object (it is less suitable for large, even areas because it is difficult to get a flat colour). In the illustrations below, the artist demonstrates how to merge two colours to obtain a smoothly blended edge by first laying the colours next to each other (1) and then rubbing the join gently with the finger to merge them (2).

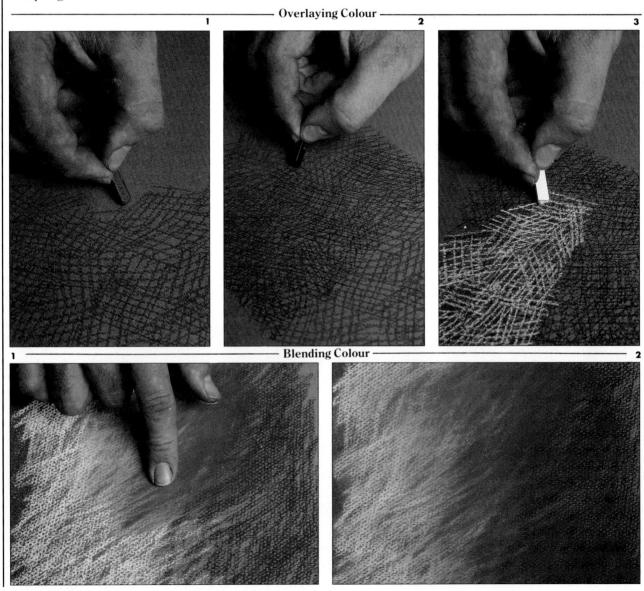

MATERIALS

Studio Sticks: Optical Mixing

Studio sticks are waxy and heavy, without the crumbly, 'blendable' texture of conté, charcoal and chalk. Although they can be mixed by overlaying two or three colours lightly, subtle hues are limited because the waxy surface builds up, becomes shiny and resists further working. With studio sticks, two or three layers of colour are the maximum, and even then it can be difficult to control the effect.

One way round this problem is to mix colours 'optically' – in the eye rather than on – the paper – by using small dots of colour to create exactly the shade you want. For example, greens can be mixed from yellow and blue dots. The shade and tone of the final green is determined by the proportions of yellow and blue, and how densely the

dots are distributed on the paper. Different blues and yellows can be used to make an almost infinite range of greens. These can then be modified with small amounts of another colour. The technique is employed in all artists' media, including paints, but is especially useful when the materials themselves do not mix and blend easily. This includes studio sticks.

Here the artist starts with a scattering of bright red marks, working over these with light blue to create violet (1). Green dots are added to neutralize this (2). The brightness of the final colour (3) is determined by the amount of white paper showing between the dots. Mixed together on the palette, these colours would produce a dull grey. Here, the separate colours are visible and the result is a lively neutral.

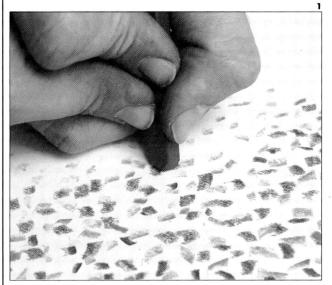

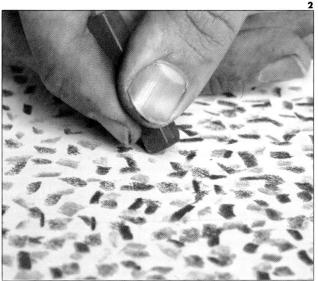

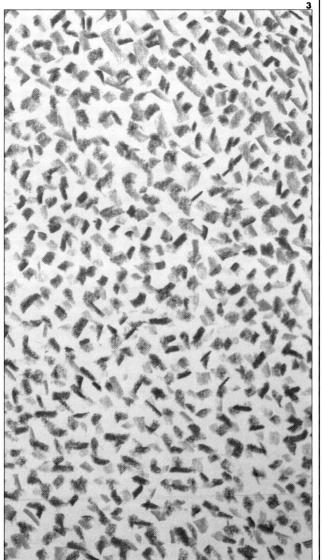

COLOUR STICKS

Studio Sticks: Laying Colour

Practice will enable you to control the colour and tone of waxy studio sticks to some extent. We have already seen how optical mixing can be used to combine colours on the support. This technique, however, is not suitable for all types of work, and you may not want your picture to be dominated by the flecked texture which characterizes optical mixing. In the pictures below, the artist demonstrates alternative ways of laying and mixing colour.

Studio Sticks: Overlaying colour

One of the best ways of mixing colour by overlaying is to hold the sticks lightly, drawing with feathery strokes, and pressing just hard enough to distribute the pigment evenly on the support. Work loosely, leaving plenty of white paper showing between the marks (a slightly rough surface will provide a 'key' and hold the colour better than a smooth paper). Here our artist lays three colours – blue, violet and finally red (1) – to obtain a deep textural purple. The more colours you attempt to add, the less white will be left showing, and the denser and more clogged will be the result. Generally, two or three are the most you should aim to use on any one area (2).

Studio Sticks: The side of the stick

To block in wide expenses, use the side of your colour stick (1). The result is an evenly spread, mottled texture with flecks of white paper showing through (2). You can also use this method to mix two or three separate colours by overlaving.

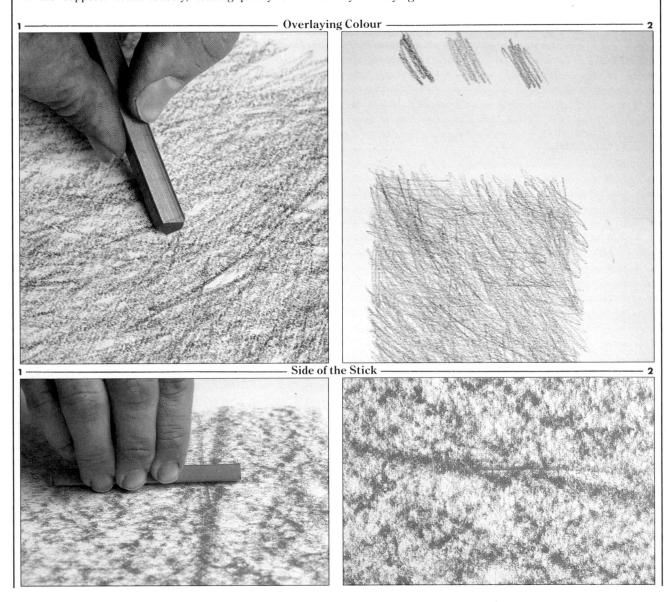

TECHNIQUES

Texture

The conveniently squared shape of conté and studio sticks means you have a lot of choice when it comes to making marks and creating texture. Draw with fine, medium or broad strokes, depending on whether you use the sharp edge, broad end or side of the stick. The textures demonstrated here show just a few of those possibilities.

Textural Marks

Long, broad flecks (1) can be used as a flat pattern. Alternatively, the direction of the strokes can be altered to indicate perspective. For example, if you wanted to render the surface of a receding road with a flecked texture, the recession and distance could be emphasized by directing the flecks towards the vanishing point of the road.

Feathery random strokes (2) are another useful method. They can be adapted to suit many surface textures, and are an excellent and quick means of turning a flat background expanse into an area of interesting broken texture.

Sgraffito

Blocks of solid colour can be enlivened by scratching texture into the dense tone with a sharp blade or scalpel. The scratching, or 'sgraffito' technique allows you to make fine etched lines which reveal the colour underneath or the tone of the paper. Here the artist is using the tip of a surgical scalpel (1) to scratch away some of the blue top colour, thus allowing streaks of the bright yellow underneath to show through (2).

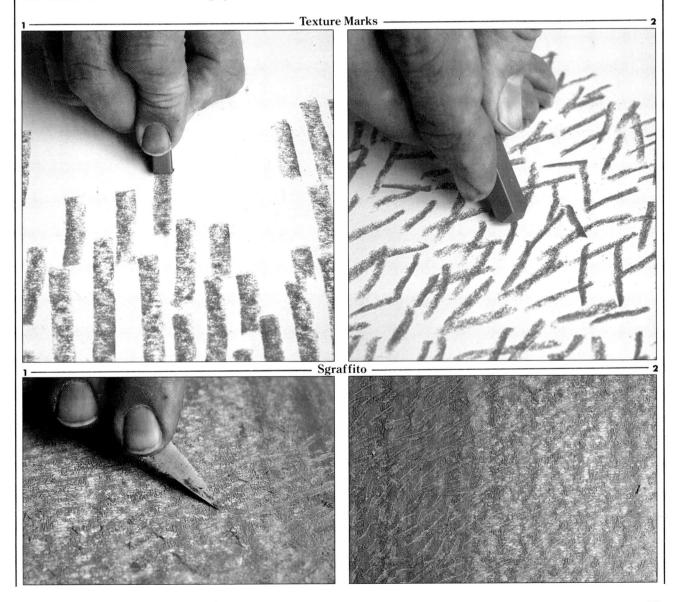

Still-life with Drapery

The cast of a head rests at the foot of a long, hanging drape, positioned near the simpler spherical form of an apple - a challenging arrangement which requires a systematic approach. The artist uses conté, which can produce darker lines the more heavily it is pressed. In order to achieve absolute control, however, the artist did not rely on different pressures. Instead, cross-hatching was used to build up the grades of tone. Fairly light cross-hatching was applied, and further layers were added where necessary to create darker regions. By adding light

layer upon light layer you can retain total control and tackle quite complex compositions.

Because conté is softer and chalkier than modern studio sticks, it can smudge. Here, an experienced artist used fixative only at the final stage. However, there is no reason why you should not spray with fixative at each stage, between tones, especially after using white. Fixative is a varnish, so a light spray is sufficient. Too much will smooth the surface which will become shiny and resistant.

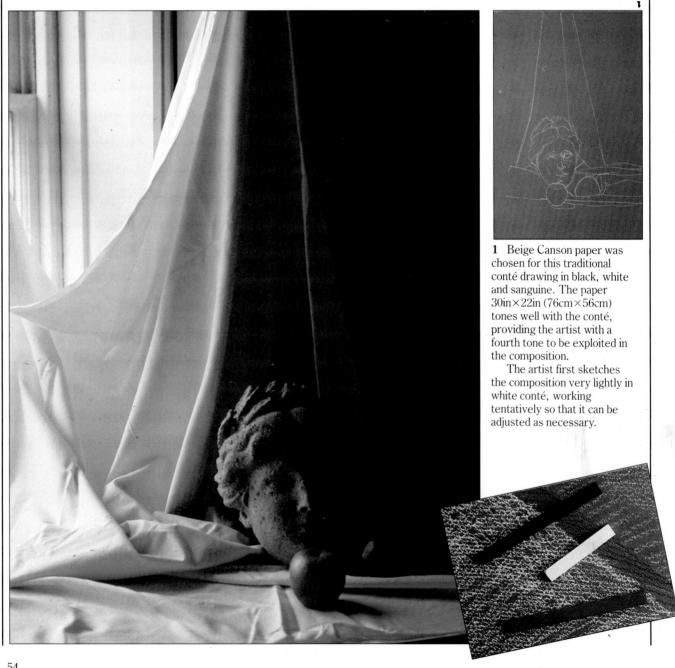

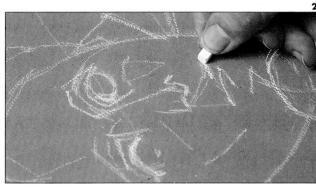

2 It is now time to strengthen the white drawing so that it can act as a sound guide for the ensuing tones. The lines are drawn over again, using the sharp edge of the conté to achieve a narrow final line. Do not be afraid to draw boldly and to correct your drawing by going over the lines again. It is far better to have two or three clear lines overdrawn on the paper, than to overdo the

rubbing out which will make the drawing fuzzy. Once you start erasing, you are in danger of losing the clarity and sharpness of the background tone. By using the sharp edge of the stick, as the artist is doing here, you are further ensuring a crispness of image in this early stage.

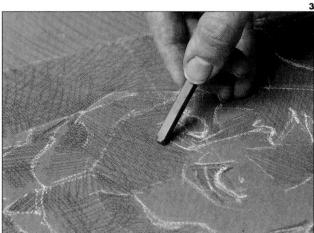

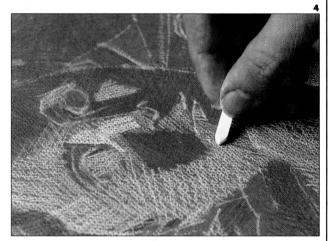

3 Reddish-brown sanguine conté is used to lightly hatch in the broad shadow areas on the face and drapery. The artist keeps the hatching loose and the lines far apart; if the work is done too densely at first, it becomes difficult to build up the colour and control the tone. This is the foundation for further blocking in of the shadow regions. The edge of the square piece of conté is employed to keep the lines fine. The conté is turned over as each edge becomes worn.

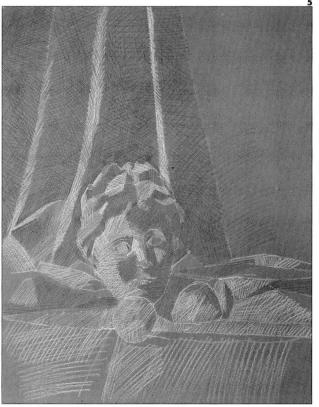

- 4 Following the general areas of shadow, the artist now turns to the lighter regions. White conté is used lightly hatching in the general areas of light. The strokes are kept loose, allowing for the brighter highlights to be added later in more dense and brighter white. At this stage the artist does not attempt to grade the white to suggest form.
- **5** The broad areas of shadow and light have now been defined. It is important to note how they have been done with extremely delicate, crisscross strokes. Already the subject has been given a certain amount of form because of the strong directional light source, even though the sanguine and white areas at this stage are still flat shapes. The directional light has picked up the strong edges of the fabric folds and the contours of the face.

CONTÉ CRAYONS/STILL-LIFE WITH DRAPERY

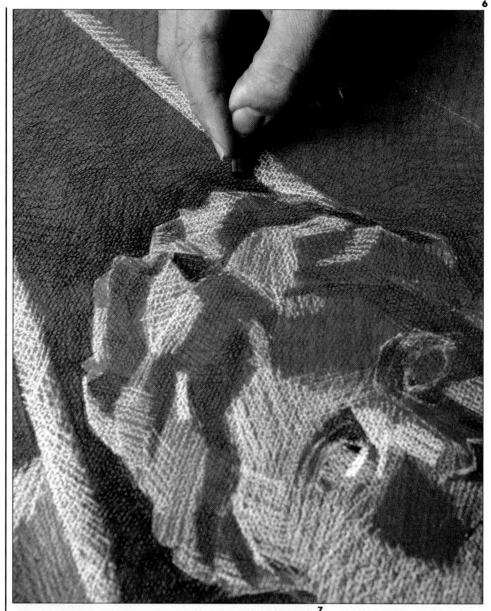

- 6 Still working in the light criss-cross technique, the artist uses black conté to develop the shadows.

 The medium dark shadows are picked out first, and are depicted with one or two light layers of hatching being worked in over the underlying sanguine. The palest shadow areas are left to be represented by the sanguine. For the darker shadows, the artist applies further layers of cross-hatched black.
- 7 The direction of the hatched lines can be exploited to describe form. In this illustration the artist is taking the direction of the cross-hatching round the curved shape of the apple to emphasize the form. A similar approach was used on the folds of the drapery where the strokes follow the long broad pleats.
- 8 With the white conté, the artist works into the light areas, picking out the highlights, reflections and brightest patches. Again, this is done by further layers of controlled cross-hatching. On these narrower highlights the artist is using a single stroke of white to draw in a thin shape of elongated light behind the apple.

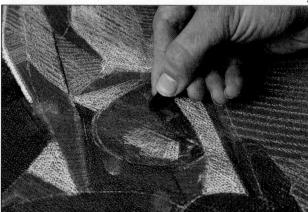

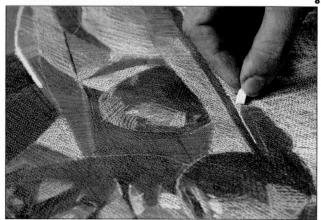

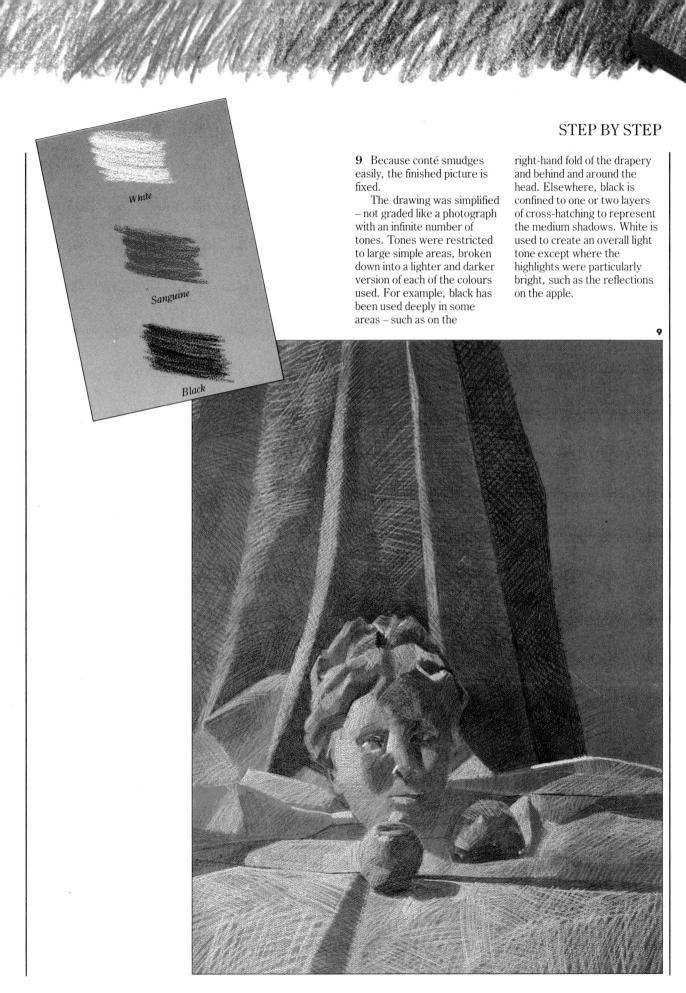

Lobster on a Plate

STUDIO STICKS

Studio sticks are an ideal medium for beginners. They are broad and chunky. One of the main hurdles when learning to draw is lack of confidence, and this tends to force the inexperienced into attempting detailed renderings. The studio stick, however, invites a bolder approach. The sticks are also available in a wide range of colours, allowing for colourful, adventurous interpretation.

These bulky sticks are used here to draw an object which at first glance seems exactly the wrong one for them – the complicated, organic twist of claw, tendrils and 'whiskers' which are typical of the lobster. The artist,

however, has decided not to carry out an intricate, academic drawing but to produce a big, sketchy image. The advantage of this is that it magnifies many of the shapes and colours which lie within the form of the lobster and which would be lost if the drawing was to real-life scale or smaller.

The artist has also decided to have no background in this picture. The lobster spreads itself across most of the support. For the drawing, it was set upon a white plate, the same tone as the paper, so that the backdrop would be white during the drawing.

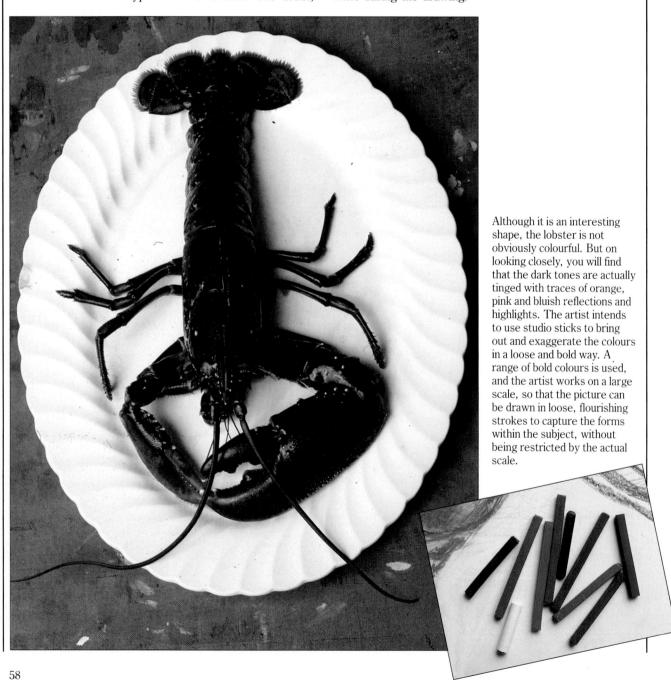

1 The artist places the subject centrally and prominently on a large sheet of cartridge paper measuring $30\text{in} \times 20\text{in} (76\text{cm} \times 51\text{cm})$. Using purple, black and brown – approximations to the obvious real-life colours – the artist sketches in the outline of the subject. The drawing movement is made from the elbow as well as the wrist, to capture the flowing curves of

the tendrils. At this stage the drawing is fairly tentative and light.

2 With black and brown, light cross-hatching strokes are made, in order to build up the dark local colours on the claw. Light and dark orange are also introduced to re-define the outline, lift the flat effect of the dark colours and capture some of the traces of bright hue present in the actual subject. The strokes are lightly applied with plenty of white paper. showing through.

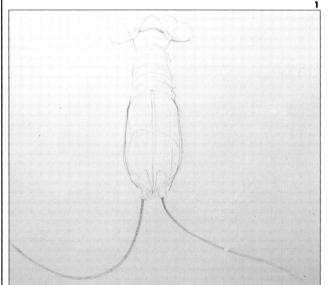

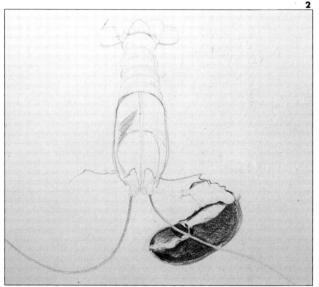

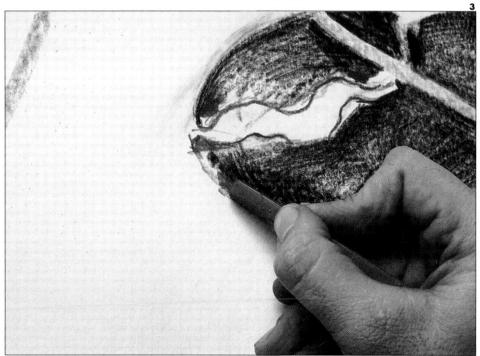

3 The artist is combining line with solid tone, re-defining and redrawing the outline of the subject as the work progresses. The lobster is being studied very carefully, so that bright colours can be picked out at this stage and introduced to the drawing. The fine wavy red lines on the inside of the claw are done with the edge of the stick. Here, the artist is using the broad side of an orange studio stick to create a wide solid wedge of colour. Notice how the dark areas of crosshatching fade out towards the outline of the drawing. This means that the brighter linear colours do not lose their effect by being swamped. They have plenty of white paper around them to allow them to show up to full effect.

STUDIO STICKS/LOBSTER ON A PLATE

4 Further layers of colour have been introduced – hatched and cross-hatched to build up the tones in black, dark purple and brown.

The tendril, which has already been lightly blocked in, passes in front of the claw. This has been preserved as a light negative shape. When using studio sticks it is difficult to make a lighter colour show up on a darker one, so areas

which are light or white have to be left – the light tone of the paper providing the light tone. When drawing the claw, therefore, the edge is brought up to the outline of the tendril to leave a clean crisp edge.

At this stage, the artist also strengthens the coloured outline to match the newly-established darker tones.

5 The artist now moves on to the rest of the lobster, having established, in and around the first claw, the basic overall tone and colour of the whole picture. The tones and colours are blocked in, in a similar way, lightly at first with a view to strengthening these later. With studio sticks you cannot be impatient when building up tone. If you use them too heavily at first, it makes

further drawing impossible. They must therefore be built up slowly and lightly, especially as in this case when two or more colours are being laid on top of each other.

The direction of the marks describes the form they represent. The head, for example, is simplified into directional planes describing the rounded form.

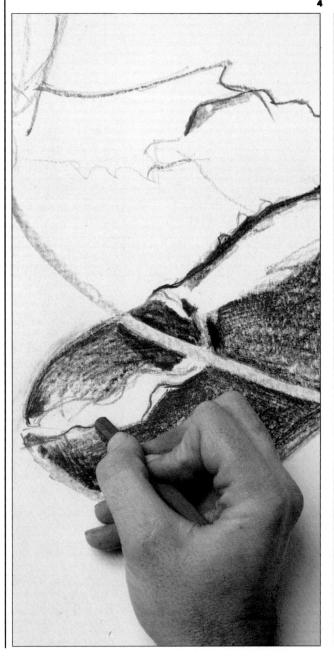

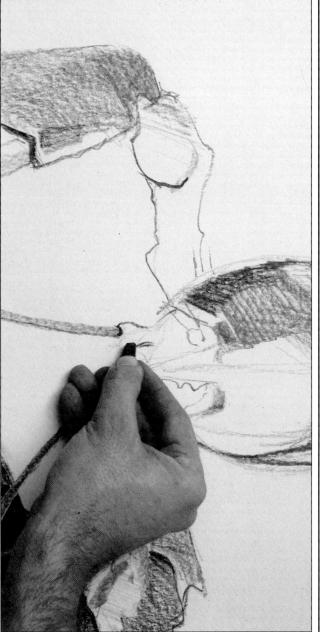

6 The artist works vibrant warm tones into the dark and cool areas of local colour. Because the undertones were lightly applied, the white paper can still be seen, and the dark colour is not too dense to receive a further lighter tone. These dashes of colour are introduced sparingly, their object being to lift the image. Too much colour here would destroy the point of these

dashes, and would work against the naturalistic effect being sought. Because the artist intends to continue to develop the local colour, the side of the stick is being used here, to keep the application light. This means darker tones can still be used over this to modify the effect of the yellow if necessary.

7 So far the claws and the body have been blocked in, and already the lobster is looking very solid because the cross-hatching has been used to depict definite planes of light and shade. Notice that on the body of the lobster the artist has paid attention to the source of light. The light is not particularly strong or emphatic, but without this highlight on the lefthand side,

the body would look flat and formless. Similarly, light ridges have been left down the back of the lobster – another area where it picks up the light source – and light highlights on the claws and elsewhere have been applied.

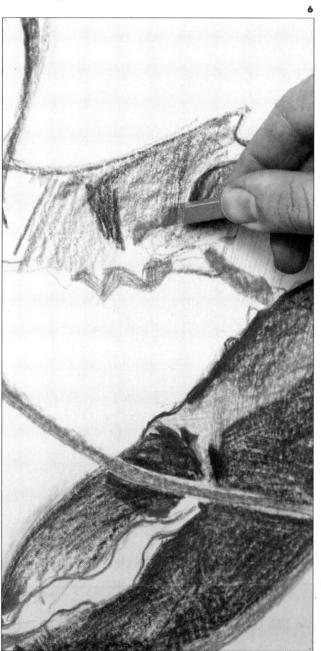

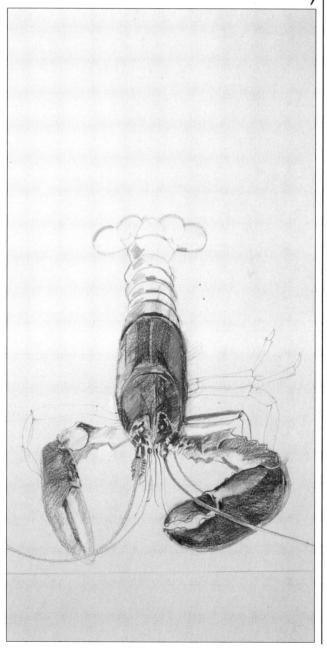

STUDIO STICKS/LOBSTER ON A PLATE

8 With studio sticks it is often quite difficult to work from dark to light. You have to leave areas of light rather than working them over the top of darker regions, because the surface becomes increasingly shiny. However, you can scratch the surface to depict highlights – or, as in this case, you can switch to chalk.

9 The artist chose chalk for highlights because its crumbly texture will adhere to the waxy surface of the studio sticks. Highlights have already been chalked in on the body, and here the artist is using chalk along the edges, in order to achieve a clean outline. The white chalk modifies the colour beneath rather than completely covering it.

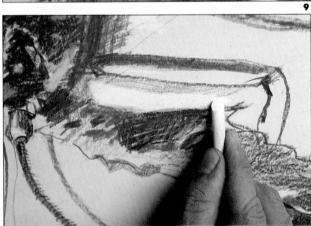

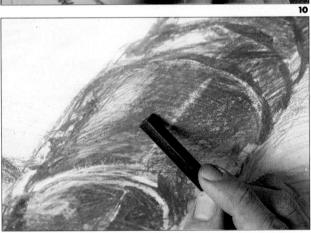

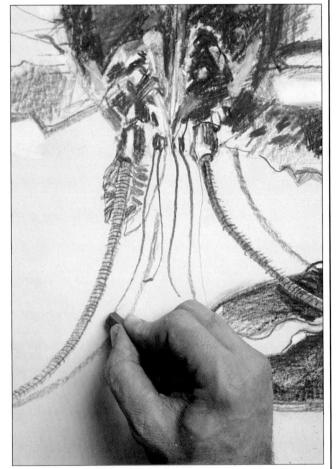

10 The white chalk is receptive to further working with studio sticks. Here the artist re-defines some of the darker tones over the light highlights.

11 Final touches are now added. The tendrils and 'whiskers', an important feature in the overall subject, are developed. The artist works round the two main tendrils in a dark purple with the edge of a studio stick, putting in their segments. Using brown, red and orange, the whiskers are added in free strokes.

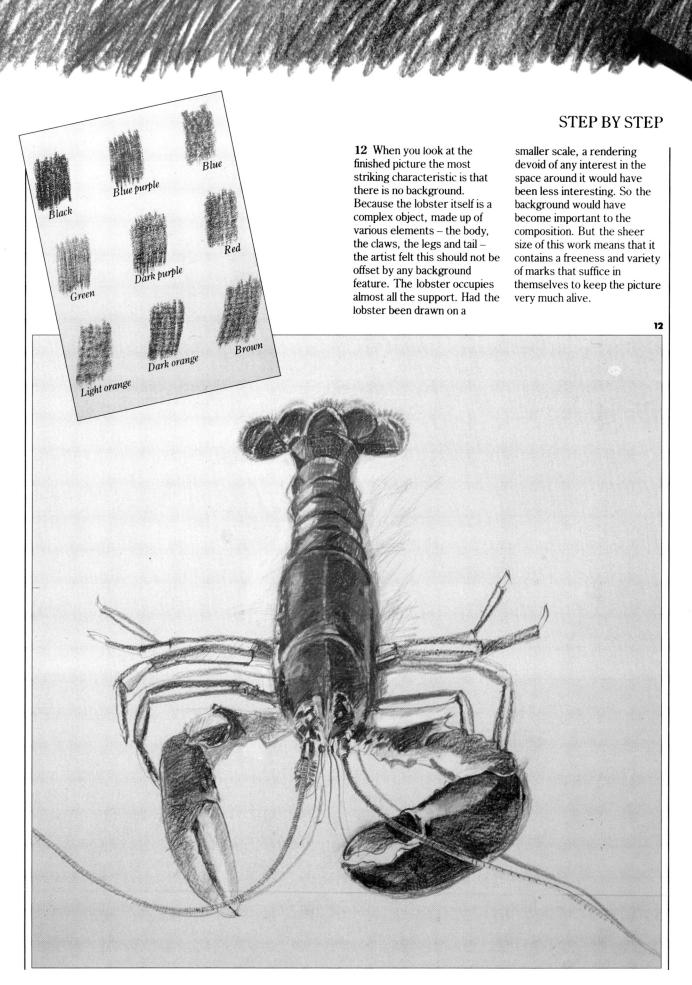

Chapter 5

Pen, Brush and Ink

This is a medium which was used by some of the great masters centuries ago and is still easily available, not only in its traditional form but also in a wide range of modern variations. When you sit down with pen, brush and ink, you may be working directly in the tradition of past artists such as Rembrandt (1606-69), who created drawings with brown ink and wash – some as preliminary sketches for paintings but many as finished pictures in their own right. Yet you are also working with a medium which allows for a great deal of experiment, for it embraces some of the latest materials.

This creative medium allows you to combine line with areas of colour and tone. It can be used in monochrome or in multi-coloured pictures. You can work with line alone, or you can use line with blocks of colour. Our artist demonstrates a line drawing with a technical pen; a bright circus scene with blocks of pure colour enlivened with dip pen and line; and a quick sketch made with an ordinary ballpoint pen.

You would be well advised to experiment with different pens. Get the feel of an old quill pen and compare it with modern fountain pens, ballpoints and technical

pens. The medium can be used for finished works or for rapid on-the-spot sketching. Inks are now available in a huge range of colours, some brilliant or even fluorescent; they also come as concentrates.

There are various ways of exploring the possibilities and limitations of the medium. You can experiment with brush drawings, such as the Chinese 'boneless' style without outlines. You can start with line and add colour, or begin with blocks of solid colour and add line.

For the beginner, ballpoints and technical pens are ideal training tools. There are no precedents (no old master ballpoint drawings!), and therefore you can feel completely free to experiment. And the limitations of these tools can also be turned to advantage for quick sketching – they produce rather boring, unvaried lines in themselves. This means you can concentrate on getting down the information without worrying about how the finished drawing looks. You can work tight or loose, or combine these two approaches in the same work. The uncompromising lines will also force you to tackle directly some of the basic techniques of drawing, such as hatching and cross-hatching, to achieve a tonal effect.

Materials

PEN. BRUSH AND INK

These materials include the ordinary, everyday pens which can be bought in stationery shops and also some of the more technical types of pen. Even though there has been impressive technological development in this field, the old-fashioned quill has still not disappeared, and in fact is increasingly used by artists who like its characteristic, natural-looking line. The quill's direct opposite, the modern technical pen, is a rewarding challenge if you are a beginner seeking to explore some of the basic principles of drawing. Our artist chooses a technical pen to illustrate some of these principles.

- Water soluble inks
- Waterproof inks
- 3 Oriental brushes
- 4 Quill pens
- 5 Reed pens
- 6 Dip pen
- Technical pen

Technical pens

The tubular nib of the technical pen produces a regular, ungiving line. This is suited to graphic, linear work, and our artist uses one in the still life on page 70. Technical pens can be bought at art shops and graphic suppliers. You can obtain different nibs - sometimes called 'stylos' from very fine to very broad. The number varies with the make. One manufacturer produces 19, another 12. The tubular nibs can clog and must be cleaned after use with a proprietary solvent cleaner. You can use special inks, made by the pen manufacturers and obtainable along with the pens, to help prevent this clogging. But if a nib does clog, soaking in solvent cleaner can often save it.

Dip Pens

These are the pens once associated with schoolrooms, where children made blots on their initial, scratchy efforts at handwriting. Dipping the pen into the ink and controlling the lines on paper was not easy for young schoolchildren at first, because the pen itself does not greatly restrict the flow of ink, and it responds to varied pressure on the paper. It is for these very reasons that the dip pen is popular with artists. The pen gives a varied and undulating line which can be turned to different effects. Most art shops have a range of nibs which are used in the same standard holder; and for tiny, extra-fine lines there are mapping nibs with their own small holders. You need a good supply of nibs. They don't last for ever, and with constant pressure they tend to spread.

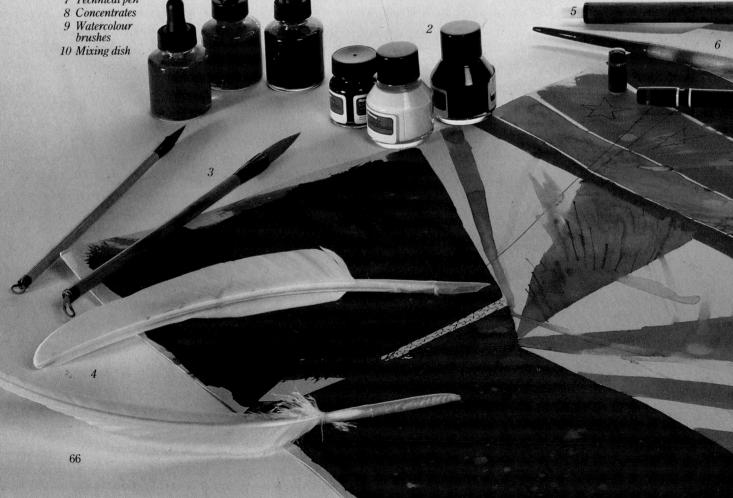

Ballpoints

These are cheap and easily available. Although they do not make interesting or varied lines, they are ideal for the quick sketch which is to be used as a reference for later work in the studio or home. They come in limited ranges of colour, usually red, blue, black and green.

Fountain pens

Fountain or reservoir pens are also useful for drawing. They offer a variable line – not quite as interesting as that of the dip pen, but you do not have to keep s'opping to dip into the ink, so they are useful for sketching. Remember, however, that the nibs are not designed for drawing, and consequently they can be comparatively short-lived.

Quills and Reed Pens

These earliest types of drawing materials have maintained their popularity over the centuries because of their ability to produce varied lines and often beautiful effects. Quills are available in art shops. You will need practice in order to develop their versatility. They require cutting frequently, to form a new nib, because the tip soon softens; use a sharp blade or craft knife for this. Reed pens can also be bought at many art shops and these make a hard, jerky line, capturing the linear effect of dip pens but on a completely different scale. You need to dip into the ink a great many times with quills and reeds, and you should experiment to collect the right amount of ink and avoiding flooding and blotting.

Inks

The last few years have seen a big increase in the range of inks. Water soluble and waterproof are the main categories. Inks come in all colours.

Waterproof concentrates can be obtained in bottles, and they are very strong. The colours can be diluted as required, allowing for some degree of experimentation. They come in a very good range of colours. Some of these, however, are fugitive and fade quickly.

Brushes

Any watercolour brushes can be used with inks. For line painting, sable has a nice, springy quality, but sablemixes and other hair brushes, are also effective. Synthetic brushes are suitable, although they have less spring. Chinese and Japanese brushes have soft, pointed bristles, good for flowing, natural lines.

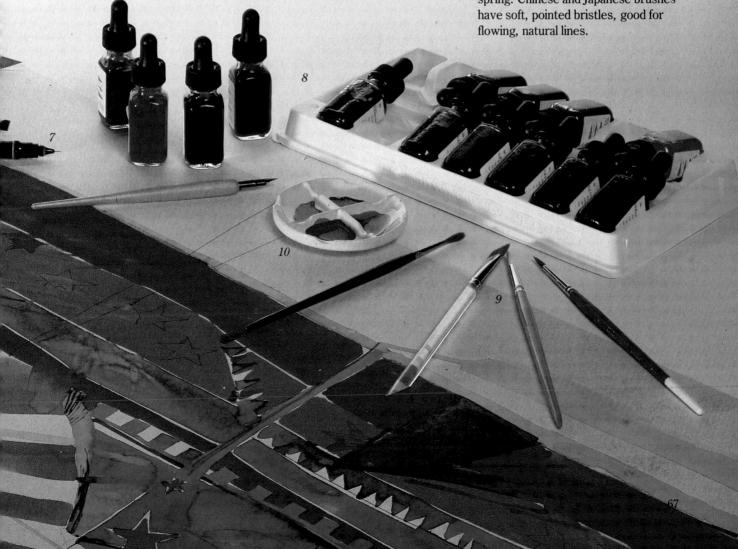

Techniques

PEN, BRUSH AND INK

Technical Pen

The technical pen forces you to use line, and only line. Tone, texture and pattern must all be created from this single element, and you therefore need to be as resourceful and inventive as possible when using this piece of equipment. And the regular, mechanical line – so restricting in many ways – also has its compensations. For example, the rigid tubular nib can be relied upon not to flood and blot, and you can exploit this constant factor by extensively weaving the fine lines into a wealth of different textures and surface patterns. Here the artist builds up regular marks of cross-hatched tone (1), using the smooth surface of white card to help produce the final, graphic effect (2).

Quill Pen

The old-fashioned quill pen differs from the modern technical pen in almost every way. Here, the problem is not one of how to make a mechanical line more interesting, but rather one of having a line which is uniquely interesting, but can also be too irregular and sometimes difficult to control! The quill needs practice, and you will have to dip into the ink frequently as you work. Do not attempt a neatly rendered drawing – instead, make the most of the natural, undulating marks which your feather pen produces. Here (1) the artist uses a scribbly line to produce an area of broken tone from the irregular hatching (2).

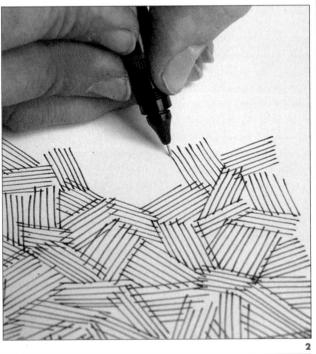

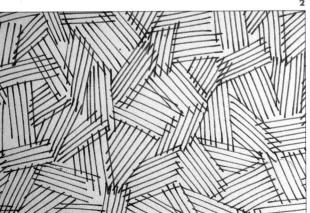

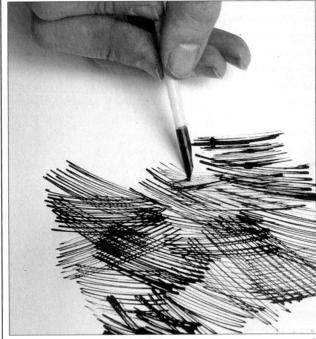

Brush

Watercolour brushes make ideal drawing tools. The finer the brush, the more delicate the line. But a word of warning – the artist who draws with the brush, must be relaxed and well-versed in the medium. Tension or uncertainty will be reflected in the quality of the lines, and the smooth, articulate flow which typifies the best brushwork will not be achieved. So spend some time getting used to the technique of brush drawing. Ideally, decide where you want to make the mark, and then apply it boldly and confidently – don't work cautiously, or hold the brush too tightly. Here, the characteristic tapering lines of the watercolour brush are used (1) to create an area of tone (2).

Ballpoint Pen

With ballpoint pens, you are not aiming for subtle drawing. This everyday, familiar writing tool comes into its own as a quick, convenient means of sketching when more conventional drawing tools are unavailable. Its techniques are confined to unexpressive line, hatching and scribbling, so get used to working within these limitations. Our artist uses scribble tone a lot when sketching with a ballpoint pen, usually starting with a loose, overall pattern (1), and then building this up to the required darkness or density (2).

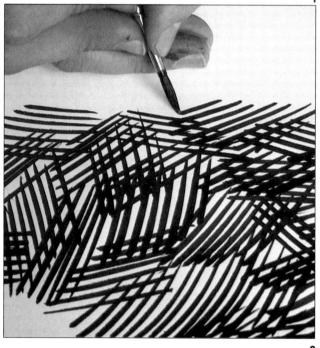

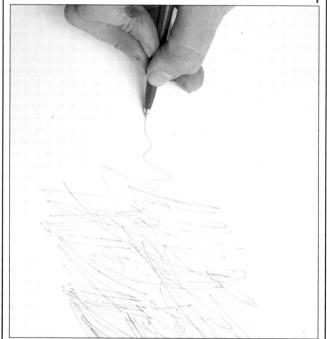

Studio Still-life

TECHNICAL PEN

The stark linear quality of the objects placed on plain sheets of paper and a sketchbook gives the artist an opportunity to use the technical pen for a task to which is well-suited – a simple graphic illustration. The arranged sheets of paper break up the composition into large shapes, already bringing the objects together into a coherent group. Notice how, in the finished picture, the abstract shapes formed by the paper and sketchbook have become a major feature. The artist has chosen to ignore the perspective of the sketchbook – preferring to present it as a rectangle. This sacrifices a feeling of space for a stronger compositional arrangement of shapes.

Because it is impossible to vary the width of line with a technical pen, the artist has employed other means to create an illusion of varied thicknesses. Occasionally, two lines are drawn very close together; if a particular line needs to be thicker or more emphatic, it can be drawn over several times to make it bolder. The artist has done this with the bottom of the jar, to indicate narrow shadow around the base.

Smooth white card has been chosen as a support, to avoid clogging the delicate tubular nib of the pen.

1 Working on smooth white drawing card measuring 14in × 18in (36cm × 46cm) the artist starts by drawing the subject in a simple linear way. You would be advised to do a very light pencil sketch before you start drawing with ink and technical pen, to make sure you have obtained the right scale and position for the subject.

2 The artist continues to make the line drawing, moving from object to object. Because the project is restricted to one type of line, the artist makes the most of the inherent textures and characteristics of the subject. For instance, the bristles of the brush are drawn in some detail; other areas are described with a single outline.

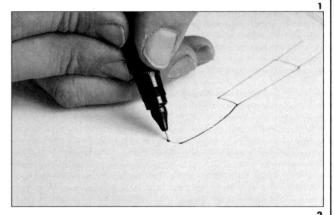

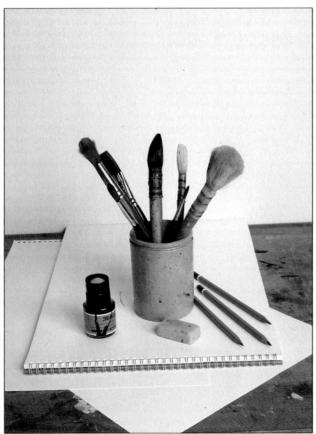

3 There is no great variation of degree for the tones that can be drawn with a technical pen. Shading and tonal contrast are restricted to areas of solid tone, or tones built up by hatching and cross-hatching with regular lines. Here, solid tone is used to draw the ink bottle. The ink has been blocked in by using very dense hatching.

4 The spiral binding of the sketchbook, on which the objects rest, is picked out with line. The regular wire curves are meticulously and systematically copied.

The binding stretches across the foreground, giving scale and space to the sketchbook which is an important element in the composition, bringing the group together into an integrated whole.

5 The artist has made a creative drawing within the very severe restrictions of the medium. Because with a technical pen it is not possible to vary the thickness of the line in any way, any detail or textural interest in the subject itself has been exploited to the full. This includes the well-observed patterns such as the wood-graining on the brush handle, and the tiny flecks of

texture on the earthenware pot. Even a slight irregularity in the eraser is faithfully included. Solid tone is used selectively and effectively on the ink bottle and the dark pencil ends. The artist has used just enough contrasting dark tone to lift the image. Too much would have looked fragmented.

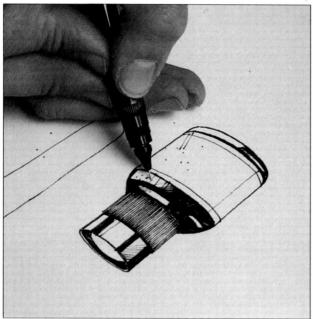

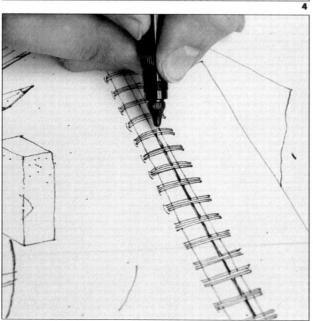

Circus scene

PEN, BRUSH AND INK

For this bright lively scene, we combined some of the techniques of both a painting and a drawing. The tent, trees and awning are blocked in with a brush. But this is done loosely, to achieve a texture in which the brush marks are visible. The artist seeks to avoid flat areas, for the inks are being used as pure unmixed colour straight from the bottle and could easily look naïve if left in uninterrupted slabs. With the large area of foliage, the artist has even splashed the ink with water, creating light blobs and blotches, to prevent any dull flatness of tone and to capture the character of the mass of foliage.

The artist chose soluble rather than waterproof ink, because it gave greater flexibility. The colour could be dissolved once it had dried, and this was exploited to create the folds in the awning and the tent, and to develop the foliage. However, the soluble ink also presented certain problems. It was difficult to lay two colours next to each other, as the first would tend to dissolve the second and the colours would run. Sometimes this bleeding effect was desirable, but not always. So the artist had to leave a narrow area of white between the colours.

1 The artist starts by making a light but precise line drawing of the subject on a sheet of heavy cartridge paper measuring 18in×22in (46cm×56cm). This drawing includes all the main forms and features. Remember, there is no correcting, so all the composition should be worked out in some detail at this stage. Starting with the trees, the artist begins to block in the colour with a large sable brush.

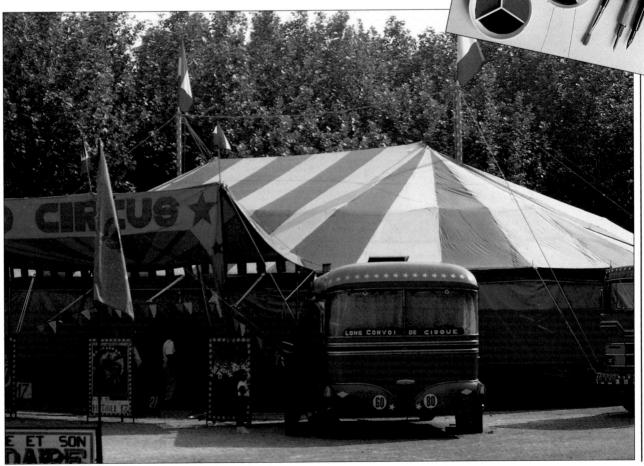

- 2 The background foliage is blocked-in loosely. Irregular patches of light and colour, visible in the actual trees, are reflected in the texture and tones of the ink. Some areas, where the colour is mixed with a lot of water, are very light. But darker shadows are painted into the pale tones. Don't overwork this stage the looser the brushwork, the more effective the treatment.
- 3 With undiluted blue, the artist paints the banner around the star shapes. This is done very carefully and bold graphic patterns, such as these stars, become a focal point in the composition, and will spoil the whole picture if badly done. Because the colours are soluble, a narrow white space is left between the green trees and the blue to prevent the inks from running.

- 4 Still working with undiluted blue, the artist draws in the decorative stars on the flag pole. These outline shapes echo the bolder white stars on the banner, and create an important contrast a balance between drawn, linear elements and solid blocks of strong colour. An old-fashioned dip pen with a medium nib is chosen for these details.
- 5 Already, with just two colours blocked in, the scene is taking on the atmosphere and character of the subject. The blue is taken carefully around the star shapes and the tiny triangular flags (these will be touched in later, when the surrounding blue is dry). There is no need to work slowly when painting precise shapes indeed, this will often produce a shaky line. Instead, try to paint briskly.

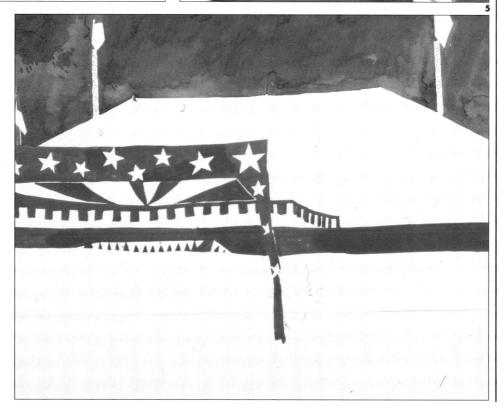

PEN, BRUSH AND INK/CIRCUS SCENE

- 6 Turning to the wall of the tent, the artist uses strong, undiluted red, yellow and blue to block in the stripes. Here the centre stripe the yellow is being painted. A narrow band of white paper is left between the colours to prevent the colours from bleeding.
- 7 The stars are now filled in with undiluted yellow. Because yellow is such a light colour, and because it is important to preserve the precise shapes of such graphic motifs, the artist fills in the centre of the stars only. This creates an irregular band of white paper between the yellow and the surrounding blue, thus preventing the blue from bleeding. This narrow band is scarcely perceptible, and in no way detracts from the bold, negative star shapes established by the dark blue outline.
- 8 The picture is almost complete, but the artist feels the need for a few linear shapes and details to break up some of the larger areas of colour. At this stage of a brush and pen work, you must be selective because indiscriminate scribbling can destroy bold graphic effects. The image here is already looking finished, and only a few linear additions are needed to pull the composition together. Here the artist uses a dip pen and undiluted green to loosely define some of the leaf texture.
- 9 Further linear details are added. Here the artist draws the red stars on the yellow fabric. The colour bleeds a little as the scarlet ink slightly dissolves the underlying yellow. This effect is anticipated by the artist, who incorporates the runny lines into the picture, using a deliberately scratchy, irregular line for the stars rather than attempting to create perfectly even shapes. You can alter the thickness of the lines by altering the pressure.

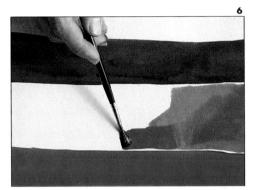

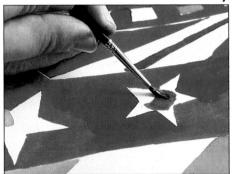

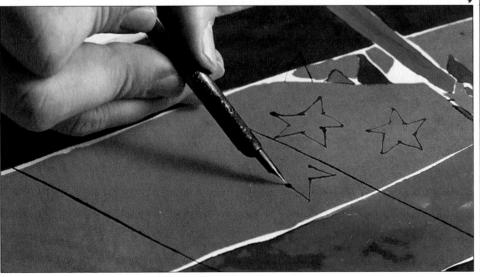

10 The picture demonstrates a successful combination of bold colour and line. By first establishing the composition with wedges of pure, unmixed colour, the artist ensured a strong graphic image which could then be elaborated and developed with selected patches of line and texture. Such a strong, colourful design could easily have looked flat bright colours used next to each other can lose their impact and effect if they are not modified in some way. In this picture the artist has exploited the white paper to separate the colours. This can be seen on the tent, where the red is contrasted with bold sections of intervening white, and between many of the other colours, where narrow ribbons of light paper tone fulfil a

similar role. In other places the colours are deliberately drawn into each other with the brush – for instance, the artist indicated the folds in the tri-coloured foreground banner by dragging a brush loaded with clean water along the shape of the creases, thus pulling each colour out of its defined area and into the neighbouring colour.

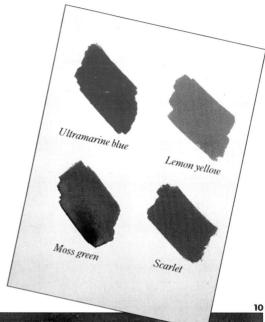

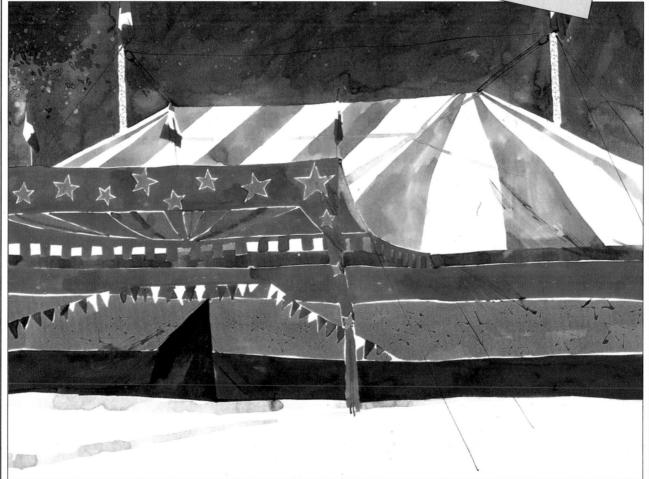

Quayside Sketch

BALLPOINT PEN

The artist is strolling by the quayside and suddenly sees a scene which can be used in a picture. The moored fishing boat, cluttered with interesting-looking tackle and other equipment, will be ideal as part of a composition planned for a later date. This is why you are recommended to carry a sketchbook as a matter of habit, and then all you need will be something to draw with – in this case a standard ballpoint pen. Such a pen might be all that is available at a moment like this; unfortunately it has definite limitations. You cannot vary the line, and the line made is not a particularly interesting one; the only way you can achieve

solid tone is to scribble furiously, building up layers of hatching and cross-hatching. However, for a reference sketch such as this, the restrictions are not important. Your ballpoint pen has much to recommend it – not least being that you do not have to wait for it to dry, so sketching can be done quickly to record data.

The fact that you know you are not creating a work of art can also be liberating. This is likely to help you concentrate on rapidly getting down what you can see, without worrying about superfluous effects.

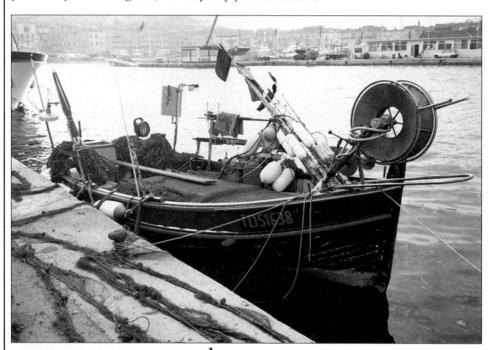

2 The object of the sketch is to record enough information about the boat to enable the artist to include the vessel in a more complex painting at a later date. Structure and detail are therefore equally important. Here the artist has established the main contours and form of the boat, as well as including some of the nautical equipment on board. When making quick sketches of this nature, the 'look' of the work is less important than the information it contains. Work rapidly. If you make a mistake or draw a wrong mark, merely draw over this with a heavier or more emphatic line.

1 An ordinary ballpoint pen and a cartridge paper sketch pad (10in×14in, 25.4cm×35.5cm) are the only items of equipment used for this rapid, on-the-spot sketch. Working quickly, the artist makes a start by roughing in the main feature of the scene – the boat – in a loose, linear manner.

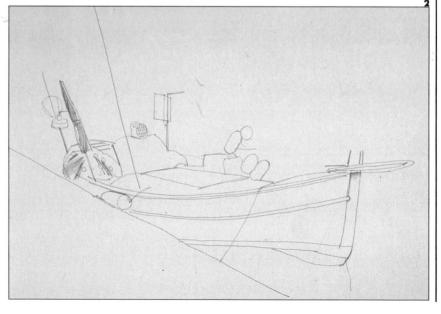

3 Tones are established quickly by building up layers of scribbled hatching. In this illustration the artist describes the curved form of the boat with close parallel lines. Because ballpoint pens produce an even line and do not respond to added pressure, tone must be built up by varying the spacing of the lines.

4 Here the artist indicates a rounded form with a graded shadow. This is simply done with regular hatched lines. On the underside of the form, where the shadow is darkest, the lines are drawn close together to produce deep tone; as the shadow gets gradually lighter, towards the top of the form, the lines are drawn increasingly further apart. Local colour too can be

indicated by tone. This is especially helpful when sketching a reference for a painting, as is the case here. By blocking in the dark grey boat in an equivalent deep tone, the artist is recording the tonal contrasts present in the quayside scene. In other words, the sketch will act as a reminder that the boat presented a dark shape against a lighter expanse of water, that

the reels and rigging on board stood out as dark shapes against a lighter background, and so on.

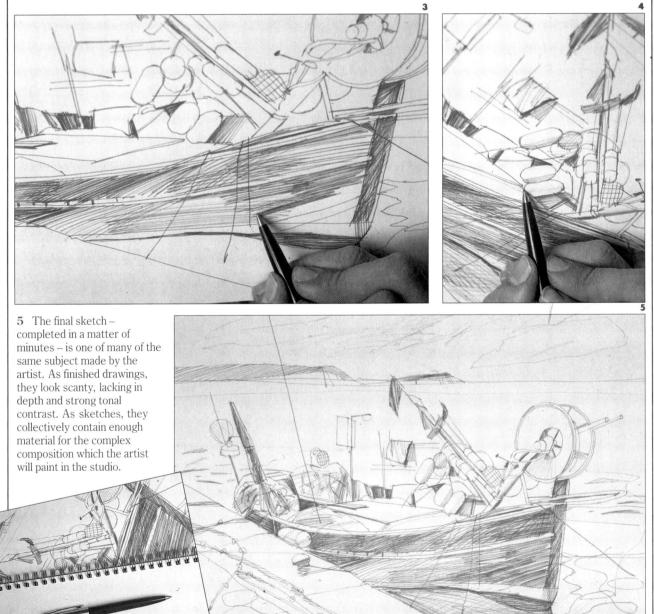

Chapter 6

Pastel

Where do pastels really belong? Some say they are really 'paints', and 'pastel painting' is often the term used for work done with them; but they are also linear tools, and therefore they have a rightful place in a drawing book. In many ways, they belong with the chunky materials such as the colour sticks, but as they require more practice, they warrant a section of their own.

Like colour sticks, pastels are ideal for large-scale work and suited to a free, interpretive use of colour. They can be employed on a small scale but there is a tendency for this to have a 'chocolate box' look if you are not careful.

They come in two definite types – the familiar soft, crumbly pastels and oil pastels. And two completely different approaches are called for. With soft pastels, colours need to be built up; blended and overlaid to obtain the right tone and colour. In this respect they are similar to paints. You therefore need a large range of colours – several tones of the same colour can be used to obtain a realistic effect. Look at the pastels of Edgar Degas (1834-1917), a formidable experimenter with techniques and materials. You will see flesh tones built up with bold directional strokes of pinks, oranges, mauves and browns

to achieve the subtle, translucent effect of human skin. This technique, however, definitely needs practice! An amateur's common mistake is to start by using the colour too densely, making it difficult to add further colours. When you have become used to them, pastels can be used to produce a beautiful finished painting with as much subtlety and detail as you may wish. Soft pastel needs fixing – a light spray with fixative after each stage will help stop the fine powder rubbing off as you work.

The more recent oil pastels are another matter. Here, there are fewer colours, with a limited range of tones to each one. They are cruder, and it is difficult to achieve any subtle effects – usually a mistake to try. Oil pastels are best for large, bold work – an immediate effect if you want a lively, colourful and quick rendering of a subject. They are extremely handy for outdoor work for this reason. Oil pastels can be dissolved with turps to achieve a blend, but this is usually best kept to a minimum, for there is no point using oil pastels if what you really require is a smoothly blended oil painting. They belong to a quick, bold, instant approach – just right if you want to build up confidence in drawing with colour.

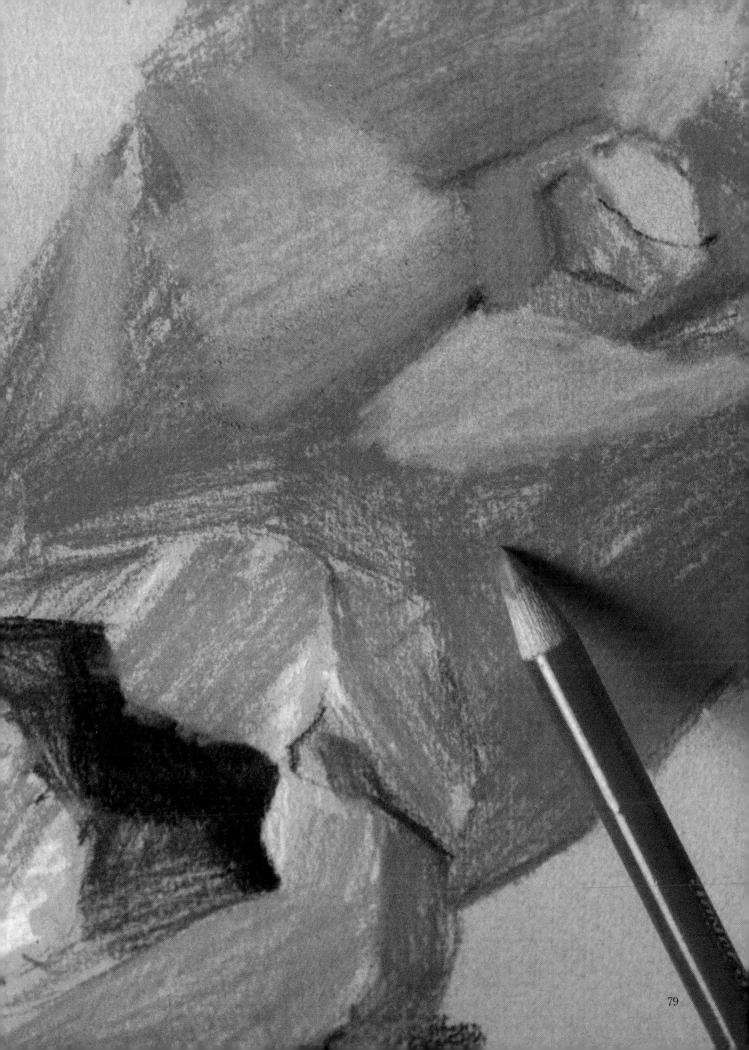

Materials

PASTEL

The so-called 'soft' pastels are made from powder pigment bound with resin or gum to hold them together in stick form. They can be square or round. Soft pastels come in three grades – soft, medium and hard. The harder pastels are mixed with extra gum or binder, which detracts from the colour brilliance; and this is why the softest pastels are the brightest.

When working with soft pastels you need a wide selection of shades or tints. The lighter the tint, the more white chalk it contains. You can buy the sticks singly or in sets containing widely varying amounts, from 12 to more then 300 sticks. You can also purchase 'landscape' and 'portrait'

sets in which the colours are biased towards either of these areas.

How the pastels are stored is important. Boxed pastels are laid on strips of ridged cardboard to separate the colours. Loose pastels become very grubby, rubbing off on each other until it is impossible to tell the colours apart. One good idea is to keep loose pastels in a box partially filled with grains of dried rice – the friction of the grains cleans the pastels and keeps the sticks sparkling and fresh.

Many artists make their own pastels, by mixing up the pigments and varying quantities of zinc white with distilled water and gelatine. Despite the wide range available,

they still prefer to make colours to match their own particular requirements. The lighter shades are made by increasing the amount of white each time, so a very large range of tones of one colour can be achieved, to fit in with an individual taste.

Choosing Supports

Supports for soft pastels are crucial. The colour of the support will become an important part of the finished picture, and should be chosen to match the subject. Papers with a matt or slightly textured surface are best for pastels. Smooth papers are less suitable although vellum or calligraphy paper is good for delicate, light pastel work.

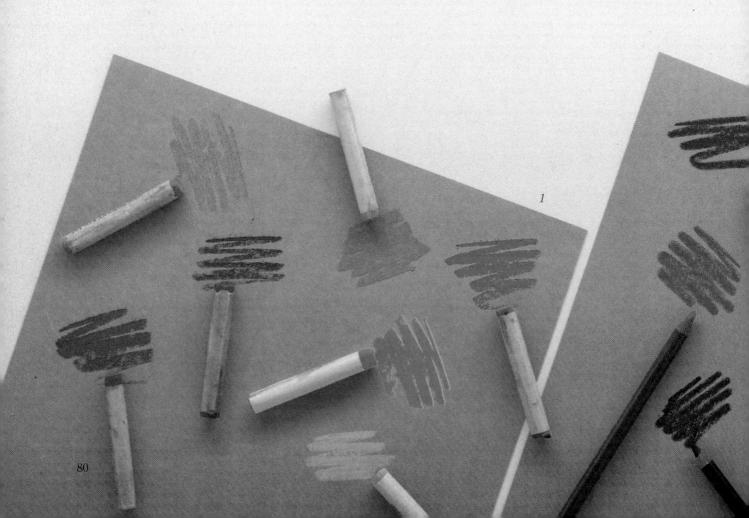

The paper must be of good quality in order to withstand the layers of pastel work. Tinted versions include Canson papers which have a slightly mottled colour, and Ingres which contain a faint linear pattern. Special pastel paper similar to the very finest grade of industrial sandpaper is available in art shops. Colours adhere thickly to this surface to give a strong, brilliant effect. Ordinary sandpaper can be used but produces a very definite effect which you may or may not like.

You need to fix the work, spraying each stage lightly and allowing it to dry. If you overdo this, however, you will create a shiny varnished surface which is unworkable. Fixing also

alters the colours, so take care. Many artists fix from the back – spraying the back of the paper so that some soaks through. Some artists find this less effective, but it does hold the powdered colour to some extent and does not darken the colours.

Use a torchon to blend the colours – buy one or make your own by rolling a piece of paper to form a stick with a pointed end. Alternatively, you can rub with tissue paper or fine cloth for larger areas. You can also use a soft brush to lift the colour, and a kneadable eraser to remove colour.

Oil Pastels

These are heavy – more like oil paint than any other drawing medium - and they do not crumble like traditional soft pastels. They are therefore ideal for outdoor colour sketching. They come in bright colours, usually available in sets. There are less choices of tone, but oil pastels are best for bold line work with the occasional block of solid colour or texture. They are best used on a large scale. Use strong paper. You can blend the colours with turps. Limited colour mixing is possible by overlaying colours, but this is not easy to control.

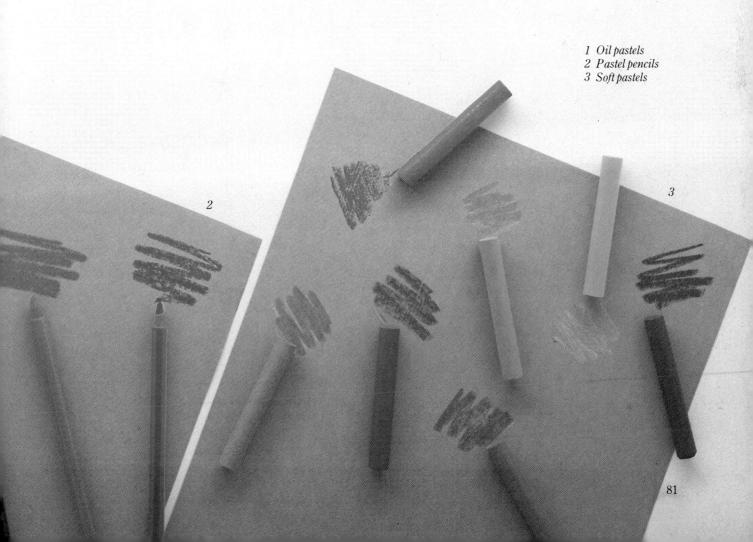

Techniques

PASTEL

Blending

The secret of successful soft pastel work lies in colour blending. With practised handling pastels are as versatile as paint, carefully blended to produce a complete range of subtle tints and hues. These may be either areas of flat tone, or textured broken colour. Here the artist demonstrates one method of blending two separate colours to create a smooth, yet broken colour combination – an effect often used to depict skies and water. Bold white streaks are first drawn on to an expanse of flat blue pastel colour (1). This is then gently rubbed to remove the harsh pastel lines and edges, thus merging the colours (2).

Mixing

Providing you apply the colour sparingly and lightly, pastels can be built up in several layers to produce beautiful and shimmering effects of mixed colour. Only by experimenting and practising will you find out how different shades and hues combine, and how many pastel colours can be laid over each other before the paper becomes clogged and unworkable. In the illustration here, the artist starts by blocking in an area of fairly solid purple, lightening this with thin white streaks (1). Light red scribbling lends a pinkish tinge to the overall colour (2). You might find it helpful to fix each colour with a light spray of fixative, allowing this to dry before moving on to the next colour.

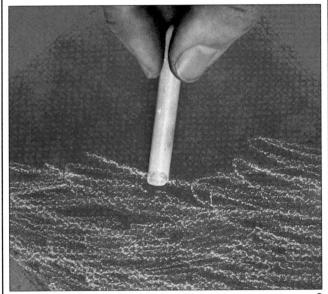

TECHNIQUES

Side of the Stick

Paper tone is an important element in pastel paintings, and this can be better integrated into your picture if you lay colour with the broad side of the stick. This method allows the colour to adhere to the raised parts of the matt pastel support, causing the paper tone to show through. With a particularly coarse support, such as watercolour paper, the effect is even more marked, and has a rough, granular texture. In the demonstration (1), bright red is laid evenly on a darker paper; the final tone (2) is influenced by the deeper tone showing through.

Scribbled Texture

Again, the tone of the underlying paper can be exploited by applying colour in scribbled or broken strokes. This basic technique may seem obvious, yet it is one of the most important underlying principles of all pastel work. Practice the method extensively, starting as the artist is here, scribbling a colour on a tinted paper (1) to produce an area of loosely broken colour (2). You can then develop this, lightly adding more colour and tone to achieve the exact combination you require. Keep the scribbles loose and wide apart to prevent the colour from becoming too dense, otherwise you will lose the light, airy quality which this approach creates.

PASTEL

Texture

Texture' is an all-embracing term which, to the artist, means the visual or tactile surface structure of the work. Thus, all areas of pattern or built up marks fall into this very broad category. Try out as many textures as you can think of. In this way you will have at your disposal a store of techniques – a sort of visual repertoire – to fall back on, and your work will be more creative and lively as a result. Here the artist experiments with a texture of looped scribbles (1) starting with one colour and adding to this with further colours worked in the same looped strokes (2).

Cross-hatching

Cross-hatching with pastel is unusual, simply because it is not strictly necessary. There are quicker ways of building up colour and texture when using pastels. However, hatching and cross-hatching does produce a crisp linear effect which can often provide a welcome contrast to the soft, smudgy nature of much pastel work. Use the pastel in exactly the same way that you would work with a pencil or pen, building up small regular lines (1) to produce an overall criss-cross texture. Here the dark red paper shows through, deepening the colour of the final effect (2).

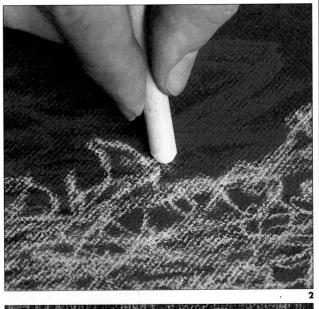

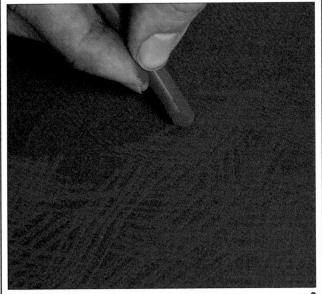

TECHNIQUES

Optical Mixing

All coloured drawing materials are ideal for mixing colour optically, and the small flecks, which mix in the eye rather than being blended together on the paper, can be easily and quickly dotted in with pastel. The soft, broad tip of the stick produces a largish mark, and the slight flick of colour, created naturally as you lay dots quickly, provides an irregular mark which prevents the pattern from looking too mechanical. Here (1) the artist combines light blue dots with bright red ones, using the tone of the paper as a third colour in the finished effect (2).

Oil Pastel and Turpentine

Oil pastels can be dissolved with turpentine or white spirit, enabling you to blend colours smoothly and completely. However, it is not a method which should be overdone. For full effect, limit these blended areas to selected parts of your drawing, and try blending the selected colours on a separate sheet of paper first – the strength and tone of oil pastels increase a lot when diluted with turpentine. Practise the technique by laying two colours next to each other (1) and using a brush or clean rag dipped in turpentine to dissolve and work the colours together (2).

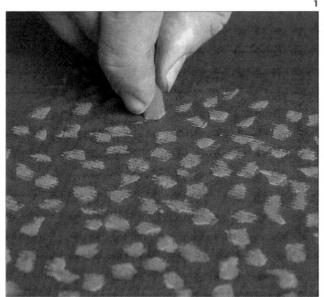

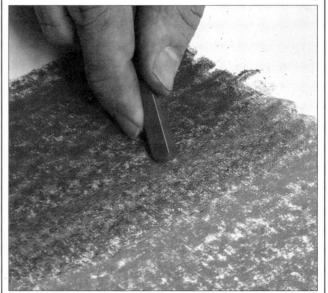

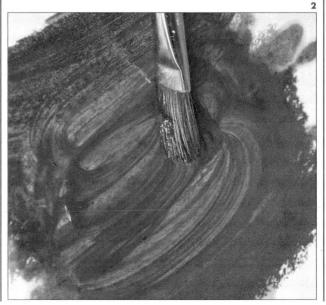

Red Cabbage

SOFT PASTEL

The drawing of the red cabbage, cut by cross section, bears a resemblance to an approach sometimes used by designers, especially in fabric. The designers will look for something interesting, often in nature, and will then blow this up into an enlarged detail; turning it into a motif in its own right. The artist here has taken a similar approach, concentrating on the basic elements of the pattern produced by the cabbage. The result is a highly personal and yet surprisingly realistic portrayal of an everyday vegetable. The cabbage has been made larger than life. Its familiar patterns have been given a special meaning and

the compact, compressed forms of its furled leaves are brought vigorously to our attention.

The drawing is very much an exercise in line. The cabbage is built up of lines. Even its solid areas are actually swollen lines. Some of these are thick, others fine and jagged, and each space between them – where the paper shows through – is also a 'line'. It is the tension between these, and the optical illusions of movement, that demonstrate the use of line at its most expert. The artist did not pick out all the cabbage's compressed leaves but aimed for a general impression.

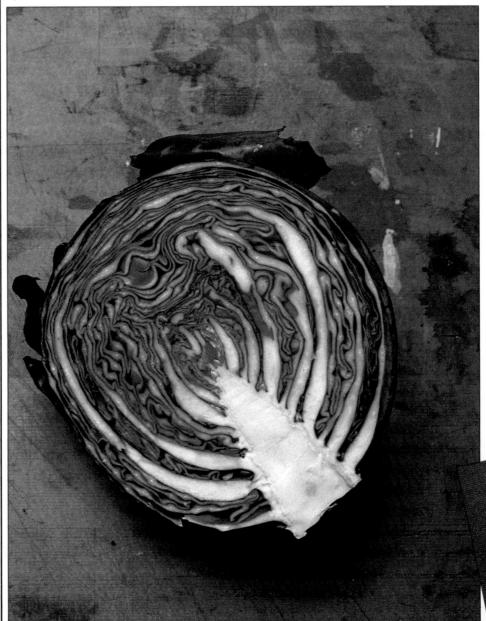

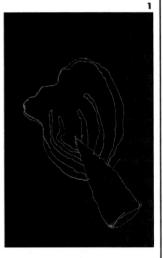

1 The artist chooses a dark red pastel paper measuring 30in×22in (76cm×56cm), a colour selected specially to harmonize with the subtle tones of the vegetable, and to maximize the effect of the white patterning. First, the stalk is lightly drawn in with pale yellow; the inside leaf shapes are then outlined in white.

- 2 Here the artist is filling in the solid white shapes visible on the cut cross-section of the cabbage. Because the patterns are too complicated to depict exactly, the drawing aims to capture the character of the subject an impression of the effect of the tightly-folded foliage rather than an accurate, map-like drawing with every leaf in the correct place.
- 4 Swirling lines of mauve are added to the pattern. Again, the artist is not taking the subject literally, but using it as a starting-off point to make a creative interpretation of what can actually be seen. A tinge of mauve, just discernible on the lighter cabbage leaves, is exaggerated to provide this vibrant and colourful addition to the drawing. Although this is boldly applied with strong linear strokes, the artist intends to modify this as the work proceeds.

3 The main white shapes are now blocked in. These show up clearly and cleanly on the tinted paper, helped by the fact that the slightly furry surface of the specialist support provides a key for the fine pastel particles to adhere to, so producing a dense effect without undue pressure being necessary. To retain the crispness of these colours, the artist gives the drawing a light

spray of fixative at this stage.

Variety of line is important here. Organic forms and natural patterns are not regular or predictable and cannot usually be described with an even or mechanical line. When faced with such subjects, try to vary the line. Here, for example, the artist used the sharp edge of the stick for fine lines. To create an undulating line which varies

from thin and spidery to heavy and swollen, vary the pessure on the pastel as you draw.

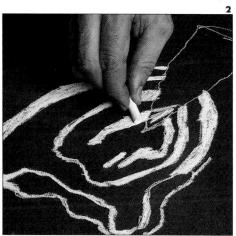

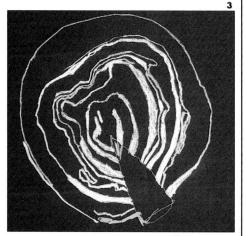

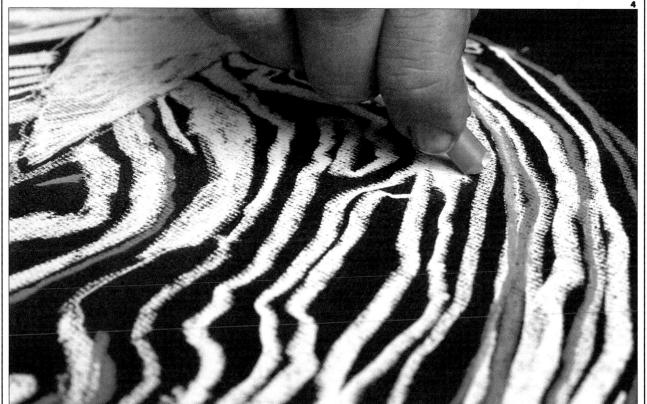

SOFT PASTEL/RED CABBAGE

5 Using alizarin and red, the artist works into the dark spaces between the leaves. This tone, just slightly lighter than the support, is scribbled in to form bold areas.

The alizarin covers up some of the brighter mauve tones – as the artist intended – although patches of the lighter colour are left showing through, to produce effects of colour, line and tone similar to those visible in the actual subject.

6 To preserve the colour and maintain the sharp contrasts between the shapes, the drawing is once more sprayed with fixative. In your own pastel drawing, you may wish to use fixative more frequently than the artist does here. This is fine, providing you don't overdo it - a few light sprays in the course of one drawing should be alright. You must, however, wait for the work to dry before you proceed. Here the artist is introducing thin black and blue lines to the fixed drawing. These define the shapes within the main outline and emphasize the pattern of the folded leaves. The black also represents the deepest shadows, thus giving a feeling of depth and surface texture.

7 Loose, jerky strokes keep the images alive and vibrant; the artist is careful not to become 'automatic' with the drawing, but constantly refers to the subject in order to maintain a fresh approach to the line and colour.

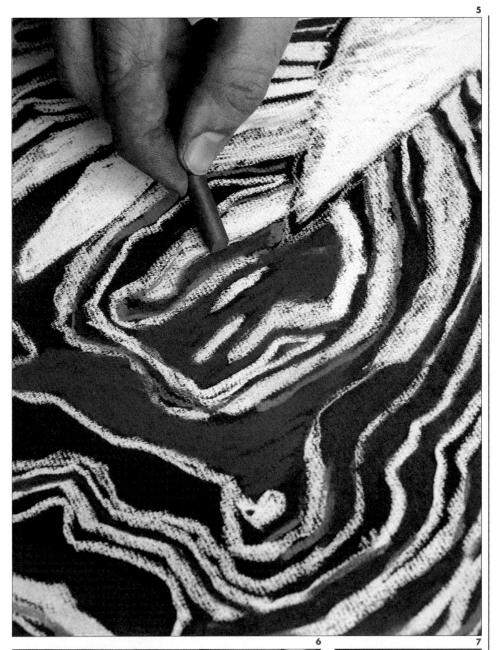

8 The artist blocks in the background using the side of a stick of orange pastel. This is done lightly, allowing the dark red tones to show through and to act as a unifying colour in the composition. Finally, the finished work is given a spray of fixative to prevent the colours from smudging.

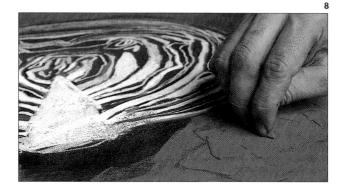

9 The finished drawing shows us a convincingly realistic portrait of a cut red cabbage. Yet the artist did not stick rigidly to the subject. Nor are the colours accurately matched to the more subdued tones present in the real cabbage. Oddly enough, had the artist set out to depict every part of the vegetable in naturalistic detail, the likeness would have been disappointing and far less 'cabbage-like' as a result. The secret of the success of this pastel drawing lies in the artist's direct approach, one which aimed not at botanical detail, but rather at capturing the essence and character of the subject – in this case, the vibrant, almost psychedelic, nature of the leaf pattern.

Black

Mauve

Alizarin

Orange

Pale yellow

White

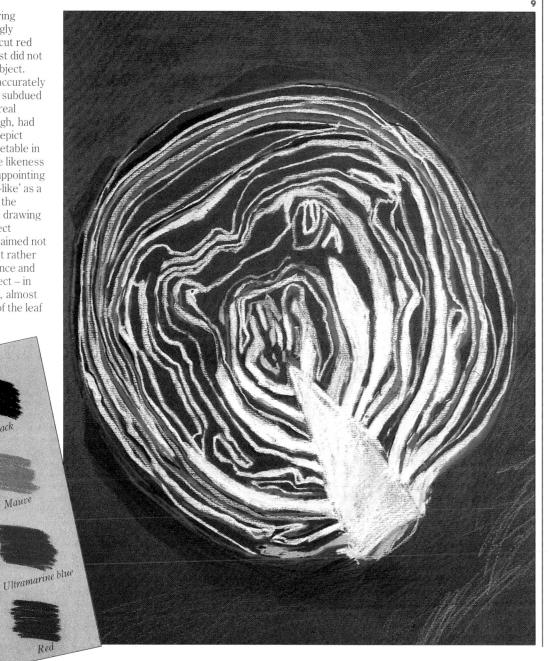

89

Swimming Pool

SOFT PASTEL

For this drawing, the artist worked from a photograph instead of operating directly from the subject itself. For the beginner, this is an excellent method of working when confronted with the problem of water. The shapes and forms are never constant on the surface. The water is moving all the time. Many artists develop set techniques for coping with this, and base their works partly on what they see in the real world in each specific case, and partly from what they know from experience. For the beginner this can be daunting – but a photograph temporarily 'stops' the world' and allows you to study the appearance of movement in a given instant. So take your camera along on some of your drawing expeditions. The artist here used a Polaroid camera which produced a photograph within seconds and allowed time for studying both the photograph and the real-life subject on the spot. After a while, you may become used to making quick drawings on the spot. and the camera will become less necessary.

Before starting work, look at the subject or photograph and select all the colours before you begin. This saves scrabbling through a box of pastels as you work, often compromising because the exact colour is not immediately to hand. If you start off with colours to hand, you are also giving yourself a colour theme. The choice of paper is also an important prior task and should work as one of the dominant colours. Here, a subdued light blue was chosen, as a crucial part of the overall colour theme.

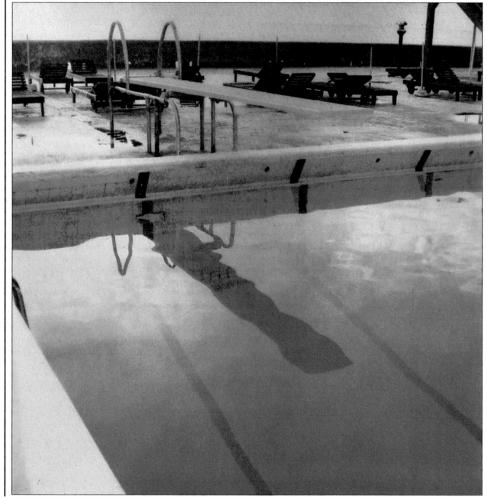

The main part of this picture is the surface of the water, with its colours and reflections. So all the artist needs to establish at this initial stage is the visible edge where the water area starts. This was drawn in with a white pastel. Then, using a dark blue-green, the main dark shapes – the shadow edge of the swimming pool and the reflection of the diving board are blocked in with dark blue-green. The artist is working on good quality light blue pastel paper measuring $20\text{in}\times20\text{in}$ (51cm×51cm).

2 At this stage the artist is concerned with blocking in the main areas of colour. These will later be modified and blended; but for the time being it is more important to cover the image rather than being concerned whether it actually looks like water or not. Some of the lighter water tones are loosely blocked in, in light blue-green. White is used to establish the surface of the

diving board, one of the lightest tones in the composition. The colour is put down quite emphatically, as a dense white, because the artist knows that in the final picture the diving board must stand out as bright white, and as work progresses other tones and colours will be related and compared with this.

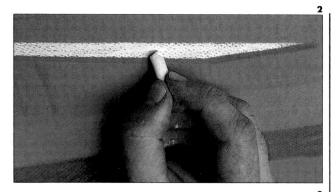

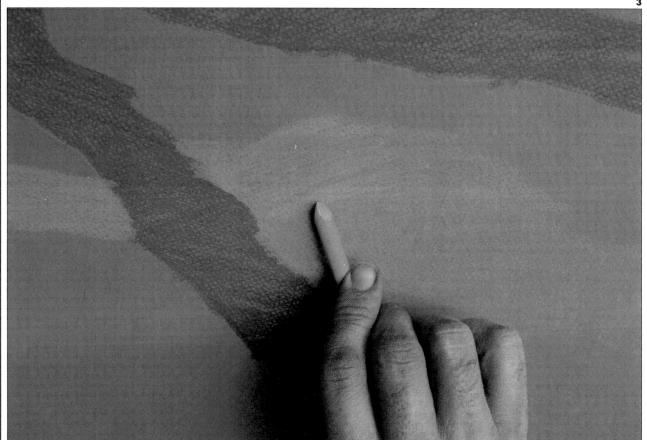

3 The artist returns to the water, continuing to block in the shapes in terms of simple patterns and colours. The main problem here is that the shapes and colours do not really have crisp edges. They merge and blend. So to some extent these shapes have to be interpreted and simplified. It would be wrong to work this area too literally at this stage.

4 Using bright blue, the artist picks out the medium tones in the swimming pool. Again, these are not exactly as seen. The shapes are more emphatic and the colours brighter than those present in the actual subject. In this illustration the side of the stick of pastel is used, making it quicker to block in larger areas.

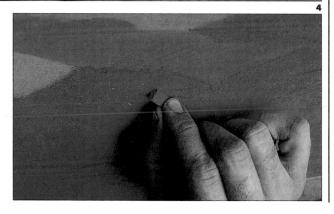

SOFT PASTEL/SWIMMING POOL

5 The artist completes the blocking-in of the main colours, working from the selected range of blues. When the blocking in is finished, it is time to blend the colours to create a more accurate representation of the smooth water surface. Here the artist is blending the shapes of colour into each other by rubbing gently with the finger tips.

7 Some artistic licence is being taken here, in order to make the water even more like water! The artist is very experienced in depicting water and its effects in this medium. So certain techniques have been developed. Here, thin wavy lines drawn loosely across the water, describe the undulating surface and effectively and convincingly suggest the image.

6 Here the distortion of a black painted line, seen through the water, is being rendered; this is simply a series of marks to indicate the broken distorted line. After looking carefully at the effect of the line through the water, the artist has noticed that it is visible simply as a definite but broken line. This is then drawn in light scribbly marks.

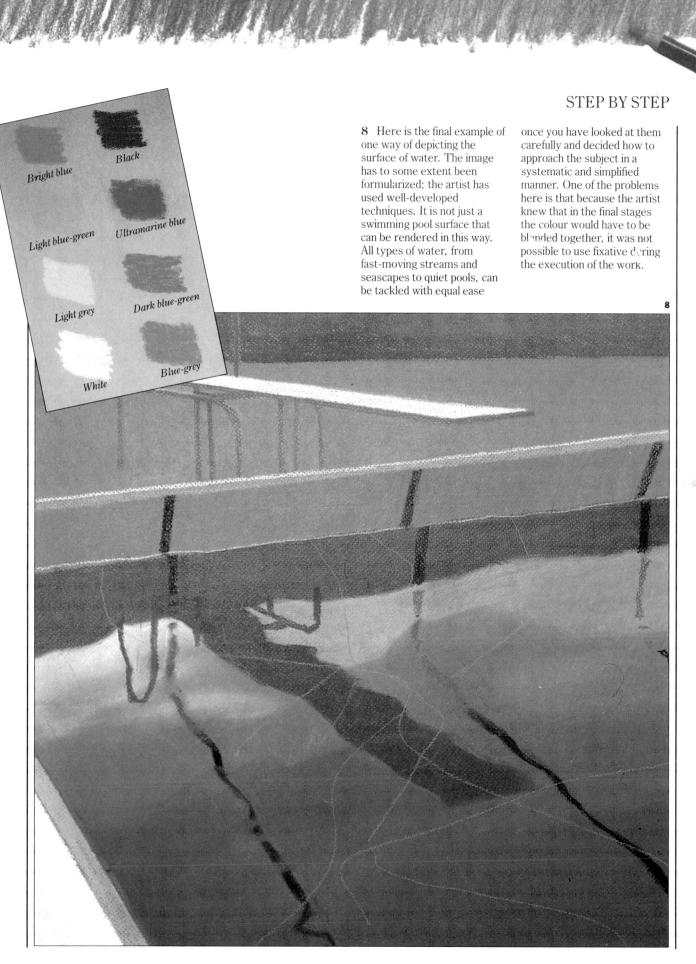

Potted Primroses

OIL PASTEL

Oil pastels are an ideal sketching medium. They offer a bold, exciting and immediate way of tackling a subject, and many artists use them to make preliminary colour sketches for this reason. Even in a finished drawing it is important to maintain their sketchy quality and not to overwork. A feeling of freshness, sometimes even an incomplete look, suits oil pastels best. These characteristics have been drawn into this picture of three potted primroses.

The picture is on a much bigger scale than real-life – a deliberate ploy by the artist. It was felt that a small subject, blown up, could produce enlarged sketchy textural qualities of the type which can be seen here. The veins and ridges of the foliage, for instance, are indicated by loose directional strokes. To have worked on a conventionally small scale would have denied the pastels their full potential. Oil pastels are not suited to tight, dense work which requires graded colour or detail.

To maintain the spontaneity and immediacy, the artist decided not to make a preliminary sketch. Instead, the aim was to start with one bloom, working outwards from this in a dynamic, organic way.

1 Working on stiff off-white card measuring 22in×30in (56cm×76cm), the artist starts with just one of the blooms. In this case there is no preliminary drawing. The petals of the centre bloom are blocked in with light and dark red, and the centres of the flowers with yellow.

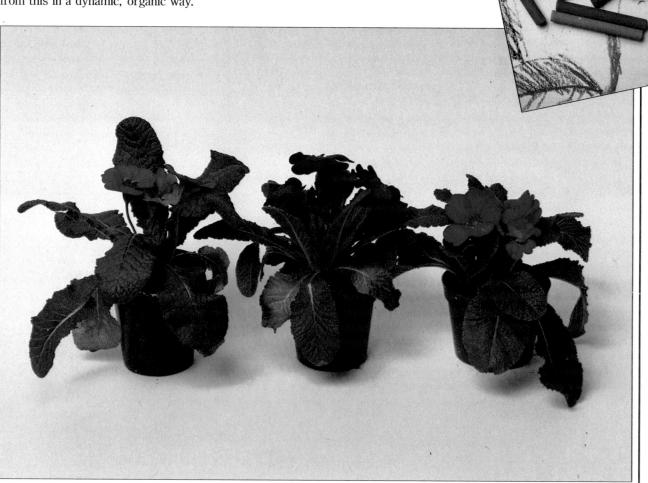

2 The artist works down the same plant, blocking in the leaves and picking out the tones in three different greens. Because the pastels are chunky and not suited to line, this blocking-in is done with loose strokes, close together, to obtain fairly solid areas of colour. The deep shadows visible between the flower-heads are established in black and blue. There is no

point in trying to achieve a subtle graduation of tone or colour with this medium.

The purpose of oil pastels is to establish an immediate lively image and these are the characteristics which you must look for in the subject.

The pastels, however, are easier to control if you do not use them too thickly in the initial stages.

3 The artist is still on the first plant, blocking in scribbly areas of tone as they are picked out in the actual leaves. In this picture the artist is taking one colour lightly over the edge of another. Because oil pastels do not blend easily, this over-laying of colour is the only way of avoiding a harsh effect. Highlights and pale colours are dictated by the amount of white paper which is

allowed to show through between the strokes. In this illustration the light side of the plant is lightly rendered with pale green, allowing plenty of white paper tone to remain. The flower-pot is drawn in its local colour, a reddish brown, with strong black shadows thrown by the overhanging leaves.

4 The shadow underneath the pot is blocked in with yellow and brown. The first plant is now complete. The artist has aimed directly at representing the bright colours and shapes of the primrose – an unusually bold approach for such a delicate subject. It is sketchy and textural, and the scale is something like twice as large as life-size, enabling the artist

to make the most of the textural pastel marks on the surface of the plant. Already the drawing is beginning to take on the brightness and sparkle which is such an advantage with oil pastels. The artist knows when to stop. If too much detail and finishing was added in oil pastels, the picture would start to lose its spontaneity.

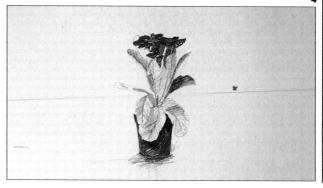

OIL PASTEL/POTTED PRIMROSES

5 The artist now moves on to the next bloom, blocking-in the petals in exactly the same way. In this illustration the pastel stick is being pressed quite heavily on to the paper to achieve a fairly solid mark. Notice how the direction of the strokes is being exploited to describe the organic structure of the plant. The foliage has been sketched in lightly with pale and dark greens. One way in which the artist has varied the somewhat inflexible marks of the pastel is to leave the foliage in a fairly loose linear state, contrasting this with the more solid wedges of colour on the petals

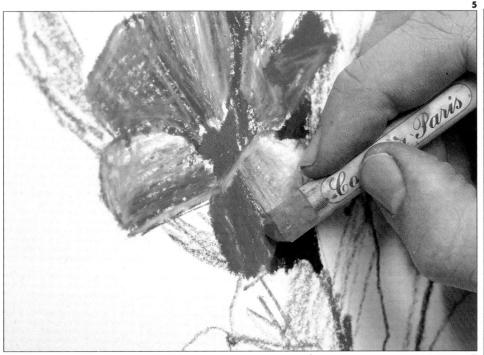

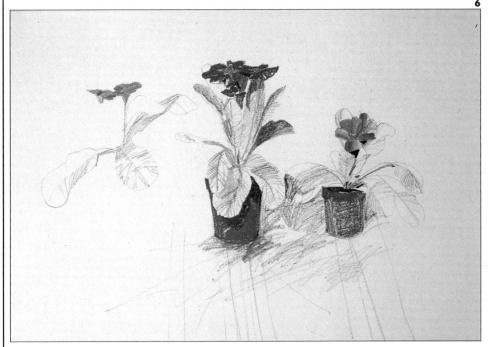

6 Two of the plants are now complete, and the artist has made a start on the third, indicating the blooms in approximate shades of pink, purple and yellow, and sketching in the position of some of the leaves. By making the leaves on this third plant

light and feathery, the artist is establishing a subtle difference between the various blooms, thus a rank-like picture of three identical pots, with the same density of colour, has been avoided.

7 The artist now turns to the flower pots, seeking to add texture and tone to some of the solid colours. Here a scalpel blade is being used to scratch back the reddishbrown and reveal the bright yellow underneath. This textural highlight brings a degree of contrast to the composition, again helping to avoid a uniform row of similar pots which would look dull. The somewhat symmetrical nature of the subject in real-life has been deliberately offset in order to create a more varied and visually interesting image.

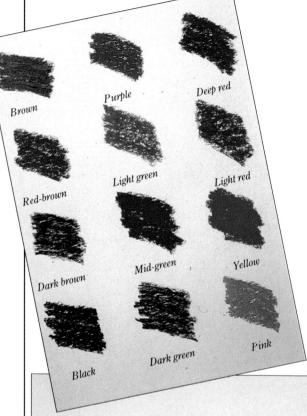

8 The artist knows that you can only work with bold strokes if you are using oil pastels. Blending is difficult and subtleties are not possible. An obvious subject for this medium would have something like a large-scale landscape, with sweeping hills, or a wide seascape. These subjects are frequently chosen by oil pastelists because of their wide expanses of bold colour.

For this project, however, it was necessary to demonstrate how the textures and sketchy hatching of oil pastels can be used in place of literal detail. Therefore, instead of taking a big subject and condensing it, the artist chose to work on a small object and blow it up to larger-than-life proportions. In this way, the real nature of the medium could be fully explored. One pot of primroses would have sufficed

for this. But the artist also sought to demonstrate that the textural nature of oil pastels can be used to achieve variety. This contrast of treatment can be exploited even within one image, to make an interesting picture. Thus three pots were placed in a uniform row, and the challenge was placed before the artist to produce lively variety in the composition.

The artist has avoided having three completely separate objects with no visual compositional link, by using the shadows and extending these in lightly scribbled black shapes. The shadows are sketched behind and between the pots, inter-relating with the foliage and establishing a sense of continuity.

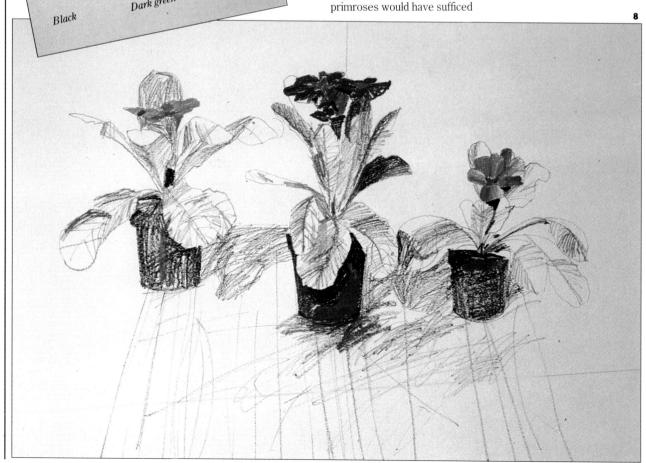

Still-life with Vegetables

PASTEL PENCIL

The fact that with pastel pencils you can switch easily from solid areas of colour to line has been exploited to the full in this picture of a group of vegetables on a kitchen table. The objects themselves were chosen with this in mind. Although the artist has used solid blocks of colour here, the picture is essentially a drawing. It is the line which holds the image together. The solid colour is used to substantiate what the lines have already suggested.

The size of the drawing is important. The advice from the artist was 'Work on a large scale so that you can make full use of the pastel pencils'. Even if your inclination is to work on a small scale, you should still aim at enlarging the actual objects you draw, when using these materials. It is a very common mistake with beginners to work too tightly; lack of confidence makes them fill in the colours meticulously, over-blending and overworking. Notice how the artist here has worked larger than life and is not inhibited from allowing the scribbled texture and loose pencil strokes to remain. If you wish to return eventually

to small-scale pictures, what you have learned by this freer approach will be of enormous benefit.

The quality support, Canson pastel paper, was chosen here because it would stand up to the heavier treatment of pastel pencils. Its warm, neutral colour provides a basis for the wood coloured tones of the kitchen table. The mellow tint also enhances the bright colours of the vegetable arrangement – thus the paper tone quickly becomes integrated into the composition.

Before starting work the artist

selects all the colours which

are likely to be used in the drawing. The subject itself is

vegetables, with different

a colourful selection of

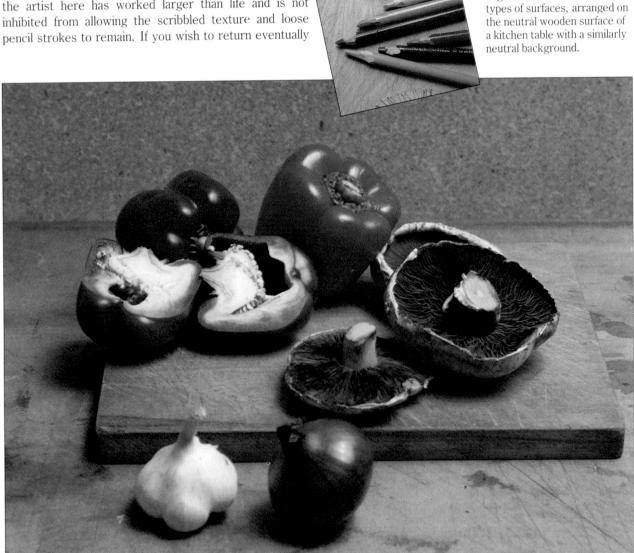

1 A neutral warm beige paper is chosen – one which reflects the tones of the table and the background wall. The support, measuring 22in×38in (56cm×71cm), is good quality pastel paper which will take the heavy pressure sometimes applied to the pastel pencils. These are harder and less crumbly than pastel sticks. The artist uses olive green to make an initial drawing, placing

the subject centrally on the support, occupying most of the space in the composition. The sketch is made lightly, the artist feeling around the objects, correcting a shape by re-drawing it. If the drawing is incorrect at this stage, no amount of rendering will put it right later. The errors will simply be magnified.

2 The artist starts to block in the drawing, carefully picking out planes of local colour, light and shade, and drawing these as simplified blocks of solid hue. Because it is fairly easy to control this material, blending the colours with your fingers or an eraser is not absolutely necessary. Generally, you can merge two colours together by gently grading the overlapping strokes, as the artist has done

here, where the dark green shadow fades gradually into the lighter, local colour – where the artist has pressed lighter with the strokes farther apart to allow more of the underlying colour to show through. Here, the artist fills in the cut cross-section of the green pepper, using even white cross-hatching to create a flat colour.

3 The artist is drawing the deep orange shadow into the forms of the yellow pepper. In this case, the colour is being applied densely to an equally dense undercolour. The strokes are applied closely but the artist makes a smooth blended transition from the orange to the lighter yellow by gradually decreasing the pressure on the pencil. The neighbouring highlights have been applied in a similar way, and the artist has gradually allowed the very pale yellow to taper off into the local colour to create a reflection on the shiny surface of the vegetable. At this stage of the work, the artist applies a light spray of fixative to preserve the colours and tones of the drawing so far.

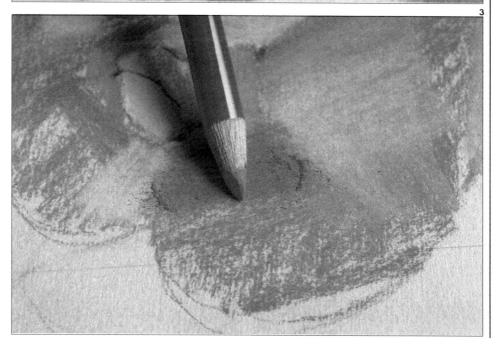

PASTEL PENCIL/STILL-LIFE WITH VEGETABLES

4 One of the great advantages of pastel pencils is that they can be used just as well for line drawing as for blocking-in areas of tone and colour. Here the artist seeks to combine these qualities in the same picture by treating the underside of the mushrooms in a linear way. The gills beneath the mushrooms are drawn in loose lines with black pastel pencil.

5 Without blending or smudging the colours, the artist has conveyed a variety of surface textures by using the pencils in different ways. The shiny peppers are rendered, with medium, dark and light tones being gradually merged to produce their hard reflective nature. The pithy core of the cut pepper is conveyed by flat matt white.

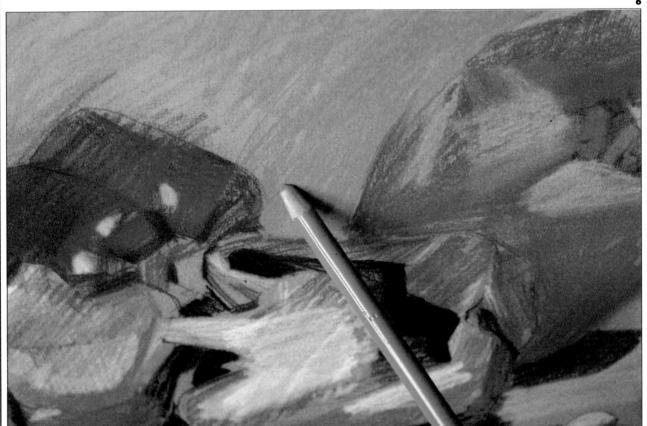

6 A cool grey has been used for the background. Strong directional strokes are applied to block in the shadow thrown onto the wall behind the vegetables. It is this shadow which defines the space between the subject and the background. The artist avoids a solid area of tone which would compete with the subject, and allows patches of the beige paper tone to show through.

7 Because they are soft, pastels and pastel pencils tend to blur and lose their crispness as work progresses. The artist has given the work the occasional spray of fixative to help alleviate this problem, yet for this final stage it is still necessary to go back over the image, re-defining the lights and darks to bring the subject back into sharp focus. First, the shadows are darkened, deepening the recesses and increasing the feeling of space

and three-dimensional form. Then it becomes necessary to go round and bring up the light areas, the highlights and reflections on the objects. This lifts them to the same point of sharpness as the shadows. In this illustration the artist is re-establishing the white highlight on the shiny yellow pepper.

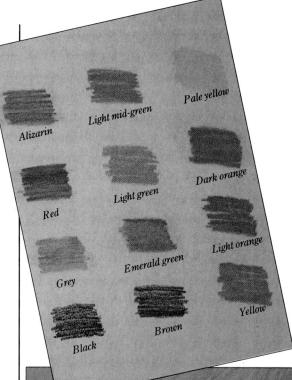

8 Two more vegetables have been added to complete the finished composition.
A Spanish onion and a garlic have been placed in the foreground, looking as if they have been scattered slightly away from the main group, and this draws the composition forward to prevent it from becoming simply a single mass of objects. The two additions create space on the paper.

Although the artist has blended the colours during the various stages, in order to create form, the texture of the pencil strokes is still an important aspect of this picture. The objects are naturally rounded and could easily become too spongy and amorphous, with each one looking too much like the

others. This has been avoided here by the strokes of the drawing. The artist has paid careful attention to the direction of the marks, so that they become emphatically separated into visible planes, both of texture and of light and shade. In the case of homogenous forms such as the onion and red pepper, which possess very little variety of tone within themselves, the artist has used the direction of the pencil strokes to separate the planes.

As an essential finishing touch, the picture is given a final spray of fixative.

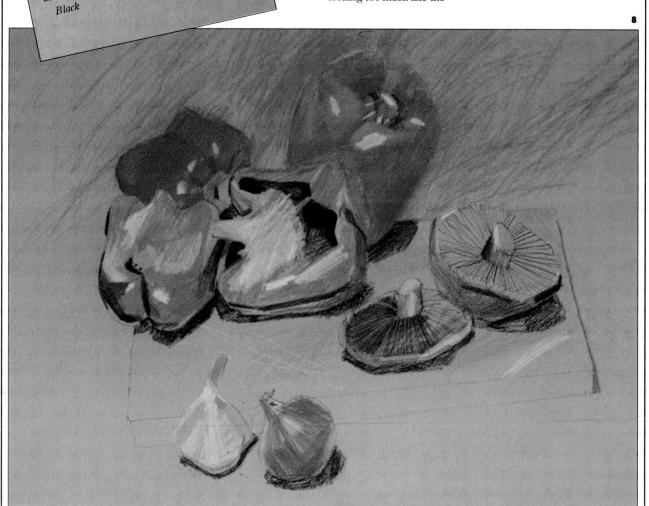

Chapter 7

Pencil and Graphite

The most common of all drawing instruments, the graphite pencil, is by no means the easiest to use. Compared with many other drawing tools, its lines can get small and fussy. They invite detail, and all too often this leads the beginner into a trap – for it is best not to pay too much attention to detail at first; far better to aim initially for the bold strokes and outlines, or areas of tone, which make up the main characteristics of a composition.

When it is mastered, however, the pencil is a versatile drawing tool with which you can create beautiful and finished pictures as well as make rough outline sketches. Although not as bold and chunky as some other materials, it has a varied range, allowing for broad, heavy and light strokes, fine lines, and subtleties of shading.

A crystalline form of carbon, real graphite has historic links with the English Lake District, where it was extensively mined and from where it was widely exported. It is found in many parts of the world, including North Carolina, Mexico, Sri Lanka and eastern Siberia. It is also manufactured artificially, both in iron furnaces and by

electrical methods. The graphite available on today's markets comes in pencil, stick and powder form.

The term 'lead pencil' gives the wrong impression. Early deposits found in England were originally thought to be lead. The first graphite pencil was made in 1662, and the design of the pencil has not changed greatly over the centuries. Early ones were rods of graphite (ground graphite mixed with gum or resin) pressed into a grooved piece of wood, rather like the modern pencil, or held in a metal holder very similar to today's clutch or propelling pencils.

The Latin 'pencillus' referred to brushes, used with ink in the Middle Ages, rather than to the pencil as we now know it. A more closely related ancestor was silverpoint, a narrow rod made from lead and tin. In the hands of such artists as Leonardo da Vinci (1452-1519) and Albrecht Dürer (1471-1528), silverpoint was made to produce beautiful pictures – fine lines, varied to create an immense range of tones. Silverpoint has its drawbacks. It needed a special ground which was time-consuming to make.

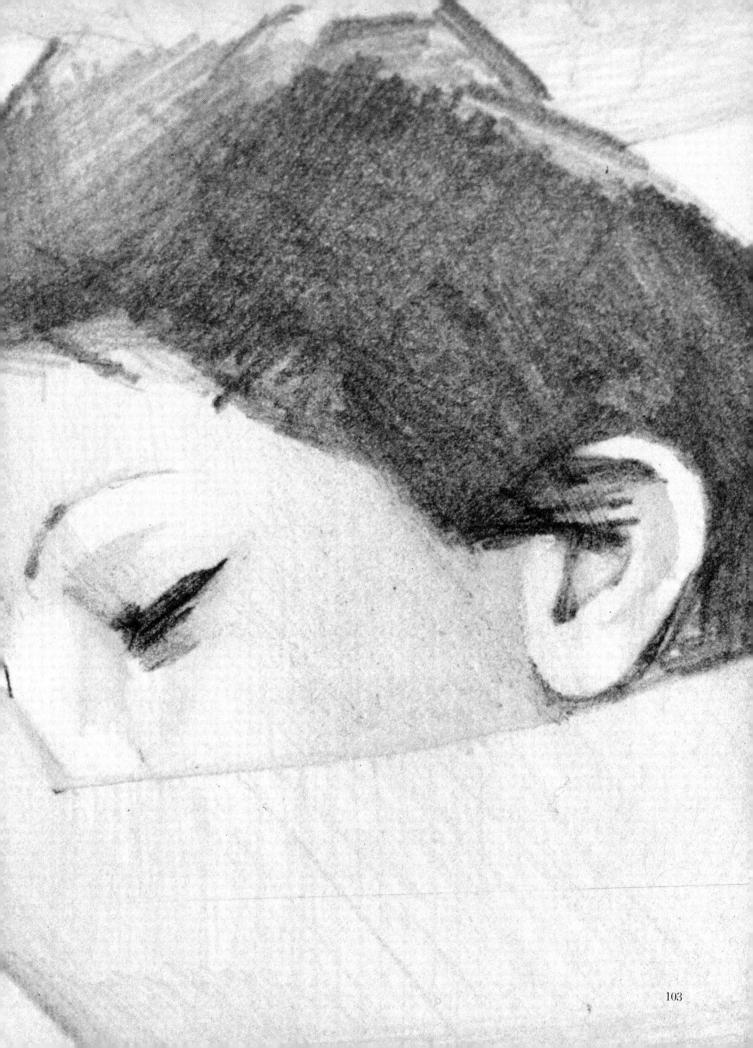

Materials

PENCIL AND GRAPHITE

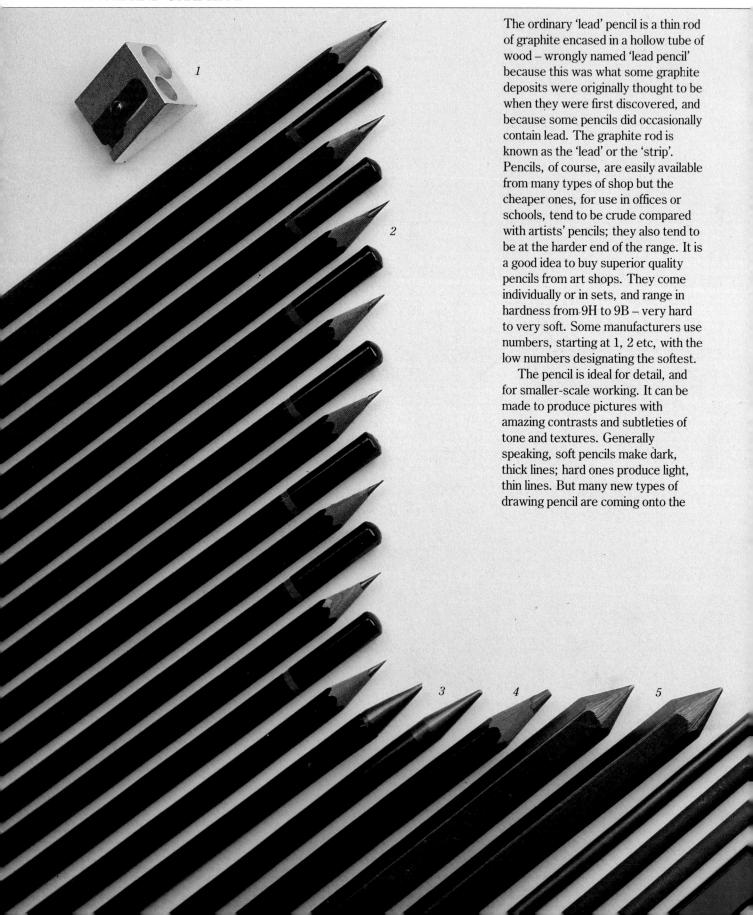

market. Some of these are extra soft, with softer, thicker strips than any in the standard range, and these can be used for large-scale work. 'Studio' pencils are also specialist tools – rectangular in shape, with a rectangular strip – and again, these are good for bigger scale drawings, allowing you to vary the thickness of the line by turning the pencil. Traditional carpenters' pencils were made to a similar design.

Clutch pencils

1 Pencil sharpener2 Graphite pencils

Most ordinary pencils can be sharpened with a pencil sharpener, either manual or electric, as well as with a craft knife or other type of blade. But the flat studio pencils must be sharpened with a blade or knife. Instead of sharpening your pencils, you can obtain clutch pencils or propelling pencils – which hold the rods of graphite in place so that they

can be extended as necessary. These rods, too, come in a full range, from soft to hard, like the wood-covered normal versions.

A wide variety of papers can be used for drawing with pencils. Smooth boards and cards, cartridge, watercolour papers, tinted paper – all these are suitable. The paper's texture dictates the effects and type of line. Generally, hard pencils do not take very well on smooth surfaces, and very soft pencils can be difficult to control on extremely coarse papers.

For lasting results, a finished pencil drawing should be fixed – and for soft pencils this is essential.

Graphite Sticks

For spontaneous and less detailed work, graphite can be obtained in chunky sticks. These are especially recommended when operating on a very bold, large scale. They allow you to achieve various degrees of softness and thickness, coming in soft-to-hard ranges like ordinary pencils and also in varying thickness. The lines can be altered by using the point, the side of the pointed end, or the flattened length of the stick.

Graphite Powder

For special effects such as softly graded tones, graphite is available in the form of fine powder. This is obtainable in some art shops and is used to produce varied areas of tone in a drawing. Rub the powder on with your finger or with a cloth, and use the smudged areas in conjunction with line. An eraser can be used to remove parts of the powder and create white zones in the dark patches. Graphite powder needs practice. It can be slippery, and must be fixed.

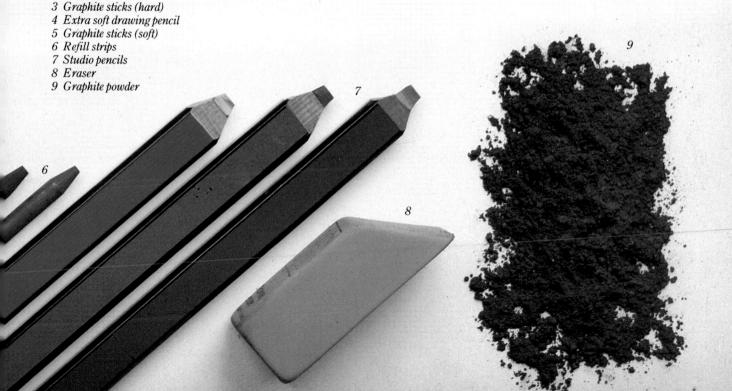

Techniques

PENCIL AND GRAPHITE

Hard Line

Hard pencils produce a paler, thinner line than the softer grades, and are generally less popular with artists than soft pencils. But the thin light line is sometimes useful for an initial drawing which is required to be inconspicuous and not to smudge. So choose a hard pencil when you specificially require a lighter tone – you will get a cleaner line than trying to use a soft pencil lightly. Avoid the mistake of so many artists who tend to stick to one pencil, varying the pressure to change the line. There is full range of pencils to choose from, so use them! Here the artist cross-hatches with a 2H pencil (1) to create an area of crisp, light grey tone (2).

Soft Line

Dark soft lines characterize the graphite pencils at the soft end of the range. The cross-hatched lines below are drawn with a 3B pencil. Without pressing too hard, the artist is able to make a fairly concise line by using a freshly sharpened pencil (1). Yet at the same time, the finished sample has a dark, mellow quality (2). The slightly rough cartridge paper contributes to the soft look, and close observation shows that the pencil lines are broken, with flecks of white showing through.

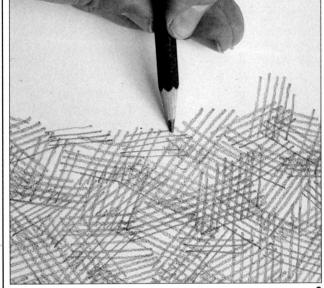

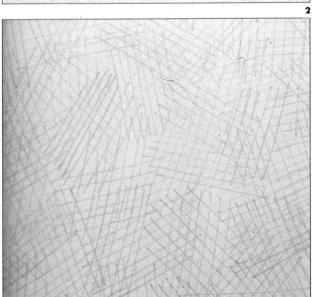

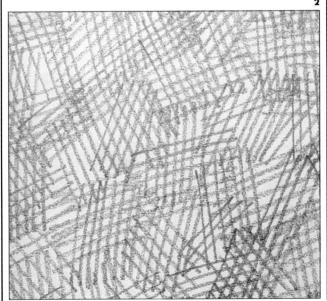

TECHNIQUES

Hard Scribble

The marks you can make with a hard pencil are limited to light grey, whether you are working in line, tone or texture. Make the most of this limitation; when you want to quickly block in a large area of pale texture and tone choose one of the H pencils. There is a considerable difference between an H and 7H pencil, so experiment and explore the possibilities of the whole range. In the illustrations below, the artist is working with a 4H pencil, using loose scribble on white cartridge paper (1). The result (2) is a loose and natural texture which the artist frequently employs to break up flat expanses of background in figure and still-life drawing.

Soft Scribble

The B pencils, the soft ones, offer a range of deeper tones. Here scribbled texture takes on a more velvety appearance than that created by their harder counterparts. A 4B pencil is being used (1) to cover an expanse of white paper with wide, regular scribbles (2). The soft, curved strokes are an ideal technique when dealing with sweeping landscapes, where areas of sky, water, hills and fields require a broad, expansive treatment.

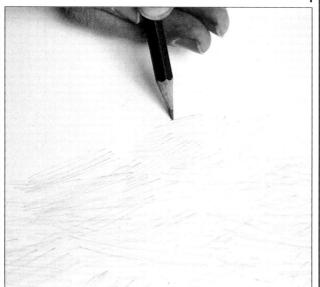

PENCIL AND GRAPHITE

Studio Pencil

A newcomer to the pencil family, these chunky studio pencils have flattened strips. The advantage here is that, by turning the pencil round, you can alter the width of your line. Here (1), the artist uses the broad edge of the graphite to block in a flecked texture of broad marks.

Graphite Stick

Graphite sticks allow you to make bold lines and to block in solid areas. Try the various types – hard and soft; thick and thin – practising their various effects. For example, in the illustration here (2) the artist uses the flattened edge of the point to lay an area of light tone on rough paper.

Blending

You can rub pencil lines to soften their effect. The softer the pencil, of course, the more effective this type of blending will be. Rubbing hard pencil lines will produce a slightly out of focus effect (1); with soft pencil marks, the result can look very smudgy and dark (2). Most artists restrict such blending to selected areas of a drawing – using it to contrast with the linear character of most pencil drawing or to knock back a tone or texture which has become too strong. Carry out your own experiments, fixing the final effects so that your work does not become more blended than you intended!

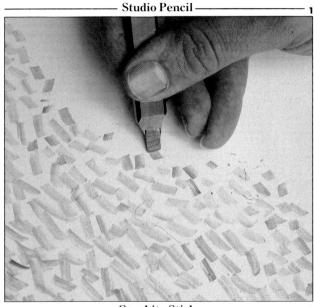

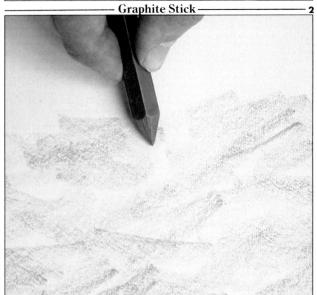

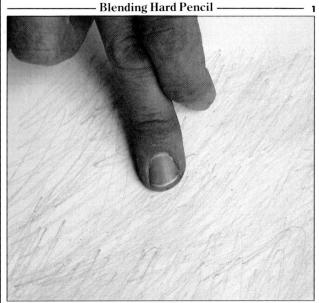

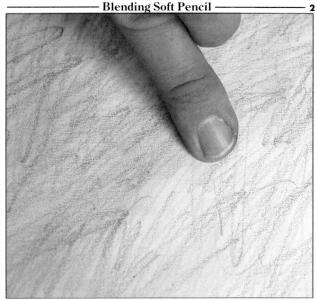

TECHNIQUES

Graphite Powder

Graphite powder is slippery and smudges easily, so don't expect to get immaculate results first time. Here you must be extremely patient and be prepared to leave some of your drawing to chance! Once again, practice is the key to successful use, and even when you are well acquainted with the material, it does not lend itself to fine detail or precision work. Use the powder in conjunction with graphite and graphite pencil, as the artist does in the demonstration on page 110. Or, if you are after a more subtle, amorphous effect, work with graphite powder alone. Start by placing a little of the powder in the area to be toned – here (1) the artist tips the graphite from the jar.

If you only require a small amount, take a pinch between the fingers. Rub the graphite on to the support using your fingers (2) or tissue (3). Any loose excess powder can be put back in the jar and re-used. The grey-toned areas can be removed easily with a kneadable eraser (4). This is useful if you want to create light areas within the darker ones, or if you have simply made a mistake and used too much powder. Remember to fix this fragile medium immediately you have finished work.

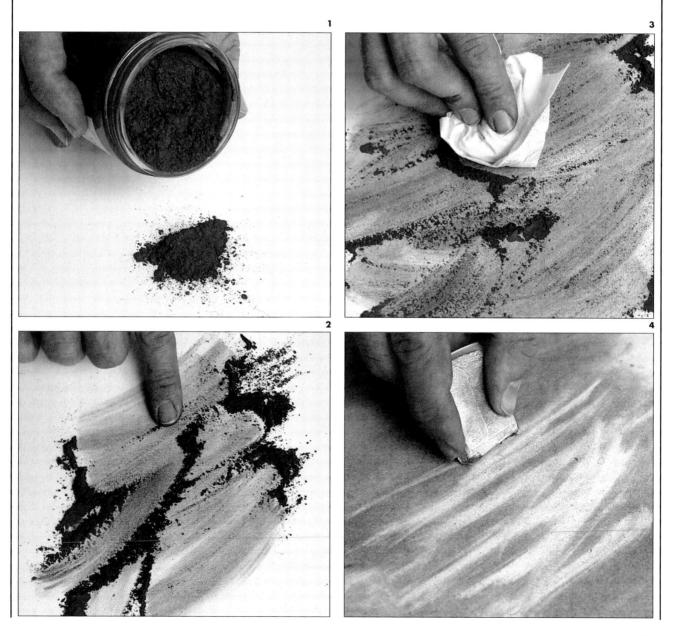

Gorilla

GRAPHITE POWDER

The artist visited a zoo to study the gorilla in this picture. Naturally, the basic problem was that the animal would not keep still. The artist is therefore presented with the problem of depicting an animal in a state of 'captured movement', in as short a time as possible before the constant continuous movements produce too much confusion. Graphite powder is one answer. It can be smudged onto the paper at high speed, and is fairly easy to manipulate afterwards.

The technique of drawing 'from the inside' was also employed here. It is a fallacy to imagine that drawing must always start with an outline – or even include line. A familiar exercise in many art schools is that of making a drawing without using line of any description. This develops the skill of building a picture from the internal forms and shadows, working outwards towards the edge of the subject. In the illustration here, the use of this technique means that the graphite powder is smudged rapidly onto the paper to block in the areas of shadow that are present within the form of the animal. But the artist

has taken care to notice the structure of the creature, paying attention to the fact that shadows and highlights are determined by the bones and muscles lying under the skin. Some patient observation of the animal and how it moves, is essential before committing any marks to the paper.

It is important to think about how the animal will fit on to the support – taking careful note of the scale and proportions to visualize where those first marks should be made on the paper.

movement of the gorilla as quickly as possible, in order to produce a lively picture. To do this, the artist has to work rapidly, immediately blocking in the main volumes of the animal, so that they can be developed later. The artist must get down an instant impression right at the start.

The problem is to capture the

1 The artist is going to work from the 'inside out' – starting with the shadows and tones rather than the outline, and working outwards from there. A small amount of graphite powder is taken up into the fingers and smudged onto a sheet of smooth white drawing card measuring 20in×28in (51cm×71cm). In this picture a tissue is being used to create the swirling shapes of the

moving animal's body and limbs. You could do the smudging with your fingers but a tissue is cleaner and enables you to spread broader marks. Any excess powder can be blown off the surface, or you can tilt the paper and tap the powder off carefully so that it can be used again.

2 Using a 2B graphite stick, the artist sketches in the rugged, furry outline of the gorilla. The graphite stick produces a bold line, and the artist builds up the outline in feathery strokes, making small jagged movements. The objective is to avoid having a hard, sharp and unnatural outline which is not suited to the soft furry contour of the animal.

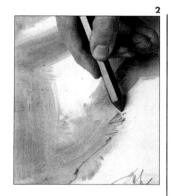

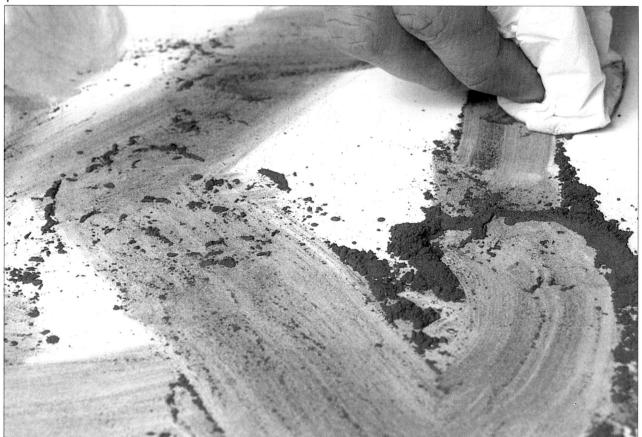

3 Already the soft graphite has helped the artist to produce a convincing portrayal of movement, as the gorilla walks across the composition. The gorilla is represented purely as an animal study without background. A hard outline would have tended to flatten the image, losing the sense of flow and rhythm so essential to this picture. In smudging on the graphite powder, the artist has picked

out the broad shadow areas visible, creating a sense of form without being committed to sharply defined contours. These regions of light and dark are only approximate at this stage; they will eventually be worked into and developed to create a more specific form.

GRAPHITE POWDER/GORILLA

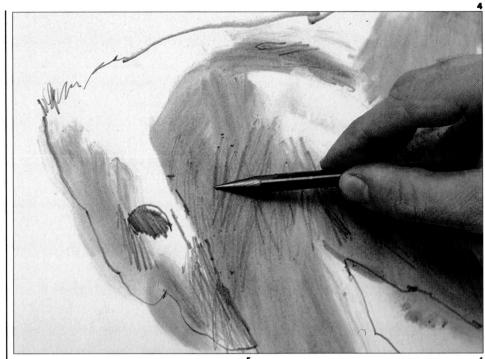

4 The artist changes to a stick of harder graphite, Grade H, and scribbles lightly over the shadows made by the previous smudging. The fur texture is built up in this way, while the artist constantly refers to the subject in order to pick out the particularly deep tones, leaving other areas untouched.

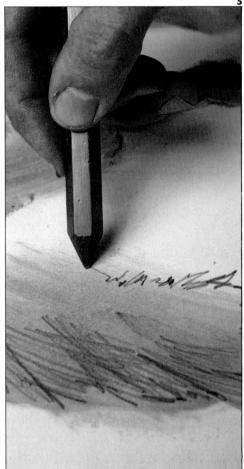

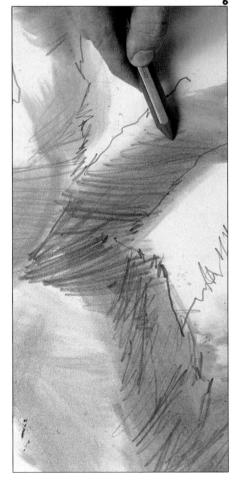

5 Changing back to the original, softer stick, the artist continues to develop the fur textures. The softer stick gives a slightly broader, softer line for this stage of the work, offering some linear variety. In this illustration the artist is using a jagged irregular line to suggest the tufted contours of the inside of the limb.

6 The artist moves across the animal in the same way, continuing with the brushing, to-and-fro movement, drawing freely from the wrist. This develops the overall fur texture. It is important to avoid texture which is too even. If you look at animals, you will see that their fur varies in places. Some is even and smooth, and some parts are more tufted and ruffled. Even though it is often difficult to get an exact impression when looking at an animal, your representation will be unrealistic if you produce too smooth and uniform a look.

7 One of the advantages of graphite powder is that a broadly defined shape can be drawn onto the paper without worrying about areas of light. You are not committed to an irreversible dark tone. In this picture, the artist is using a soft, kneadable eraser. The graphite powder is easy

to remove, so the eraser

should be able to rub areas of highlights completely clean, making them as light as the paper. Nothing is permanent and any surplus tone can be removed. 8 Because of the fragile nature of the graphite powder, it is essential to fix the picture as soon as it is finished.

The smudgy nature of the medium makes accidental smudges look all the worse!

The powder has enabled the artist to make a mark on the paper straight away - on a large scale - and to block in these large areas with any other drawing material would have taken time. When you are dealing with animals there is rarely any time available they are constantly on the move. Then, instead of trying to turn these tonal smudges into a static image by containing them within a rigid outline, the artist has been sensitive enough to keep the outline-marks nebulous and undefined. The picture needs

to be developed in the same spirit as the initial marks that established the shadows. In this case the artist achieves this soft definition by making a broken line of short, jerky marks to indicate rather than to define the contours of the animal.

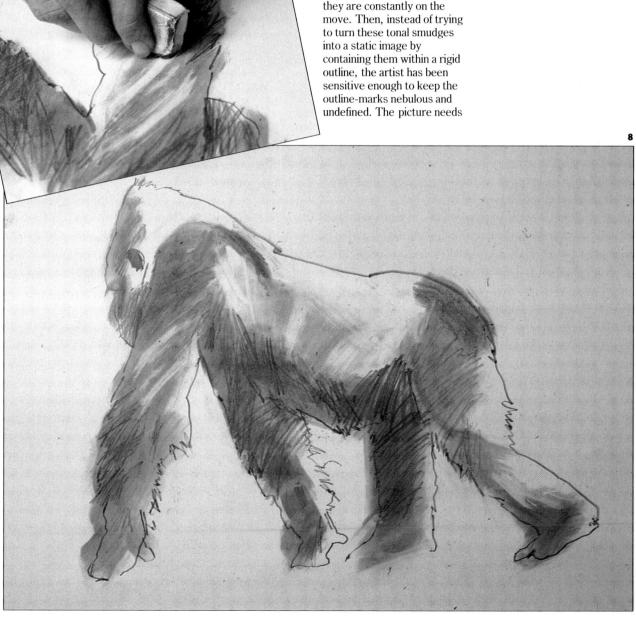

Female Nude

GRAPHITE PENCIL

This is very much a study in light and shade, and yet the artist has not worked without a linear guideline. An outline has been drawn – very faint, so that it does not interfere with subtle shading later. Because it was crucial to get the outline exactly right, the artist spent some time on this early stage, employing the 'measuring' technique (see page 16), taking the length of the visible arm, from the shoulder to the elbow, as a reference against which other distances could be measured and brought into proportion.

Four pencils, ranging from 2B to 4H, were selected for the drawing. This gave a range of tones from light to dark grey, without the artist having to resort to varying the pressure on the pencil for darker or lighter areas. Many artists simply use one pencil and rely on pressing harder or lighter. But the type of pencil determines the nature of the mark it makes. An H pencil gives only a pale line, however hard you press; a soft one can be controlled by pressure but even the lightest lines will be soft and blurred compared with the hard pencils. Because this drawing relied so much on shading, the artist preferred to keep

absolute control over the degrees of crispness of the shapes. For example, this made it desirable to switch from a soft to hard pencil when the drawing called for an area of light tone.

For much the same reason, a smooth paper was chosen: This gave the artist more control over the marks. A granular paper imposes its own texture upon the picture.

The nude is reclining against a

background of white sheets

which means the overall tone

of the body is generally darker

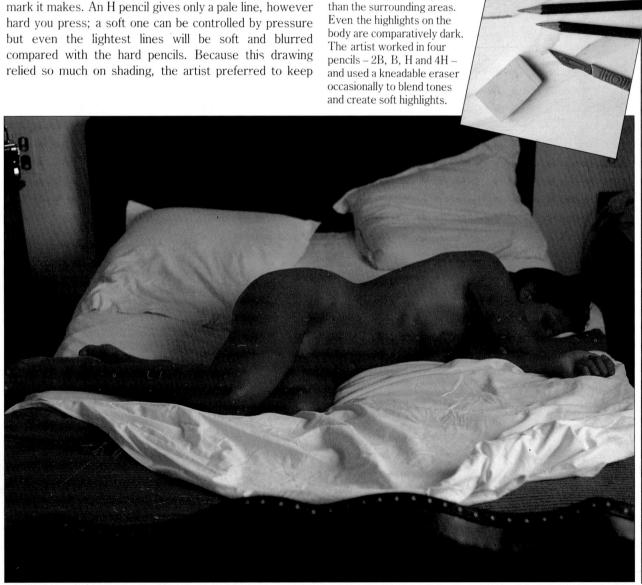

- $1\,$ On smooth white cartridge paper measuring $20\text{in}\times30\text{in}$ $(51\text{cm}\times76\text{cm}),$ a faint outline is sketched with the B pencil. The figure is placed prominently, so that it occupies almost the full length of the support. Changing to the softer 2B pencil, the artist established the darkest tones, the hair and eye, using bold directional strokes.
- 2 Taking the hair as the darkest tone, to which all other tones can be related, the artist then switches to the H pencil. The side of the graphite point is used, and the artist starts to indicate the lighter shadows on the arm. These are graded from dark to light as the shadows merge into the highlights along the centre of the arm.
- 3 Before continuing with the figure, the artist blocks in some of the deep, dark area of the bed-head. This will act as a general reference point for the rest of the tones. It will help show how light and how dark the shading on the figure has to be, in relation to this. Here a 2B pencil is being used to block in the bed-head area.
- 4 The artist wants to establish a difference in texture between the fabric and the flesh tones. Therefore the shading on the figure is smoother, built up gradually to describe the curved surfaces of the form. In this illustration the H pencil is used to depict a shadow area.

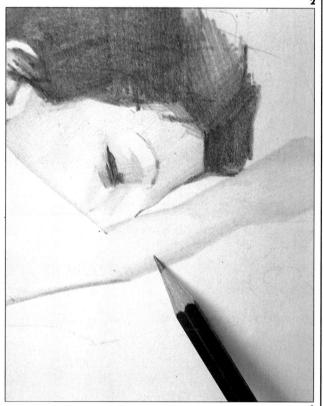

GRAPHITE PENCIL/FEMALE NUDE

5 The artist works across the whole body, looking carefully at the shadows and developing these gradually to bring the tones into line with each other. Gentle cross-hatching is being used here to block in the triangular shadow between the arm and the torso. The darker shadows here are the equivalent of the hair, and the artist relates these accordingly. It is essential

with this type of shaded drawing to refer constantly to the subject. Because it is a fairly laborious procedure, it is very easy to get carried away and unthinkingly shade in what you think should be there, rather than what actually is there. If you do this the figure will become flat and lifeless. 6 So far the artist has worked some of the tones into the top part of the figure, relating these to the flat shape of the bed. In this case, the figure has been started in one place, and the artist is completing this before moving on to the next part. Each region is being brought to a stage of near-completion before moving on.

7 The foot is outlined as a negative shape. The artist has blocked in the tone behind it, making it stand out as a flat white area. Here a 4H pencil is being employed to lay in the area of shadow which describes the form of the foot. The 4H pencil enables the artist to keep the tones lighter in this part of the drawing.

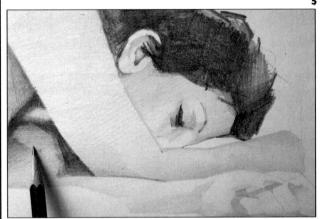

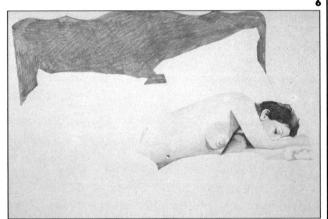

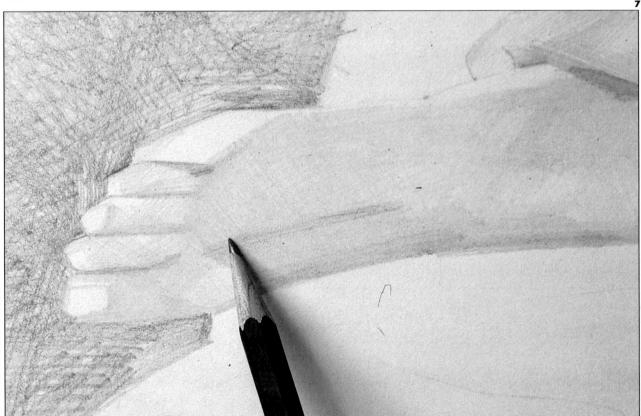

8 The highlights on the sheets are crisp, white and geometric. The artist tackles this by blocking in the shadows, alternating between the B and the H pencils, depending on the depth of tone required, and then using a kneadable eraser to define and develop the highlights. Again, this is an effective technique, so long as you do

not get carried away and forget about the subject. Refer constantly to what is before you, if you want to obtain a convincing impression.

By using the sharp edges and corners of the eraser, you will find it is possible to create surprisingly sharp, fine highlights.

9 This is one of several ways of drawing the figure. There is no single, right way of approaching this subject – a complicated arrangement of form and volumes. Each artist adopts an individual method. Some artists work in line, and some rely more on tones to express the human form. Many work on the whole image at one time, moving across the support and bringing up the whole picture simultaneously.

Here, the technique has been very much concerned with describing the subject in terms of light and shade, analyzing the forms into tonal planes to show where the light falls and how this casts shadows elsewhere on the form. In this composition, the background is crucial. This is

because the shading on the figure is light, and in many places minimal; an isolated study on plain white would not have worked at all in this case. The white highlights on the figure would simply have merged with the paper tone. In this picture, however, the surrounding tones are carefully worked out and clearly defined, so that the figure is established in a definite spatial environment. Thus a three-dimensional form is already suggested; the figure is already defined by the space; and it does not require more than subtle shading to bring the figure to life.

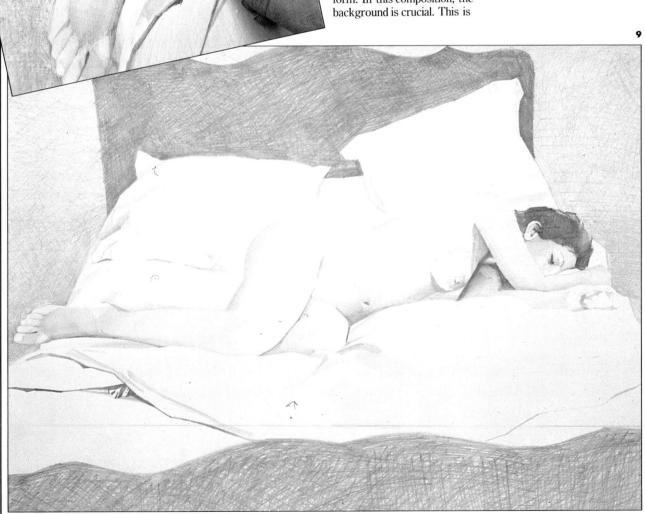

Chapter 8

Coloured Pencil

The striking characteristic of coloured pencils over the last few decades has been their coming of age. They are no longer exclusively the playthings of children experimenting in the nursery. They are sophisticated tools, continually evolving into more refined products. This is not to criticize the activities of schoolchildren – what we learn with coloured pencils in the classroom is probably the best grounding of all for potential artists and designers. But nowadays, large sets of artists' pencils, some of them containing a range of 72 colours, give the adult artist command over an extremely subtle variety of tones. This vastly increased range can even threaten to overwhelm the beginner.

Both ordinary coloured pencils, and their water soluble versions (sometimes called watercolour pencils), are extremely popular with illustrators and animators. They produce a certain effect which has become fashionable – a lightly-textured delicate finish seen in many animation films and children's and magazine illustrations. This lightness, in fact, is the symptom of a characteristic

which, for the fine artist, can be quite a problem. It is difficult to build up tonal contrasts; the white paper is rarely completely obliterated. Even if you are using black, it is difficult to prevent the paper from playing a lightening role. It is not easy to build up tone as you would with paint, because the waxy nature of the pencil colours obliterates the slight texture of the paper surface, the 'key', making the support increasingly smooth with each additional pencil stroke. Most artists take this into account, and use pencils for certain tasks and particular subjects, working within these limitations.

For work on a smaller scale with coloured pencils, you can combined blocked-in areas of colour with linear drawing, producing a detailed or naturalistic finished picture. But one of the areas where coloured pencils really come into their own is in mixed media work. Here you can combine the light touch of the coloured pencil with the stronger, denser tones of inks, paints and many other materials. These, and other adventurous combinations, open up a range of unusual and experimental effects.

Materials

COLOURED PENCIL

Coloured pencils are made from a mixture of clay and pigment, bound together with gum, soaked in wax and pressed into rods encased in wood. In recent years, there has been an enormous increase in the variety of coloured pencils available on the market. Not only has the range of colours been vastly expanded, but you can now obtain watercolour pencils – allowing you to dissolve or partially dissolve the colours on the paper with water. Ordinary coloured

pencils differ according to the manufacturer and the series you choose. Some of them are waxy and extra hard; others are soft and crumbly, approaching the pastel pencils in texture and effect.

Factories produce billions of coloured pencils to a high degree of precision, ensuring that once a hue has been established – careful measurements of components churned automatically in huge drums – the same colour is reproduced-

exactly. The wood encasements are often made from soft Californian cedar so that the pencils can be sharpened without splitting.

Coloured pencils are more difficult to erase than graphite pencils. The only way to remove a heavy coloured pencil mark is to scrape it back to the surface with a sharp blade. However, this type of correction must be severely restricted because the roughened paper surface quickly becomes unworkable.

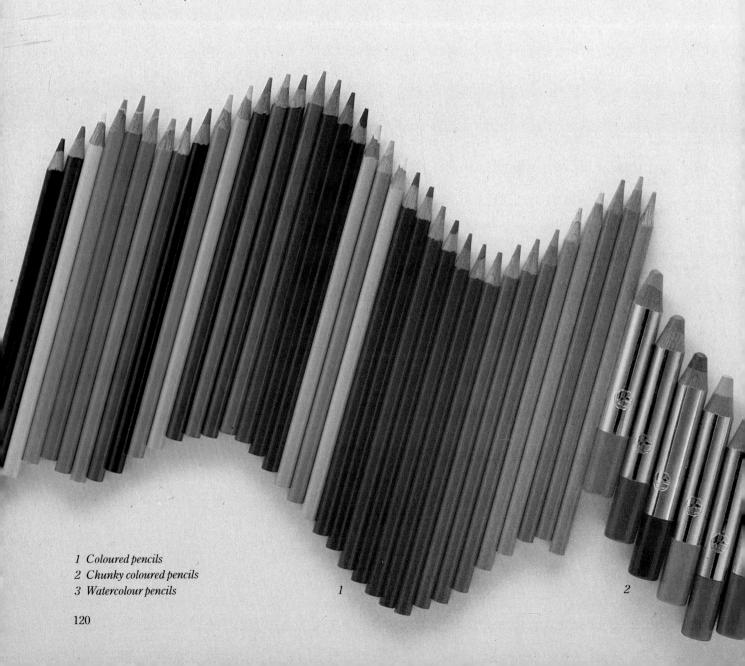

Ordinary Coloured Pencils

You can buy ordinary coloured pencils individually or in sets of up to 72 colours. Children's and general purpose coloured pencils are all right for quick sketching and drawing, but they are less refined than those made specifically for use in the studio. The pencils can be obtained in round or hexagonal wooden encasements. They look practically indestructable – but like all pencils, they must be handled with care. This is something a lot of people do not realize – if you drop them or treat them roughly, the

colour strips inside the wood will fracture. Thus when you sharpen the pencil the short crumbled pieces will simply fall away.

Special coloured pencils are produced for use on film and acetate. This type of pencil is used mainly by illustrators and in animation studios, and is unnecessary for ordinary drawing.

Watercolour Pencils

These can be used as ordinary coloured pencils, or as 'painting' pencils. When using them in a

painterly way, apply clean water with a soft brush to those areas which you want to blend or soften. Alternatively, you can dampen the paper first, so that the marks made by the pencil will bleed and expand slightly to produce a broad, soft line.

Very soft, chunky jumbo-sized watercolour pencils are now available, ideally suited to large scale work. They come in sets, complete with their own pencil-sharpener – standard sharpeners do not fit these outsize materials.

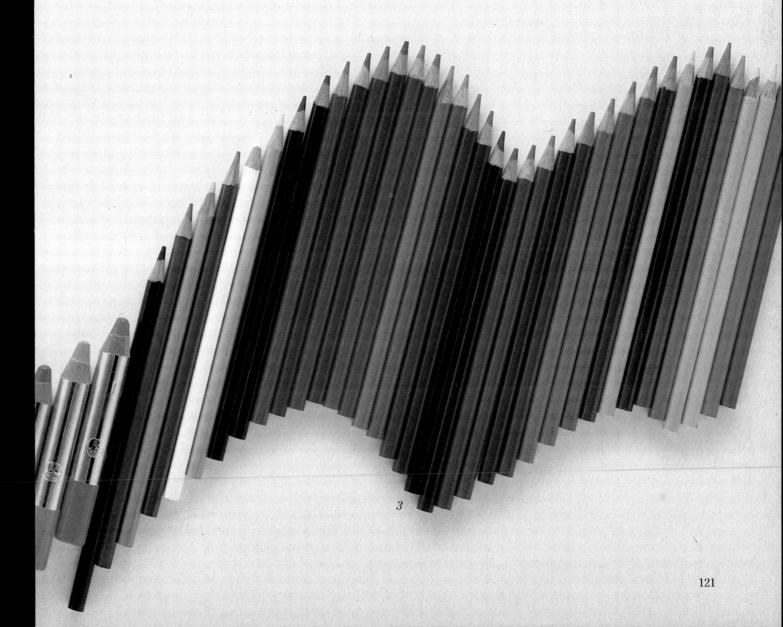

Techniques COLOURED PENCIL

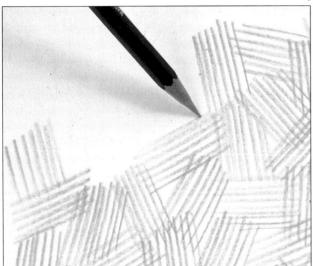

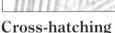

The secret of mixing coloured pencils is to make the white or light tone of the paper work for you. Artists and illustrators who work frequently with this versatile medium know that you cannot bully coloured pencils into forming a particular colour – you have to cajole them. For example, if you decided to mix green from blue and yellow - and a 'mixed' green composed of flecks of yellow and blue is far more interesting than a green which is merely picked from the box – you could not easily achieve this by simply scribbling dense yellow over dense blue. The result would be uneven and unattractive, and such closely worked strokes would automatically prevent you from building up further colour should you so wish, because the surface would already have become shiny and unworkable. By far the best approach is to build up the colour gradually, using widely spaced lines with plenty of white paper showing through – as the artist is doing in the illustrations on this page. Cross-hatching is a good way of doing this because the fine, regular lines give you maximum control over the final result. First, patches of regular blue hatching are applied evenly over a fairly large expanse of white cartridge paper (1) - if the area is too small it will be difficult to appreciate the overall effect. Yellow hatching of a similar texture is then worked on top of this (2). The result is a lively, broken colour in which the pure yellow and blue are still discernible, yet which is interpreted by the viewer as green (3).

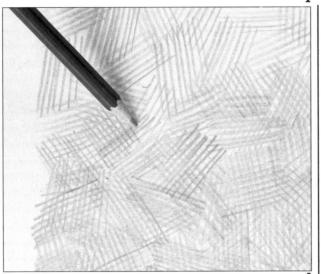

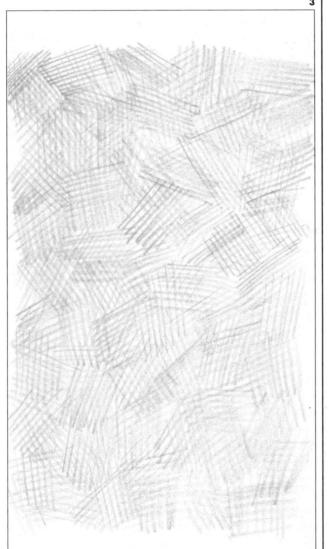

TECHNIQUES

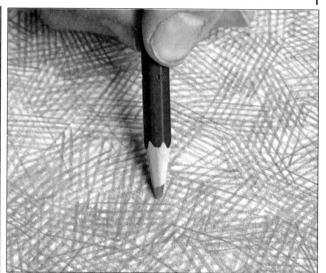

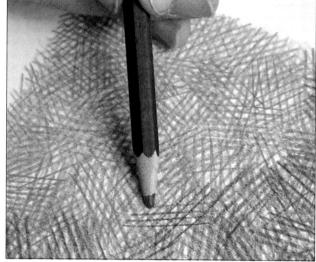

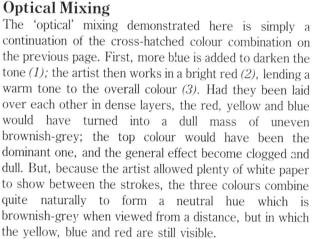

These illustrations demonstrate one of the basic principles of coloured pencil drawing, and they also help to explain why the medium has become such a popular one. With coloured pencils you can achieve glowing and shimmering effects by building up the colours. And the more you can exploit these colour combinations, the more interesting the result is likely to be. Why use flat orange, for example, when you can create a whole range of exciting, multi-colour oranges from red, yellow and tinges of any other colour you care to add? The resulting mixtures - often delicate and unusual - have far greater visual impact than flat, commercially mixed colours. Try your own colour mixing. The result will be surprisingly effective and encourage you to experiment further with this innovative medium.

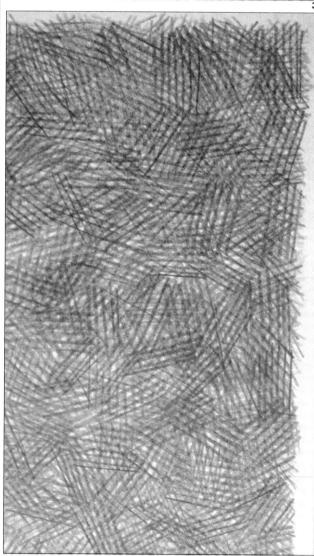

COLOURED PENCIL

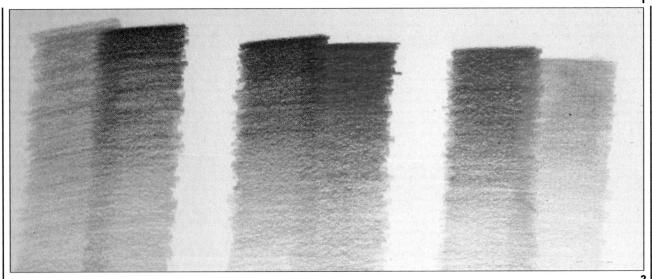

Colour Mixing

We have talked about the various ways of mixing colours—including cross-hatching, optical mixing and overlaying. And with a little practice you will be able to use the materials without any problem. But knowing how to blend and mix the pencils does not actually tell you what colours to choose if you want to make a particular colour. For this you need to know a little about colour theory, and to experiment by trying as many colour combinations as possible. Work through your pencil set, taking each colour in turn and overlaying this with every other colour in the box (1). You might find it useful to keep a chart of your discoveries, a handy reference to help you see at a glance how to mix the colour you want.

Water soluble pencils can be blended with water. After lightly overlaying the required colours, take a soft brush and work the overlaid colours with a little clean water. The result is similar to that of watercolour paint, and often has the same delicate transparent quality (2). There is one problem with this technique; the colours tend to darken and change – sometimes quite dramatically – when they are wet. It is not always easy to know what the result will be. Again, practice will help you to anticipate a likely outcome. But in any case, you should not attempt to imitate watercolour paint with watercolour pencils – they are essentially a drawing medium and are at their best when blending is restricted to limited areas.

TECHNIQUES

Blending

On the previous pages we looked at effective ways of mixing colour, of overlaying two or three separate colours to create a new one. This was made possible by using the white paper and by building up the pencil lines gradually in several easily controlled stages. The 'blending' here is done more directly, by overlaying colours, one flat area on top of another. If you decide you want this type of flat tone rather than the broken colours of optical mixing and cross-hatching, you must remember the limitations of the material and proceed carefully. First, apply the initial colour as lightly as possible with the side of the pencil (1). This method does not completely destroy the key of the paper surface and enables you to add one or two more colours if you continue to work as lightly as possible (2). Deeper tones can be created by building up two or three flat, light colours (3) but already the artist is finding it difficult to add further red because the underlying pencil is too dense to receive more colour.

The texture of the paper is important when blending coloured pencils. Here the artist made the task easier by using fairly coarse cartridge paper – the waxy colour got caught on the raised parts of the support's surface texture, leaving the minute indents as white. Regular sharpening is another essental if you want to keep the colours unfuzzy and clear, and the surface of the paper as unclogged as possible.

Palm Trees

WATER SOLUBLE PENCIL

With these chunky, water soluble pencils, you can produce a picture which reflects a sense of fun. These palm trees have not been represented in exact realistic detail, but have been converted into a bright design in which the colours combine in cheerful harmony. The whole emphasis is decorative, a stylized version of an organic subject, capturing some of the familiar aspects we associate with palms, such as their broad leaves. The background has been left out, isolating the palms so that they form an almost abstract pattern. This fits the medium, because it is difficult to create a sense of space and recession which would require more graded tones.

The medium is best suited to work on a large scale, so the artist here aimed for a bold overall design. The chosen colours are based in reality, yet they are bright – a range of five greens, two browns, black, and an orange used

Alternatively, these pencils can be used with water to produce a soft, bleeding line. To do this, dampen the paper with clean water, and then draw onto the surface while the paper is still wet or partially wet.

The chunky, water soluble

pencils shown here are

best for colourful, large-

scale line work. For this

reason the artist chooses

a clump of palm trees,

whose characteristic wide flowing leaves are

ideal for the bold lines

so suitable for this

medium.

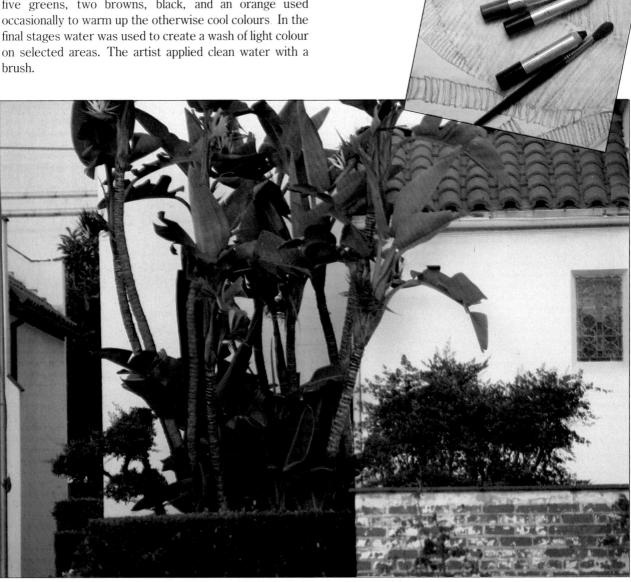

- 1 As the artist is not aiming for a particularly naturalistic effect here, the work is begun with an outline which has a more flat look, offering a simplified view - rather like the approach often used by illustrators and designers. Heavy white cartridge paper, measuring 30in \times 20in (76cm \times 51cm), is being used. The paper should be as strong as possible; card could be used instead. For the artist intends to dissolve the colours with water in the later stages.
- 2 The first tree has been well established in outline, using the local colour of the part of the tree being depicted. For example, the trunk is in brown and the leaves in browns and greens. Some of the early textural blocking in has begun to describe the leaves. The artist has simplified the image and has been selective about which parts of the subject should be included. Brown, black and dark and light green are used to shade in the leaves.
- 3 The artist continues to build up the patterns in the leaves, using a bright leaf green over a darker green. In this way, the artist develops the foliage, blocking in each leaf with a slightly different combination of colours. This produces a decorative effect, but is also used to make the subject look slightly realistic, in that subtle variations, even on one leaf, can give a hint of light and shade. By creating so many different colour combinations, from a basic selection of pencils, a bright, yet harmonious theme is established.

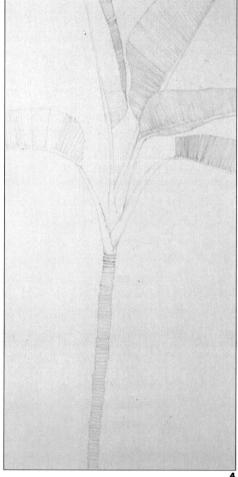

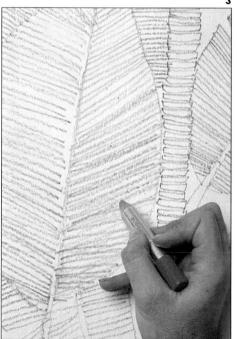

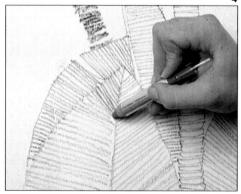

4 The artist uses a darker green along one side of a leaf, building up a density of tone and colour. The other side is left lighter, with more white space between the lines. This adds a touch of realism to the overall design effect.

WATER SOLUBLE PENCIL/PALM TREES

5 The artist is pressing harder on the pencil in order to draw in the segments on the trunks of the palm trees.
This is aimed at producing a darker tone. Remember that with this type of pencil, blocking-in is not easy.
The pencils are too soft to enable you to control the tone. You have to find other ways of developing tonal contrast.
This can be done by pressing

hard as the artist is doing here, giving an extremely soft, broad line. Alternatively, you can use hatching and cross-hatching to build up a more controlled area of tone. Best of all, however, is the principle that tools should be used for the task that suit them best — so do not make life hard for yourself by choosing a subject which requires substantial solid areas, requiring blocking

in, or subjects which need carefully graded areas of tone. In these cases, chunky water soluble pencils such as these are not the right tools for the job. When looking for a subject, go straight for the bold linear qualities that will bring out the best characteristics of this medium.

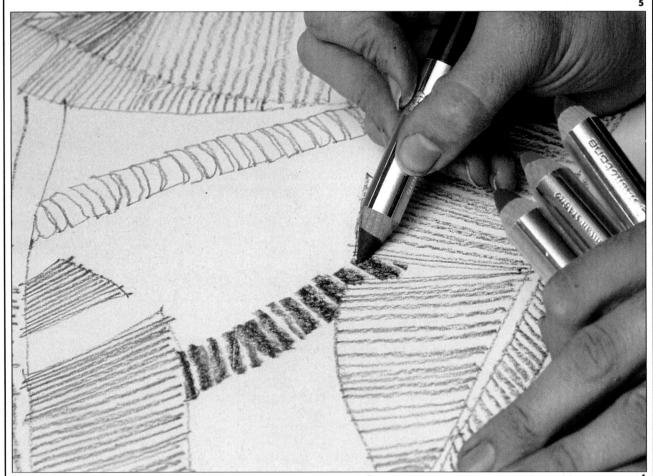

6 This close-up of a section of the leaves shows how the artist has exaggerated the subtle veins and texture of the subject, making them into an intricate pattern of directional lines and interesting variations of colour. The leaves cease to be leaves and become interwoven into an almost abstract design. Black, brown, dark and light green and a dull

olive green are used here to build up the combination of inter-relating colours. This brings together elements of what the artist sees in the subject, plus some creative and imaginative interpretation.

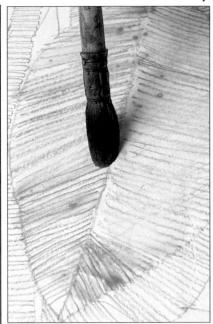

7 Still conscious of the overall design, the artist uses water on selected areas to blend the colours into each other. Clean water is worked lightly across the drawn lines without rubbing too hard. This releases just enough colour to produce a light wash which complements rather than replaces the linear pattern.

of the importance of choosing a subject and a medium which suit each other, a point so often forgotten when beginners embark on a drawing. The pencils should be used gently and loosely. In this picture, the artist used water in the final stages, in order to introduce a contrast between some areas of line and some of wash.

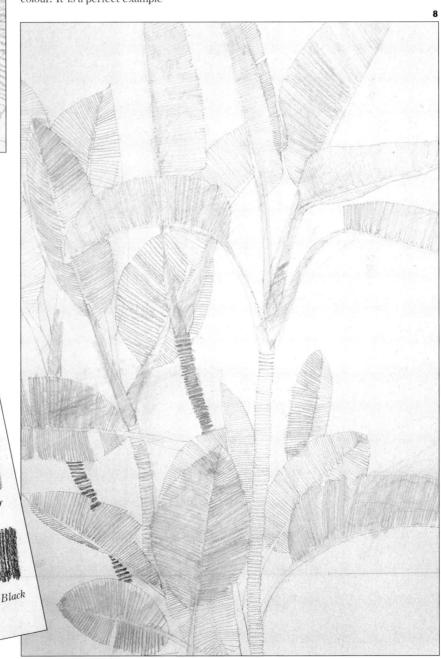

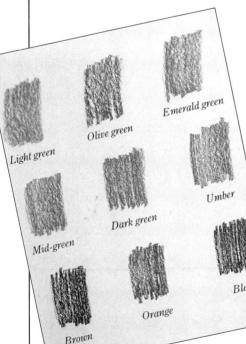

Girl on the Beach

COLOURED PENCIL

For a bright, sunlit picture with stark contrasts between light and shade, the artist uses only coloured pencils, sketching in the outline with various local colours. There is no need to use an ordinary graphite pencil. Although the colours here look simple – predominantly red, yellow and blue – a surprisingly large range has been used, and is particularly necessary to depict the subtle tones of human flesh.

Skin colour is so complex that it is not just a question of separating the areas between those which are touched by light and those which are in shadow. Each one of these regions, in fact, has its own combination of warm and cool tones. The skin of all races is transparent, with blended colours, and the best way of portraying this is to render it literally in layers. With coloured pencils, you can work over an area lightly, layer by layer, leaving some of the underlying tones to show through between the strokes. This gives a transparent effect if built up in extremely thin layers. If the colours become too dense, use an eraser to remove some of the excess.

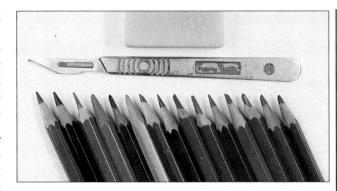

A selection of 15 pencils is used here. The artist has to hand an eraser, and also a scalpel – it is essential to keep the pencils sharp, or the lines will become fuzzy. The subject is strong. A tanned figure in a bright yellow swimsuit sits against a red windbreak under a clear blue sky. Strong light

produces emphatic tonal contrasts and the figure is defined by deep shadows and clear highlights. Sunlight casts a strong dark shadow across the sand.

White cartridge paper is used, measuring $20\text{in} \times 30\text{in}$ ($51\text{cm} \times 71\text{cm}$).

- 1 The artist starts by drawing the outline of the figure. Each part of this initial outline is depicted using the local colour of the area it represents. Here, for example, the flesh tones of the face are drawn in terra cotta; the hair and sunglasses are outlined in black.
- 2 The artist blocks in the hair. The flesh tone is built up on the face by lightly drawing one area and then placing another layer on top. Starting with Naples yellow, warmer shades of brown and red are then worked in. Cool shadows are hatched on top of this in black and blue. Areas of white paper represent the strong highlights.

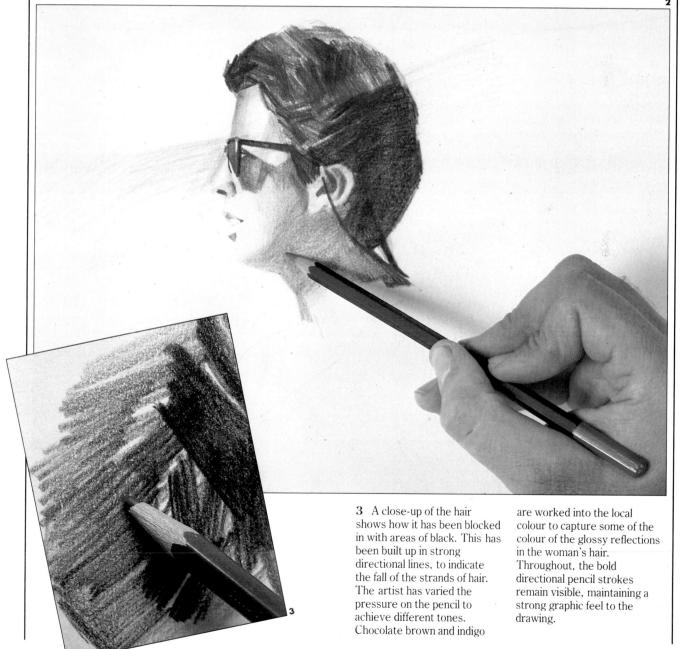

COLOURED PENCIL/GIRL ON THE BEACH

4 The red awning and yellow swimsuit have been blocked-in lightly, without developing any of the colour variations within the forms. The artist has tried merely to establish an approximate tone around the figure. Now the flesh colours can be built up. In this illustration the artist is working on the darker flesh tones of the arm, using brown, chocolate, Naples yellow, lemon, burnt umber and terra cotta.

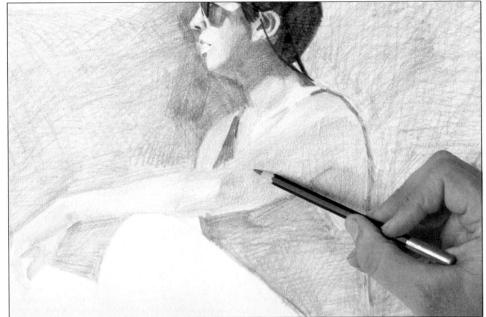

5 Working across the image, the warm and cool tones are picked out. In this picture the artist applies a cool indigo tone over a light shadow area.

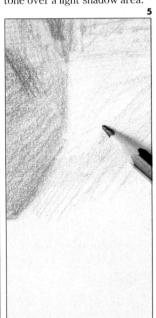

6 The artist moves into the red awning behind the figure, which has already been established as a flat shape. The shapes of the creases are drawn in. Their upper edges, which catch the light, are left as light red with touches of orange. The shaded areas generally fall into two tones – medium and dark.

7 Red pencil is used on the shaded side of the leg. This has already been built up densely with layers of blue, browns and terra cotta. The darkest planes are on the top and underside, and the entire area is built up with smooth directional lines. A definite cool blueish shadow is added where the figure is seated on the sand.

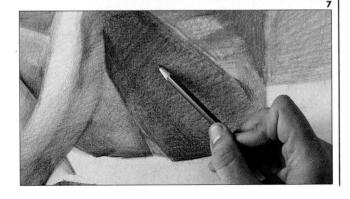

8 Although the finished picture is a composition, the figure is the central part. This has been emphasized by bringing into sharp focus the red awning immediately surrounding the figure while leaving paler, sketchier areas towards the edges of the picture. A major part of this project has been involved with building up flesh tones, which are a subtle mixture of warm and cool tints. Coloured pencils are ideal for this, so long as you lay the colours lightly, building up the tones gradually to enable the colours

Light blue

Cobalt blue

Prussian blue

Indig0

Deep vermilion

Madder carmine

Orange chrome

Naples yellow

underneath to show through. In this way it is possible to achieve the delicate transparent effect of human flesh. The artist worked with a wide range of tones to achieve this effect. The cool, shadowy areas, for instance, were developed with four blues and a green; the warmer sunlit tones with three yellows and four reddish tints.

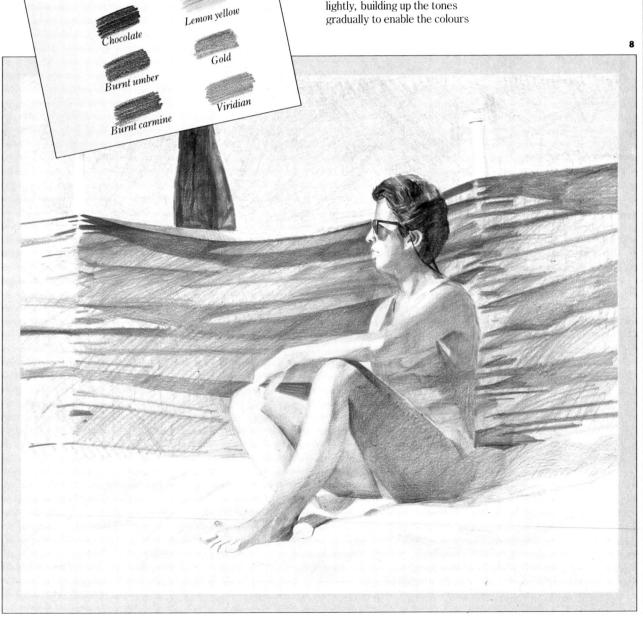

Chapter 9

Markers and Fibre Pens

Technology is relentlessly improving upon the marker and fibre-tip pen, and new products are coming on to the market all the time. There is no need to recoil in puritanical shock from this brash young medium – it is available for all types of artists to experiment with, even though they have come to be associated normally with the graphic artist's studio. For the fine artist, the wide variety of products available offers a whole range of colours and lines which can be used in a completely different way from their normal commercial role.

The 'traditional' wedge tipped studio markers, with their thick rectangular drawing points, are commonly used for presentation work, graphic design and occasionally for animation. In the commercial studio, marker artists are specialists who learn a whole range of techniques to fit the product. Wood grain, reflective metal surfaces and even the subtle gradations or tints of portrait and figure work can be miraculously rendered with markers. However, without going to these lengths of expertise, and without producing the finish necessary in studio work, markers can be borrowed from their commercial settings to produce

lovely and unusual drawings. They exist in their own right as a colourful and chunky drawing material.

Our artist, a painter, uses them in an individual way – creating graphic pictures which exploit the crisp quality of markers; yet making the colours work in a controlled manner. However, he has not forgotten the basic characteristics of the medium. Remember that you cannot produce traditionally-rendered pictures with a flat colour. There are limitations. The secret is to choose a subject which suits this medium, something which can be illustrated in a striking, graphic manner, rather than a subject calling for traditional toning. Look for something bright and bold – and have a go.

There are numerous felt-tip pens, liners, fibre-tip brushes and other tools which come into this broad new category. You don't have to become an expert in them all. You are probably familiar with some of these pens as writing tools. Be open-minded and experiment with the different marks. A good artist is not dependent on conventional pens and pencils – a marker or felt-tip pen can be made to do some spectacular work.

Materials

MARKERS AND FIBRE PENS

As any graphic artist knows, there are thousands of markers, fibre-tip pens and related drawing implements now on the market. Not only does every manufacturer produce its own range of such materials, but these are changing and being developed all the time, with superb and bewildering ranges to choose from.

For the fine artist, however, there is no need to worry too much about technical categories, or about their specialist role in the designer's studio. Your interest will probably be of a more general and experimental nature.

Markers

136

Wedge tipped markers come in sets or can be bought individually. Each marker has a broad, obliquely cut felt tip which draws the ink from the cylindrical, glass holder. This glass holder has a removable screw top to allow for refills. Many artists prefer these traditional markers to some of the more recent streamlined types because when not in use they can be

stood upright rather than left rolling around the desk or table. Markers come in a wide range of colours, and each colour is usually available in a number of shades. For example, one product has nine cool greys and nine warm greys. The colours are very accurate, but they do darken with use. The life of a marker can be extended by diluting the ink with lighter fuel, although this obviously lightens the colour.

Marker artists generally work on special marker paper because the colours tend to bleed on ordinary, more porous surfaces. This makes them unsuitable for the slick finish which markers are most often used for. However, as a drawing and sketching medium this may not matter. Indeed, you probably prefer a brighter, more spontaneous effect.

The marker ink is soluble in lighter fuel, making it easy to spread the effective way of creating broken

demonstration on page 146, the artist spatters the fluid onto a flat area of dried marker colour to make the pebble texture of the beach.

Felt-tip Pens

Broadly speaking, felt-tips are flexible and wide. Markers fall into this category. There are many other brands available. Some, such as the luminous 'highlighters', are made specifically for office use. Others come in a range of colours and are available from art and graphic suppliers. Look at the label to see if you are buying a soluble or waterproof product.

'Brush' pens have a soft, pliable tip and produce lines similar to those made with a watercolour brush. Some of these have a solid, pithy tip; others are actually made like brushes, with tiny synthetic bristles.

Fibre-tip Pens

Again, the choice is a wide one. Try one or two brands to see which suit you best. Some have hard tips, others are more flexible; some pens are watersoluble, others permanent. You can buy sets of felt-tips in a wide range of colours – some of these are manufactured specially for the artist, others for use in the office or playroom. The 'office' variety tends to come in limited colours, often black, blue, red or green.

For drawing and sketching, your main concern will probably be with the width and type of tip. New tips are usually rigid and produce a hard line, and become more flexible after being used. Many artists keep two pens to hand – a new one for strong, hard lines, and an old favourite with a 'broken in' tip for softer shading.

Fine Liners

The terms 'fine liner' is used broadly for all those synthetic tip pens which

produce a characteristic thin, spidery line. These pens are used in offices and graphic design and illustration studios. In many ways the fine liner is a disposable version of the technical pen – the drawing on page 142 is almost indistinguishable from one done with a technical pen. Fine liners are excellent for detailed, illustrative work and for small-scale drawings and sketches.

- 1 Jumbo-size markers
- 2 Fine liners

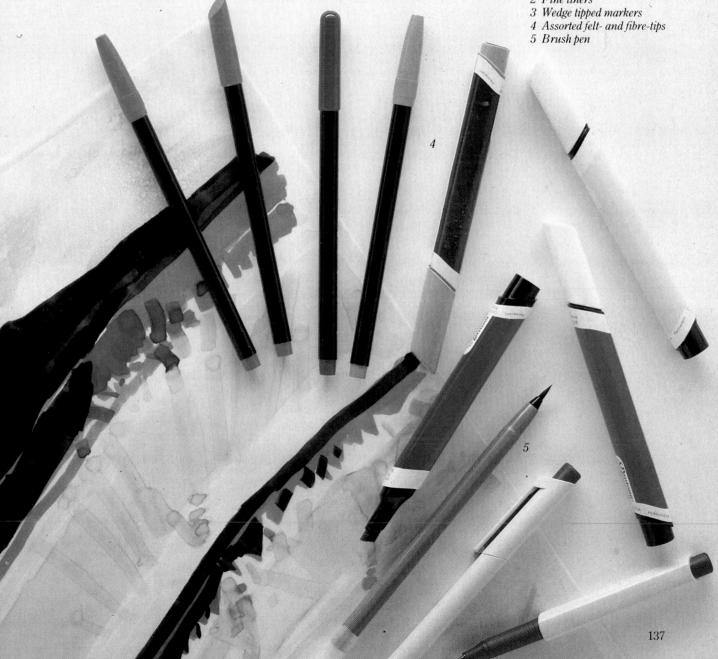

Techniques

MARKERS AND FIBRE PENS

Using Markers

Probably the most popular type of marker in use is the wedge-tipped variety, so-called because of its broad chiselled end. With this one drawing tool you can make three widths of line, lay broad areas of colour and tone, and glaze one colour over another.

Practice is the key to successful marker work. Markers have definite limitations, and specialist marker artists readily admit that their job consists chiefly of finding ways round these limitations. However, if you are using markers solely as an adventurous drawing and sketching

1 The wedge-tipped studio

medium, you need not worry about these professional drawbacks. Your main concern is to familiarize yourself with the materials so that you can use them confidently and quickly. The techniques on this page are simple and straightforward, but you do need to try them out several times before attempting to integrate them into a drawing. Use good quality products - not only are the results smoother and easier to achieve, but the colours are less likely to bleed and 'drag' into each other when one marker is laid over another.

marker is capable of producing a variety of marks. Here the artist uses different sides of the felt-tip to make broad, medium and narrow lines. Practise this until you achieve a smooth, even flow - by turning the marker as you draw, you can vary the width of a particular line, producing a flowing, undulating mark.

- 2 To lay a flat colour, work quickly in broad, horizontal lines, taking each line over the edge of the previous one before it has time to dry. For a iarge expanse of colour, use lighter fuel to spread the ink (see page 141).
- 3 To overlay colour, allow the first layer to dry before working quickly over this with a second colour. Providing you choose a good quality product, work quickly, and allow the first colour to dry properly, the second colour should not 'drag' or disturb the underlying colour.

TECHNIQUES

Stripping a Marker

To block-in large areas of really flat colour, you will find it convenient to use the whole of the length of the felt strip rather than being confined to the comparatively narrow tip. This entails the careful removal of the strip from its container – a process which is only possible with the screw-type of marker container. You must then lay the colour fairly quickly before the colour dries. As the strips run out of colour, they become fainter, but if you only need to lay a small quantity of colour, replace the strip in the container and screw the top back on ready for re-use.

- 1 To strip a marker, first cut the plastic seal around the metal cap. (Remember, 'stripping' is only possible with markers which have screw tops.)
- 2 Remove the metal top. The drying process begins as soon as the strip is exposed to the air, so work as quickly as possible.
- 3 Tip the container to bring the strip to the mouth of the container.
- 4 Hold the strip firmly and remove from container. When you have finished work, this strip can be replaced for further use.

MARKERS AND FIBRE PENS

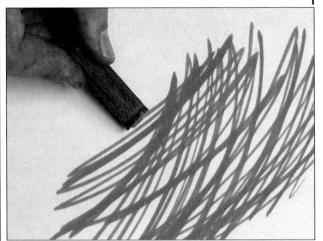

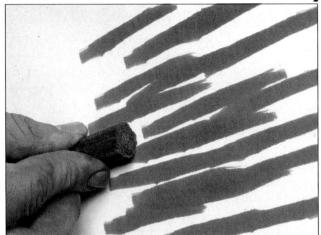

Making Texture

- 1 Markers produce a steady flow of even colour. This makes them excellent for some types of work, but limits their use in other ways. For instance, to produce the light feathery texture demonstrated here, the artist works in loose, scribbly strokes, relying on the irregular, broken shapes of white paper showing through to produce the textural effect.
- 2 Broad flecks of colour are laid with the wide end of the marker strip. The pattern of such marks can be varied to suit the subject in hand, and the flecks can be close and dense or wide apart, depending on the required texture and density of colour. Here the marks are laid in a loosely parallel fashion. The technique is often used by this artist to block-in wide expanses of flat ground - the direction of the marks being used to indicate the direction of the flow of the landscape.
- 3 Use the side of the marker strip for blocking in broad areas. Again, the technique is useful for wide, directional sweeps of colour. To achieve a flatter effect, use lighter fuel with the marker (see opposite page).

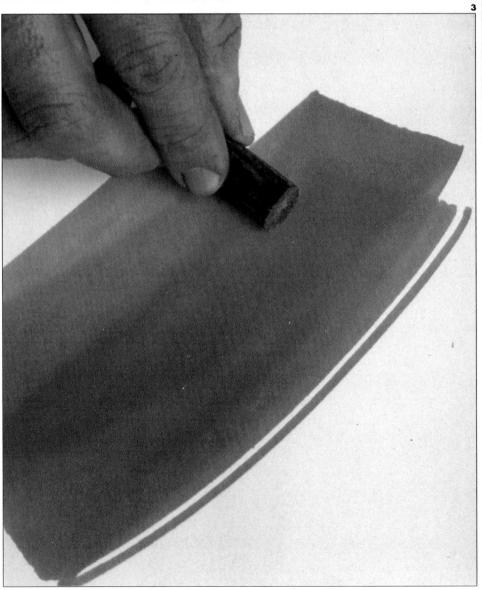

TECHNIQUES

Using Lighter Fuel

Lighter fuel – normally used to refill cigarette lighters – is extremely versatile and useful, and an essential item in the marker artist's studio. Not only can it be used to dilute the ink, thus extending the life of a marker, but it can also be exploited to create a whole range of texture effects. Although most marker manufacturers make proprietary solvents, specially suited to their particular products, lighter fuel is a cheap, all-purpose alternative and works quite adequately with all petroleum-based markers. You must, however, treat lighter fuel with respect. It is highly flammable and it also gives off dangerous fumes, so be sure to work in a well-ventilated area, away from cigarettes and naked light.

Although markers can be used to create flat areas of colour, this becomes tricky if you have to cover very large areas. The ink tends to dry in streaks before you have time to blend the edges. However, if you first spread lighter fuel over the area to be rendered, the marker colour remains wet long enough for the marks to bleed, or blend together and the result is completely even. This technique can be adapted to create multi-coloured 'washes', and to lay graded colours.

Choice of paper affects results, especially when using lighter fuel to spread the colour. Proper marker paper is sealed on one – occasionally, both – sides. This stops the marker inks from bleeding, thus producing brighter colours and also enabling you to produce crisp shapes and hard edges. Other papers, not specially prepared for use with markers, absorb colour and give a softer, amorphous effect. One drawback with 'non marker' papers is that the colour soaks through to the reverse side. This can be messy and will spoil any paper underneath, especially if you are working on a pad.

2 Holding the marker strip firmly between the thumb and forefinger, lay the colour with parallel, overlapping stripes. As the marker ink starts to run out, the colour becomes lighter.

Orange Lily

FINE LINER

An extra-fine member of the fibre-pen family is used for this drawing. The 'fine liner' offers a precision which can draw detail. But it also produces a mark on the paper which is regular – almost like a technical pen – and which is uncompromising. The lines cannot be harder or softer. narrower or wider. Tone and form must be made with one unchanging type of line. For this reason, the exercise is ideal for beginners – a true challenge, because the pen acts against you as you try to vary the tonal effects. If you can use the fine liner for a subtle drawing like this, controlling tone only with line, you will find other work much easier when you come to use more sympathetic materials. More malleable materials will allow you to create grey areas, but here you must operate purely in black and white. The 'greys', the less dark shadows, are made up of black lines by means of hatching.

The size of paper here is immaterial because the image does not fill the available space. This picture is a study of an individual flower, not a complete composition.

The shading around the central object fades into white space. The artist does not have to worry about background. The subject is presented as a vignette – an image without a defined edge – traditionally a popular way of portraying an isolated object.

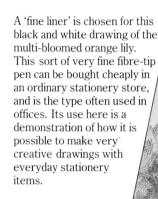

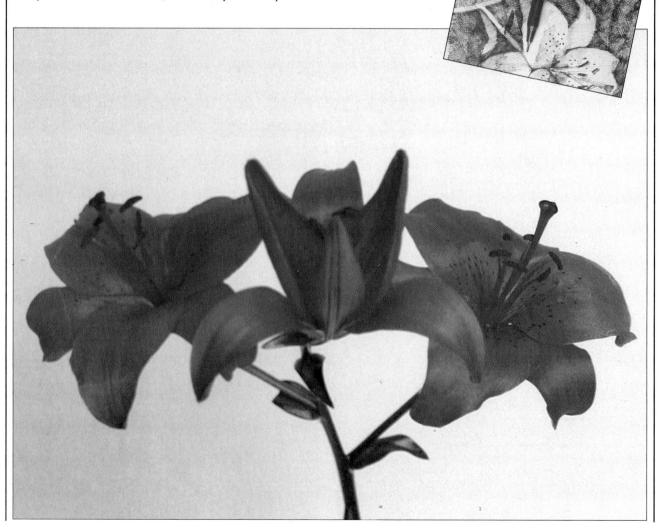

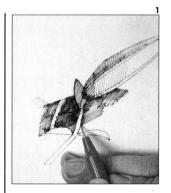

1 Working on smooth white card, measuring $20 \, \text{in} \times 24 \, \text{in}$ (51 cm×61 cm), the artist starts drawing the main part of the flower in the centre of the support. In this case, the pen was used directly, without any preliminary pencil sketch. But there is no reason why you should not make a light pencil drawing first, to act as a guide, if you wish. Shading is begun immediately – before

the whole outline is complete. A small portion is outlined and then shaded in.

2 Rather than picking out the flower, the artist is depicting the shapes of the bloom and stem by blocking – in the areas behind them. The point of the pen is too fine to allow any practical attempt to block in solid areas of tone. It is a tool for drawing line. However, the

artist does not want a flat tone — little patches of hatching and cross-hatching are built up instead. This is taken carefully up to the outline of the detail, so as not to destroy the delicate shape. The background is actually made quite dark, with extensive hatching, and this throws out the shape of the flower in stark silhouette.

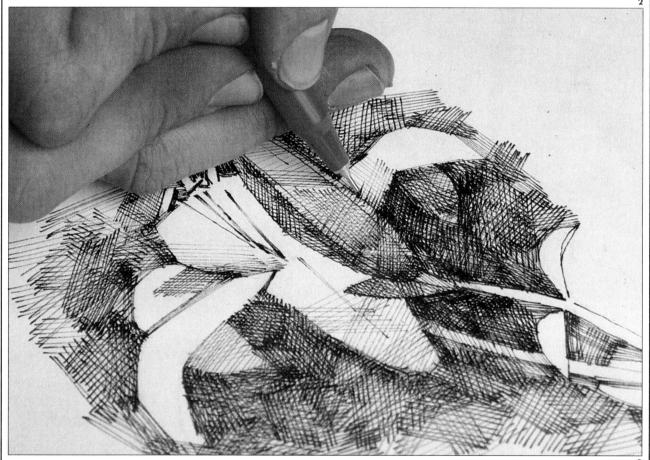

3 The first bloom is now established by this 'negative' process of blocking in the surrounding areas. Notice how, as the shading was taken farther away from the flower, it became less dense, allowing the edge of the picture area to fade slightly into the surrounding white instead of standing out as a sharply cut-out shape. The artist has also moved into the area of the

flower itself. Again, it is the shadow parts which are worked upon, with crosshatching on the petals. But these areas are kept relatively light at this stage. Otherwise the crisp white shape would be overworked, and the image would be lost. The artist continually thinks about the relative tones. Too much deepening of tone, too early, can lead you into an

irreversible situation, so always be patient when building such areas as shadows.

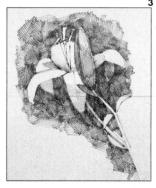

FINE LINER/ORANGE LILY

4 Before moving on to the next flower head, it is important to get the tones absolutely right in this one. The artist therefore moves into the petals, looking carefully to find the darker tones, These are established in regular directional strokes which describe the direction of the petals. Parallel criss-cross lines are hatched down the length of a bud.

5 The next bloom is treated in exactly the same way as the first, by indicating the outline and then emphasizing the shape with darkened background behind it.

Instead of simply drawing the second bloom on to empty space, the artist has observed and drawn the shape of the space between the two blooms.

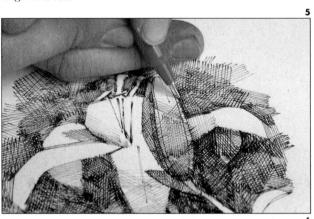

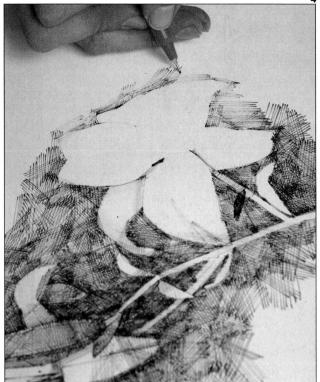

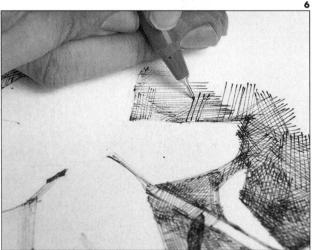

6 The artist develops the background tone around the newly-established flower. This background appears very daunting, as if every line has to be meaningful, and drawn in exactly the right place. In fact, however, the artist is working very quickly. If each line was a considered, slowly drawn mark, you would lose the effect of the almost mechanical criss-cross motion, and the

overall tone would in fact be much harder to control. Here, the artist adds the tone patch by patch in a series of rapidly-drawn lines. Each patch is assessed in much the same way as a brushstroke would be, if you were painting – i.e. it is either left, or darkened by more strokes to build up the required tone.

7 In this picture you can see quite clearly the light and precise shape of the subject. Yet it is the background, not the flower, which essentially has been drawn. The artist has been able to control this drawing by working from light to dark – the way a watercolourist would operate – starting with light tones and gradually darkening as necessary. This is the only

way to work with all types of pen, because it is difficult and time-consuming to erase the lines. Normally with pen drawing, once a mark has been placed on the paper, you are committed. Thus it would be a mistake to over-darken a particular area too quickly. The gradual approach is the only one.

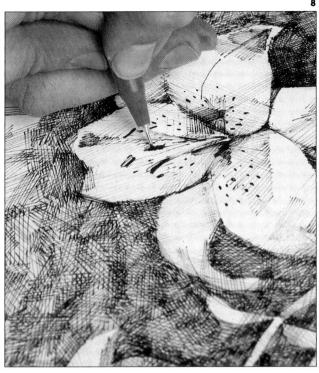

8 The background is now complete around both blooms, and the artist has also developed the flower petals with cross-hatching. Again, the artist is aware that the petals must remain considerably lighter than the background. In this picture, details of the flower's anatomy are being dotted in. These finishing touches bring the flower to life, giving it an identity.

9 The final picture demonstrates how crosshatching, although it appears to be a haphazard zigzag, can in fact be used to produce carefully controlled effects. For instance, on the petals you will notice that the hatched lines describing the shape of the petal are closer together towards the darker centre of the flower. The lines gradually spread out as they move towards the outer edges of the petals, where the light is falling more directly. Thus, not only can you indicate simple light and dark tones by varying the density of hatching - you can also describe form by means of light. The final illustration also shows how the fine liner produces an effect similar to that of a technical pen – regular and unforgiving - yet it is slightly softer.

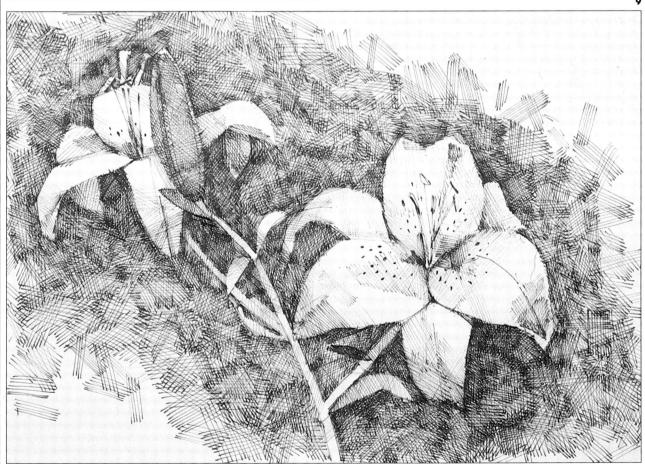

Deserted Beach

WEDGE TIPPED MARKER

The composition is perfectly suited to the medium – a deserted beach, with no figures and few objects; not even the sea to introduce complicated shades of reflected colour. Yet there are challenges. The shadows play an important role and must be dramatically emphasized, in order to hold the composition together. The very simplicity could result in an uninteresting picture. And there are also technical problems involving the medium. Yet here, however, the upright umbrella and the strong horizontal shadows thrown across the sand divide the rectangular support into a harmonious and visually satisfying arrangement of shapes.

When you lay one marker on top of another, the second colour dissolves the first. This means you have to work quickly and decisively with the second colour, not returning to change or rework what went before. Alternatively, you can exploit this property, using the top colour in the same way as the artist uses lighter fuel—dabbing the colour off so that the white paper shows through in places to give a desired effect. With magic markers, it is difficult to build up tone and colour in order

to describe form. So this artist avoided any subject which involved complex portrayal of form and space. Instead, a graphic picture has been produced, in sympathy with the somewhat drastic emptiness of the scene.

Eleven markers are selected for this strikingly graphic beach scene. The markers are mainly blues and greys, the main colours in the subject, and these provide an overall theme to the colour composition. But a black permanent felt-tip marker is also added, as the black of the marker range in this case is not as deep as will be required.

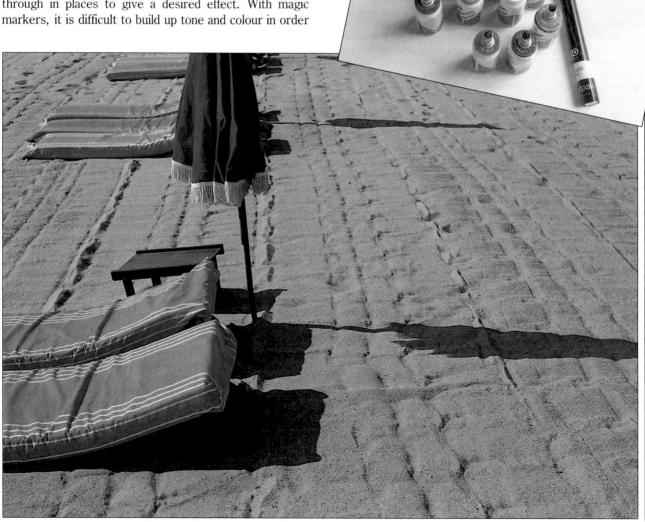

- 1 Because marker bleeds when used on ordinary drawing paper, the artist opted for a thin sheet of special marker paper, measuring $15 \text{ in} \times 20 \text{ in } (39 \text{ cm} \times 51 \text{ cm}).$ However, the artist made a pencil drawing of the subject on a sheet of cartridge paper and laid the transparent marker paper on top of this so that the lines would show through. Brick white is used for the sand, stripping the marker (see p139) in order to lay a broad expanse of colour quickly. Lighter fuel is sprinkled on the sand area, to achieve a slightly mottled effect. This is dabbed with a piece of tissue.
- 2 The beach colour dries quickly and when this has happened the artist starts to apply more colour, working from light to dark. With markers it is important to start with the palest colours as nothing can be toned down in later stages. Two tones of blue stripes are laid on the folded umbrella; a single stroke of marker being used for each stripe.
- 3 So far, the artist has followed the principle of working in broad, graphic shapes. The subject was specially chosen for this, making the procedure easier there are no rounded forms or subtle graded shadows. The lightest tones have been indicated, including an initial pale blue area in preparation for the darker blues - of the sun-beds. Before going on to the next stage the artist waits for this early blocking-in to dry thoroughly.

WEDGE TIPPED MARKER/DESERTED BEACH

- 4 A small decorator's brush is dipped in lighter fuel and the artist flicks this across the sand, creating more texture. This 'spattering' technique, done by rubbing the fingers across the ends of the bristles, is a popular marker method for creating mottled and marbled effects. The fluid dissolves the dried colour, showing up the white of the paper in speckled areas.
- 5 When the mottled beach has dried, the artist works into the light blue of the sun-beds. First, a mid-blue is used to define the basic shapes. In this illustration, a shaded edge is being added in a darker blue. The shapes are kept flat and graphic. When using markers you have to work quickly, so shapes need to be simplified.

6 The artist has worked into the area of the sun-beds with greys and more blues, adding these as simple flat shapes. Again, it is important to allow the colours to dry before applying new ones. Even then, the artist works quickly, to avoid disturbing the colour beneath, which dissolves as

new marker is applied. The next stage is to indicate the deepest shadows in the composition, in the areas of the umbrella and sun-beds. This was initially done with the marker black, but the result was not dense enough, so the artist resorted to the stronger tone of a permanent felt-tip pen.

7 The shadows are strengthened, the dark blacks being emphasized with permanent felt-tip. Here, it is employed in a continuous bold stroke down the shaded side of the umbrella. The marker black is reserved for the elongated shadow shapes which the evening sun throws across the sand. The shadows in this composition are as important as the actual objects. Without them, the picture would consist only of the isolated umbrella and the beds on the left-hand side. Therefore the very definite shadow shapes have to be boldly depicted, with hard edges, rather than being merely suggested by a few wispy strokes. It is this strong graphic approach which is so well suited to this particular medium.

Manganese blue
Cool grey (dark)

Cool grey (medium)

8 The strong, dark, horizontal shadows have now been established across the sand; but this causes a problem, the sand has been textured, giving an impression of a rough, bumpy surface. The artist therefore uses the same spattering technique on the shadows, to integrate these with the sand.

9 For this picture, the artist has employed markers in an unconventional way. Usually, the marker belongs in a commercial studio. It is used for layouts, for drawing up designs which will be presented to potential clients, and for producing slick photographic images. Here, however, it has been employed by a traditional artist seeking to portray an outdoor, landscape scene. The exercise succeeded, not because the artist was skilled with this medium, but because a subject was chosen which could be treated in the same, simple, graphic terms as those employed in the commercial studio. In other words, you should not overdo the adaptation of a medium for a task outside its normal role. Had the artist chosen a

portrait or something similarly complicated, the experiment would not have worked.
But this subject – the empty beach with a minimum of clutter and disturbance, and also a minimal amount of form – presented a perfect opportunity for a dramatic, simplified approach.

Antwerp blue

Prussian blue

Phthalo blue

Light blue

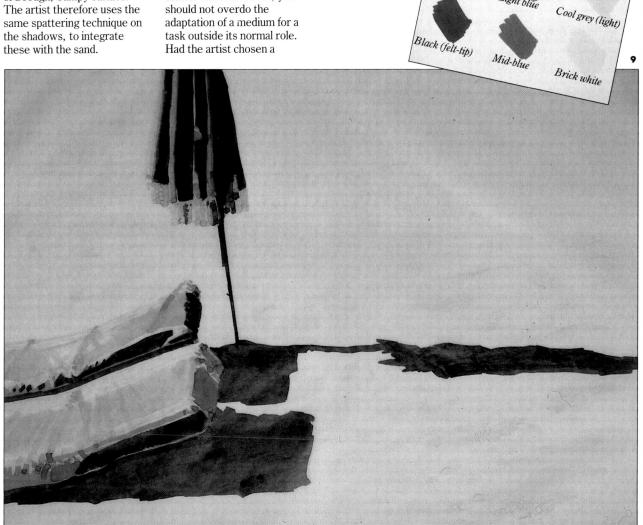

City street

FELT-TIP PEN

The monumental buildings and wide vista of this cityscape demanded careful attention to perspective and to perpendicular lines. Despite the superficial detail and activity in the picture, the basic elements are quite simple, and the artist has exploited this underlying simplicity in the construction of the composition.

When tackling a subject such as this, in which blocks and buildings play an important role, it is useful to follow some basic rules. Firstly, make sure that all your buildings are standing upright. This advice may sound obvious, but in beginners' work there is a frequent and surprising tendency for the perpendiculars to lean outwards from the centre of the paper. This common mistake can be avoided by keeping the uprights in line with the edges of the paper.

Another important principle here is that of linear perspective. Remember that parallel lines on the same plane meet at a 'vanishing point', a theoretical spot on the horizon (see page 20). This rule is particularly important in urban street scenes like this one, because the buildings are usually uniform and geometric. If your perspective is

wrong, the whole drawing will look odd. Applied perspective gets easier with practice, although even experienced artists occasionally get it wrong! Meanwhile, you might find it helpful to plot the vanishing point and converging lines of your composition in the very early stages of the drawing to act as a guide. This subject also contains some aerial perspective, notably the haziness of the further buildings. However, the hard, dark lines of the felt-tip pen restricted the artist in this respect, making any indication of atmosphere and recession impossible.

All the tones and shading were left to the final stages; the prime concern lay with establishing the main elements of the composition. When this crucial stage was complete, the linear sketch had the formal and impersonal quality of an architect's drawing – a feeling emphasized by the uncompromising, mechanical nature of the line made by the felt-tip pen. The subsequent shading is free and loose in comparison, and to some extent this provided the artist with an opportunity to put a personal stamp on an otherwise anonymous drawing.

This wide New York street recedes into the distance, converging at a theoretical spot on the horizon – a good example of linear perspective.

1 Working in a sketchbook measuring 16.5in×11.5in (29.7cm×42cm), the artist starts by drawing the outline of the distant yet dominant

Empire State Building; the correct positioning of the main compositional elements in this intitial stage is crucial to the finished work.

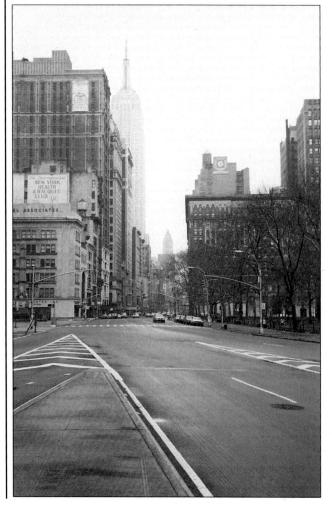

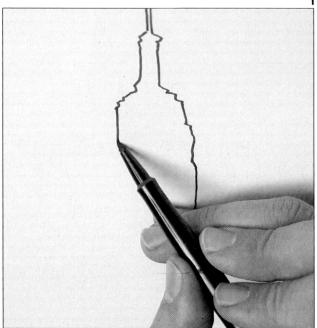

- 2 Adjacent shapes are established with the same single outline. Because the felt-tip pen cannot be erased, care is taken to establish these accurately, and this is done by relating the size and position of each new building to shapes already established.
- 3 The artist continues to build up the composition, with each new line being drawn in carefully observed relationship to its neighbour. Here the building on the right-hand side of the street is drawn again, the artist plans the position of each new mark with care before committing it to paper.

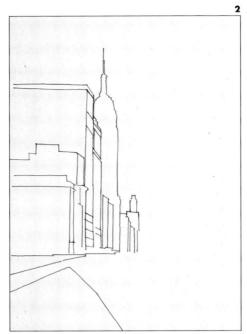

4 The trees are treated simply, each being drawn as a basic arrangement of main branches and a trunk. However, the artist pays careful attention to the scale – the effect of distance is dependent on the receding sizes of the trees. The principle of linear perspective applies here; if an imaginary line was drawn along the bases and tops of the trees, those lines would meet at a vanishing point on the horizon.

FELT-TIP PEN/CITY STREET

5 The uprights of the buildings are kept strictly perpendicular and should be at right angles to the bottom of the paper. Here the artist suggests the windows of one of the blocks with short, broad upright strokes.

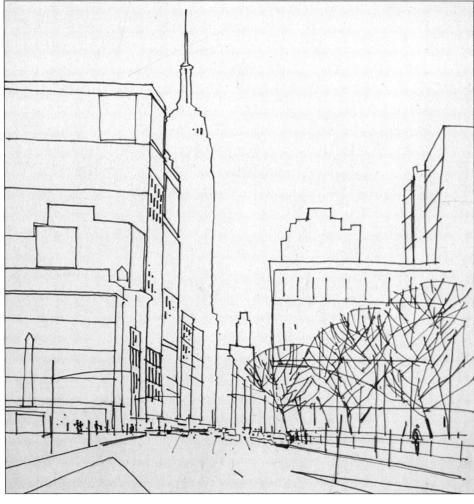

6 The outline drawing is now complete. The main shapes and forms are established in outline; some details, such as windows and the people in the street, are suggested with short upright strokes to lend a sense of scale to the whole composition.

7 With the basic drawing now complete, the artist turns to the tones – the lights and darks of the composition. Although the subject itself is on a grand scale, and the composition seemingly complex and busy, the basic forms are actually quite simple.

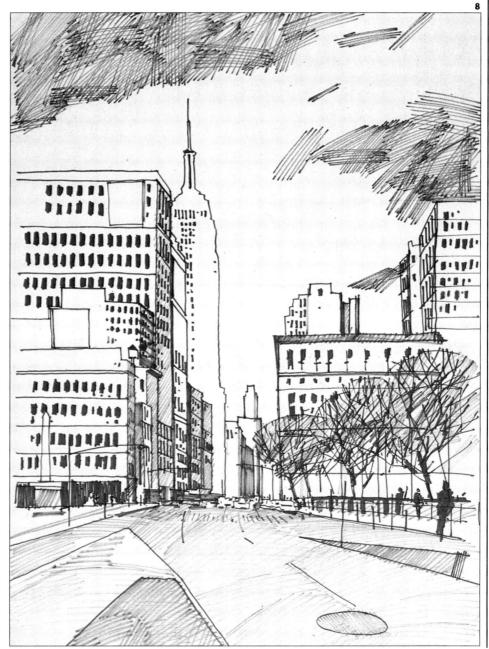

8 In the finished sketch, the buildings are treated as simple blocks, the strong directional sunlight making it easy to pick out the light and dark sides of the rectangular forms. Some local colour is suggested in the same way – for example, the street is lightly hatched with long horizontal strokes, and the sky is broken up with patches of cross-hatching.

Glossary

Abstract A drawing which relies on shapes, colours, textures and forms rather than on a realistic impression of the subject.

Aerial perspective Space and distance indicated by tone and colour. Objects in the distance appear lighter and bluer than those in the foreground.

Bistre Rich brown colour. Bistre pigment was originally obtained from soot.

Bleed The effect of two or more wet colours running into each other, or the effect of one colour applied to a wet support.

Blending Merging two neighbouring colours so that the join is gradual and imperceptible.

Blocking In Refers to the initial stages of a drawing, when the main tones and forms of the subject or composition are laid.

'Boneless' style Brush drawing technique which does not rely on outline. The term is usually used to describe a specific Oriental style.

Broken Colour Technically, this term refers to a colour mixed from two secondary colours. However, it is more generally used to describe a method of mixing colours on the support rather than on the palette. **Optical Mixing** is one way of applying broken colour.

Clutch pencil Graphite or other type of pencil **Strip** held in a metal holder.

Composition Arrangement of elements – objects, shapes, forms and colours – in a painting or drawing.

Conté crayon Square, pastel-like crayons, originally available in traditional colours – sepia, sanguine, bistre, greys, black and white – but now manufactured in a full colour range.

Contour Line defining shape or form.

Cool Colour Colours can be divided into two main groups, 'warms' and 'cools'. Blues, greens and blue-violets are all cool colours.

Cross-hatching Technique of laying tone by building up a series of criss-cross lines.

Dip Pen Drawing and writing tool consisting of a handle, or holder, and a changeable nib.

Erasing Shield A small metal or plastic shield with tiny cut-out shapes. The shield protects the rest of the drawing allowing the tiny shapes are precisely erased.

Felt-tip Pen Drawing and writing tool with a pliable tip, usually used in offices and design studios.

Fibre-tip Pen Term used for one of the many new disposable writing and drawing tools which have synthetic, fibre tips.

Fixative Thin varnish which is sprayed onto drawings to prevent smudging.

Form The outward surface of a three-dimensional object.

Graphite A type of carbon. This is

compressed with clay to make the 'lead' or **Strip** of a pencil. Graphite is also available in stick and powder form.

Hatching A technique for drawing areas of tone in fine, parallel strokes. The closer the strokes, the deeper the tone.

Highlight Emphatic patches of light, usually on a smooth or reflective surface.

Internal Colour Actual or suggested lines describing the form within the outlines of a drawn object.

Key The irregularities – the dints and bumps – on the surface of the support which enable drawing materials to adhere to the paper. The key is sometimes referred to as the **Tooth.**

Linear Perspective A means of indicating a sense of distance and recession on a two-dimensional surface by means of converging lines and a **Vanishing point**.

Local Colour The real colour of the surface of an object without being modified by light and shade.

Masking The use of fluid, paper or tape to isolate a particular area of a work. This enables the artist to work freely, drawing and painting over the mask. The masked area remains unaffected.

Mass Bulk or volume. The satisfactory arrangement of the main masses in a composition is an important factor when planning a drawing.

Monochrome Usually refers to a drawing tone done in black and white, but can also mean a drawing done in another single colour.

Negative Shapes The spaces between the shapes. For example, in a plant drawing, the leaves and stems are the positive shapes; the spaces between these are the negative shapes.

Neutral True neutrals are greys mixed from the three primary colours – red, yellow and blue. More generally, the word refers to a mixture of colours which approaches grey.

Oil Pastel Pastels made from pigment suspended in oil. Oil pastels are soluble in turpentine and white spirit.

Optical Mixing Mixing colours optically, in the eye, rather than on the support. For example, dots of red and blue combine in the eye to produce an impression of purple.

Overlaying Putting one colour or tone on top of another.

Pigment Basic colours obtained from earth, mineral, plant or animal sources, or synthetically manufactured.

Plane Flat areas which make up the surface of an object. These can be large and obvious, such as the sides of a geometric form. Alternatively, they can be small and subtle, as on the human figure. Planes are revealed in terms of light and shade. Propelling Pencil Similar to a Clutch pencil. The Strip of a propelling pencil can be controlled, usually by turning a small knob.

Rendering Drawing or reproducing a subject.

Sanguine Traditional drawing colour of light

Sepia Traditional drawing colour. Brownish pigment, originally obtained from the ink of the cuttlefish

Shading Blocks of tone used to indicate shadow areas.

reddish brown.

Silverpoint Method of drawing used extensively during the Renaissance. The technique involved the use of a silver-tipped drawing tool on a specially prepared ground.

Soft pastel Pastels made by compressing pigment with gum and chalk. 'Soft' differentiates them from oil pastels.

Spattering Producing a marbled or mottled texture. This is done by drawing the fingers across a stiff brush loaded with colour to flick the texture onto the support.

Still-life Drawing and painting of inanimate objects such as flowers, fruit, vessels, utensils, etc.

Stippling Applying colour or tone as areas of fine dots. These can be done with brush, pencil, pen and ink and most other drawing implements.

Strip The coloured or graphite core of a pencil. Sometimes wrongly referred to as the 'lead'.

Support The surface on which the drawing or painting is executed. This can be paper, canvas, board, or other material.

Technical Pen Pen with a fine tubular tip which produces a regular, precise line.

Texture Drawing the patterns, minute moulding or structure of a surface.

Tint Slight or subtle colour.

Tone The degree of lightness and darkness of a colour. The tonal scale runs from black to white and every colour has an equivalent tone on this scale.

Tooth See Key.

Torchon A pointed stump, usually made from rolled paper. It is used for spreading and blending drawing materials such as pastel, charcoal and chalk.

Value Tonal value, sometimes referred to merely as 'value'. See **Tone**.

Vanishing Point The theoretical point on the horizon at which two parallel lines meet. See Linear Perspective.

Warm Colour Colours can be divided into 'warms' and 'cools'. The warm colours are red, orange and yellow.

Index

A	D	I
Aerial perspective 20, 150	Degas, Edgar 78	Ink
	Deserted Beach 146	suitable papers 30
В	Dip pen 64, 66	water soluble 67
Ballpoint 64	Drawing	waterproof 66, 67
Quayside Sketch 76-77	approaches 12	_
technique 69	human face 15	L
Bleeding 72, 74	human figure 16, 17	Leonardo da Vinci 48, 102
Blending 14	introduction to 10	Light and shade 14, 15
coloured pencil 125	'measured' 20	highlights 14
charcoal and chalk 39, 40	starting 12	planes 15
pastel 82	Drawing board 25	shading techniques 14
Bistre 48	Drawing Form 40-41	tone 14, 15
'Boneless' style 64	Durer, Albrecht 102	Line 106
Broken colour 82	E	Linear perspective 20
Brush 69	E	Lobster On A Plate 58-63
technique 69	Easel 27	Local colour 14
	box 27	
C	sketching 27	M
Carrés colours 48	watercolour 27	Markors/Markors and fibra nana 124
Charles colours 48 Chalk 35	Equipment see Materials and Equipment	Markers/Markers and fibre pens 134 Deserted beach 146
Charcoal/Charcoal and chalk 26, 32-45	Eraser 25	making texture 140
blending 35, 36	ink 25	spattering 148
charcoal pencils 34	kneadable 25	stripping 139
compressed charcoal 34	plastic 25	suitable papers 31
Drawing Form 40-41	Eraser shield 25	techniques 138-141
hatching and cross-hatching 37		using lighter fuel 141
Sheep's Skull 42-45	F	Masking fluid 26
suitable papers 30, 35	Female Nude 114-117	Mass and volume 17
techniques	Fibre tip pen	Materials and equipment 22-31
Circus Scene 72-75	City Street 150-153	ballpoint 67
City Street 150-153	suitable papers 31	brushes 67
Clutch pencil 105	Fine liner 134	charcoal and chalk 26, 30
Colour	Orange Lily 142-145	colour sticks 30
broken 82	Fixative 26	coloured pencils 118
choosing 46	Fixing 26	conté 26, 48
optical mixing 51, 85, 123	from the back 26	drawing board 25
overlaying 50, 51	pastel 78	easel 27
Colour sticks 46-63	Form 14	eraser 25
suitable papers 30		eraser shield 25
techniqes 50-53	G	felt-tip pen 136
Coloured pencil 118-133	Girl on the Beach 130-133	fibre-tip pen 31, 137
blending 125	Gorilla 110-113	fine liner 137
colour mixing 124	Graphite powder 105,	fixative 26
cross-hatching 122	technique 109	fountain pen 67
Girl on the Beach 130-133	Gorilla 110-113	ink 30, 67
optical mixing 123	Graphite stick 105	introduction to 22, 23, 24
techniques 122-125	technique 108	knives, blades and sharpeners 24, 25
Composition 10	-	markers 31, 136
negative shapes 19	Н	marking 26
planning 18		oil pastel 81
Compressed charcoal 34	Hatching14	pastel 26
Conte 26, 46, 48	charcoal and chalk 37	pen 30, 66, 67
blending 50	Highlights 14	quill pen 67
overlaying colour 50 Still-life with Drapery 54-57	Human figure 16, 17	reed pen 67
Cross-hatching 14	'cylinder' approach 17	ruler 24, 25
charcoal and chalk		sketchbooks 24, 25
coloured pencil 122		sticky tape 24 studio sticks 48
•		
pastel 84		technical pen 66

INDEX

water soluble crayons 49 wedge tipped markers 137 wax crayons 49 Measured drawing 20 Measured farwing 20 M	torchon 35	suitable papers 30	overlaying colour 52
was crayons 49 Measured driving 20 Measuring 20 Messuring			
Measuring 20 Formule Nuke 114-117 hard line 106 hard scribble 107 propelling 105 soft scribble 107 propelling 105 soft scribble 107 soft line 106 soft scribble 107 soft line 106 soft scribble 107 propelling 105 soft scribble 107 soft line 106 soft scribble 107 strip 107 strip 106 soft scribble 107 strip 106 soft scribble 107 strip 106 soft scribble 107 strip 107 strip 106 soft scribble 107 strip 106 soft scribble 107 strip 107 strip 107 soft scribble 107 st	wedge tipped markers 137	Pencil/pencil and graphite 30, 102-117	sgraffito 53
Mensuring 20 Female Nude 114-117 Subject 10 Surports see papers	wax crayons 49	blending 108	texture 53
N	Measured drawing 20	clutch 105	Studio Still-life 70-71
Negative shapes Possible 107 Negative shapes Negative shapes Possible 107 Soft include 106 Soft include 107 Soft pastel 46, 78, 81 Potted Primmse 94 With turpentine 85 Potted Primmse 94 With turpentine 85 Potted Primmse 94 Note and Primmse 94 Note and Primmse 94 Note and Primmse 94 Note and Primmse 95 Potted Insign 91, 85, 123 Perspective 20, 150 Sacial 20, 130 Incar 20, 150 Incar 20, 150 Sacial 20, 150 Sacial 20, 150 Incar 20	Measuring 20	Female Nude 114-117	Subject 10
Negative slapes O Oil pastel 46, 78, 81 Poited Primmse 94 with turperlutie 85 Periodis larpener 23, 105 Periodis larpener 24, 105 Periodis larpener 24, 105 Periodis larpener 24, 105 Periodis larpener 25, 105 Optical mixing 61, 85, 123 Optical mixing 62, 85, 84 Palm Trees 126-129 Paper 28 Red Cabbage 86, 89 Special purpose 28 Sugar paper 29 Suga		hard line 106	composing and arranging 18
Segitive shapes Soft line 106 Soft scribble 107 Strip 104 Strip 104 Strip 105 Stri	N	hard scribble 107	Supports see papers
Soft inter 106 Office of the primary of the properties of the pro	Nagative shapes	propelling 105	Swimming Pool 90-93
Oil pastel 46, 78, 81	regative shapes	soft line 106	_
Oil pastel 46, 78, 81 Potted Primmes 94 with turpentine 85 Optical mixing 51, 85, 123 Oriental brush 66, 67 P Paim Trees 126-129 Paper 28 Bockingford 28 Borstol board 28 Cortnan 28 Cotrona 28 Cotrona 28 Cotrona 28 Refil strips 105 Refil strips	0		T
Our paster 46, 78, 81 Potted Primares 94 with turpentine 85 Optical mixing 51, 85, 123 Orange Lifty 142 Oriental brush 66, 67 P Palm Trees 126-129 Paper 28 Arches 28 Bockingford 28 Bristol board 28 Carson 28 cartridge 28 Cotman 28 Cotma			Technical pen 66
Potent Primors 94 Techniques 100-109 Pencil sharpener 24, 105 Perspective 20, 150 Section 24, 150 Section 29, 150 Section 29	I Table 1 Tabl		4 10 10 10 10 10 10 10 10 10 10 10 10 10
with turpentime 80 Optical mixing 51, 85, 123 Orange Lily 142 Oriental brush 66, 67 P Palm Trees 126-129 Paper 28 Arches 28 Bockingford 28 Bristol board 28 Camson 28 Catridge 28 Cotman 28 Red Cabbage 86, 89 Red Cabbage 86, 89 Refull strips 105 Refull strips 105 Saugar paper 28 Resida purpose 28 Sugar paper 30		and the second s	
Optical mixing 51, 82, 123 Oriental brush 66, 67 P Palm Trees 126-129 Paper 28 Parches 28 Bockingford 28 Bockingford 28 Bristol board 28 Canson 28 Cartridge 28 Canda 28 hot-pressed 28 hot-pressed 28 hot-pressed 28 hot-pressed 28 Hollingworth 28 Red Cabbage 86, 89 Refill strips 105 Refill strips 105 Sanguine 48 special purpose 28 special purpose 28 sugar paper 28 special purpose 28 sugar paper 28 Soft pastel 46, 80 Whatman 28 Spatishing 82 Spatishing 82 Spatishing 82 Spatishing 83 Red Cabbage 86, 89 Red Cabbage 86, 89 Rest Spatishing 82 Spatishing 82 Spatishing 82 Spatishing 82 Spatishing 83 Spatishing 84 Spatishing 85 pastel 83, 84 Tron 80 Trone 14 Trorbon 35 with chalk and charcoal 39 with pastel 81 Values 14 Vanishing point 20 Volume and mass 17 Values 14 Vanishing point 20 Volume and mass 17 W Water soluble ceraty 49 Water soluble crayon 49 Water soluble crayon 49 Water colour brush 66 Watercolour brush 66 Watercolour brush 66 Watercolour brush 66 Watercolour orecentrates 66 Watercolour ore	•		
Oriental brush 66, 67 P Palm Trees 126-129 Paper 28 Arches 28 Pockingford 28 Bristol board 28 Canson 28 Cartidge 28 Cotman 28 Cotman 28 Cotman 28 Cotman 28 Cotman 28 Cotman 28 Polited Primese 66, 67 Poportion 16 Palmarks 55 Portion 16 Proportion 16 Proportion 16 Pulman figure 16 Pour 16 Proportion 16 Proportion 16 Pulman figure 16 Proportion 16 Pulman figure 16 Proportion 16 Proportion 16 Pulman figure 16 Values 14 Vanishing point 20 Volume and mass 17 Pulman figure 10 Values 14 Vanishing point 20 Volume and mass 17 Pulman figure 10 Values 14 Vanishing point 20 Volume and mass 17 Pulman figure 10 Values 14 Vanishing point 20 Volume and mass 17 Values 14 Vanishing point 20 Volume and mass 17 Pulman figure 10 Values 14 Vanishing point 20 Volume and mass 17 Values 14 Vanishing point 20 Volume and mass 17 Values 14 Vanishing point 20 Volume and mass 17 Values 14 Vanishing point 20 Volume and mass 17 Values 14 Vanishing point 20 Volume and mass 17 Values 14 Vanishing point 20 Volume and mass 17 Values 14 Vanishing point 20 Volume and mass 17 Values 14 Vanishing point 20 Volume and mass 17 Values 14 Vanishing point 20 Volume and mass 17 Values 14 Vanishing point 20 Volume and mass 17 Values 14 Vanishing point 20 Volume and mass 17 Values 14 Vanishing point 20 Volume and mass 17 Values 14 Vanishing point 20 Values 14 Vanishing point 20 Values 14 Varishing point 20 Values 14 Varishing point 20 Values 14 Varishing point 20 Values			
P Interact Just 166, 67 Interact Just 167, 150 Palm Trees 126-129 Palm Trees 126-129 Paper 28 Arches 28 Pottad Primmose 94, 97 Arches 28 Propelling pencil 105 Proportion 16 human figure 16 human figure 16 cartridge 28 choosing 28 Patriano 28 had-made 28 hot-pressed 28 Hollingworth 28 Red Cabbage 86, 89 Refill strips 105 Sapecian 48 weight of 28 Sapecial purpose 28 sueight of 28 Sunders 28 sueight of 28 Sunders 28 sueight of 28 Sunders 38 Whatman 28 Pastel 26, 78-101 blending 82 Sheck Shell 42-45 Shell in the shelp in the part and for the use of his studio, Daler-Rowney, for advice and for providing materials and equipment; Mrs Smallman and the staff of the Daler-Rowney, shop, Percy Street, London, for their help and patience. All the artwork, demonstrations and step-by-step projects were done by Ian Sidaway. Studio pencil 105 Studio steks 46, 48 Pastel pencil 98 Studio steks 46, 48 Pastel pencil 98 Studio steks 46, 48 Pastel pencil 98			
Palm Trees 126-129 Pigment 120 Pigment 120 with chalk and charcoal 39 with pastel 81 Planes 15 Planes 15 Planes 15 Planes 15 V Propelling pencil 105 V Bockingford 28 Proportion 16 Imman figure 16 Values 14 Vanishing point 20 Volume and mass 17 V Acricle 28 Quayside Sketch 76-77 W Coman 28 Quayside Sketch 76-77 W Cottoma 28 Quayside Sketch 76-77 W Fabriano 28 Quayside Sketch 76-77 W Fabriano 28 Quayside Sketch 76-77 W Fabriano 28 Water soluble crayon 49 Water soluble crayon 49 Water soluble pencil 121 Palm Trees 126 Water colour brush 66 Watercolour pencil 121 Wax crayon 46, 49 Wax crayon 46, 49 Wax crayon 49 Wax crayon 49 Wax crayon 49 Water soluble pencil 121 Wax crayon 49 Water soluble pencil 121 Wax crayon 49 Water soluble pencil 121 Wax crayon 46, 49 Water soluble pencil 121 Wax crayon 46, 49 Water colour brush 66 Watercolour brush 66 Watercolour brush 66 Watercolour pencil 121 Wax crayon 46, 49 Wax crayon 46,	Oriental brush 66, 67		
Palm Trees 126-129 Pigment 120 with chalk and charcoal 39 with pastel 81 Paper 28 Arches 28 Potented Primmuse 94, 97 Propelling pencil 1005 Values 14 Vanishing point 20 Volume and mass 17 Values 14 Vanishing point 20 Volume and mass 17 Q Q Q Q Q Q Q Q Q Q Q Q Q Q Q Q Q Q	n.		
Paper 28 Arches 28 Potted Primrose 94,97 Paper 28 Bockingford 28 Bristol board 28 Canson 28 Cartridge 28 Choosing 28 Cotman 28 Cotman 28 Potted Primrose 94,97 Propelling pencil 105 Proportion 16 human figure 16 human figure 16 Vanishing point 20 Volume and mass 17 W Water soluble crayon 49 Water soluble pencil 121 Palm Trees 126 Hollingworth 28 Hollingworth 28 Hollingworth 28 Red Cabbage 86,89 Red Cabbage 86,89 Red gen 66 Refill strips 105 Red jen 66 Refill strips 105 Saunders 28 Registro 48 Saugar paper 28 Social purpose 28 sugar paper 28 Social nate texture 28 Water soluble crayon 49 Water soluble pencil 121 Palm Trees 126 Watercolour brush 66 Watercolour brush 66 Watercolour pencil 121 Wax crayon 46, 49 Verdits Credits The author would like to thank all those who have helped in the preparation of this book. Special thanks to lan Sidaway for his expert and helpful advice, and for the use of his studio; baler. Rowney, for advice and for providing materials and equipment; Mrs Simallman and helpful advice, and for the use of his studio; baler. Rowney, for advice and for providing materials and equipment; Mrs Simallman and helpful advice, and for the use of his studio; baler. Rowney, for advice and for providing materials and equipment; Mrs Simallman and helpful advice, and for the use of his studio; baler. Rowney shop, Percy Street, London, for their help and patience. Red Cabbage 86-89 Soft pastel 46, 80 Soft pastel 48 Soft bale 40 Soft pastel 46, 80 Soft pastel 46, 80 Soft pastel 47 Soft pastel 48 Soft pastel 48 Soft bale 40 Soft pastel 48 Soft bale 40 Soft pastel 40 Soft pastel 46, 80 Soft pas	P		with chalk and charcoal 39
Arches 28 Bockingford 28 Bristol board 28 Canson 28 cartridge 28 Cotman 28 Red Cabbage 86,89 Red Cabbage 86,89 Red Cabbage 86,89 Rejil strips 105 Sort pastel 26, 78-101 Behading 82 Spattel pencil 98 Pastel pencil 98 Pastel pencil 98 Pastel pencil 98 Pastel pencil 98 Pastel pencil 98 Pastel pencil 98 Pastel pencil 98 Pastel pencil 98 Pastel pencil 98 Pastel pencil 98 Pastel pencil 98 Pastel pencil 98 Pastel pencil 98 Pastel pencil 98 Pastel pencil 98 Pastel pencil 98 Pastel pencil 98 Studio sticks 46, 48 Pastel pencil 98 Pastel pencil 98 Pastel pencil 98 Studio sticks 46, 48 Pastel pencil 98 Pastel pencil 98 Pastel pencil 98 Studio sticks 46, 48 Pastel pencil 98 Pastel p	Palm Trees 126-129		with pastel 81
Arches 28 Bockingford 28 Bockingford 28 Borkingford 28 Bristol board 28 Canson 28 Cartridge 28 cartridge 28 cartridge 28 choosing 28 Cotman 28 Comman 52 Cotman 28 Comman 62 Cotman 28 Red Cabbage 86, 89 Cotman 28 Cotman 29 Cotman 28 Cotman 29 Cotman 28 Cotman 29 Cotman 20 Cotman 29 Cotman 20 Cotm	Paper 28		
Bristol board 28 Cartridge 28 Cartridge 28 Cartridge 28 Choosing 28 Cotman 20 Cotman 28 Cotman 20 Cotman 20 Cotman 28 Cotman 20 Cotman 20 Cotman 28 Cotman 20 Cotman 2			V
Canson 28 Cartridge 28 Cartridge 28 Cotman 20	Bockingford 28	1 01	V 1 14
Carson 28 choosing 28 Choosing 28 Choosing 28 Cotman 29 Cotman 29 Cotman 28 Cotman 29 Cotman 29 Cotman 20	Bristol board 28		
cartrage 28 choosing 28 Cotman 28 Cotman 28 Cotman 28 Cotman 28 Fabriano 28 hand-made 28 hand-made 28 hot-pressed 28 Hollingworth 28 Received 8 Hollingworth 28 Kent 28 Kent 28 Reed pen 66 Refill strips 105 Received 9 Refill strips 105 Received 121 Reversolour brush 66 Watercolour concentrates 66 Watercolour pencil 121 Wax crayon 46, 49 Patrolour concentrates 66 Watercolour pencil 121 Wax crayon 46, 49 Patrolour concentrates 66 Watercolour pencil 121 Refill strips 105 Received 9 Watercolour pencil 121 Refill strips 105 Received 9 Watercolour pencil 121 Wax crayon 46, 49 Patrolour concentrates 66 Watercolour pencil 121 Wax crayon 46, 49 Patrolour concentrates 66 Watercolour pencil 121 Wax crayon 46, 49 Patrolour pencil 121 Wax crayon 46, 49 Patrolour pencil 121 Vax crayon 46, 49 Patrolour p	Canson 28	numan figure 16	81
Corosing 28 Cotman 28 Cotm	cartridge 28	0	volume and mass 17
Cotman 28	choosing 28	Q	W
hand-made 28 hot-pressed 28 Hollingworth 28 Hollingworth 28 Red Cabbage 86,89 Reed pen 66 Refill strips 105 Reed pen 66 Refill strips 105 Saunders 28 Saunders 28 Sugar paper 28 Sugar paper 28 Subtana 28 Pastel 26, 78-101 blending 82 broken colour 82 cross-hatching 84 fixing 78 mixing colour 82 mixing solour 82 mixing solour 82 mixing colour 83 side of stick 83 suitable papers 30, 80 techniques 84 Pastel pencil 98 Studio sticks 46, 48 Pastel pencil 98 Studio sticks 46, 48 Red Cabbage 86, 89 Refill strips 105 Saunders 2 Red Cabbage 86, 89 Refill strips 105 Credits The author would like to thank all those who have helped in the preparation of this book. Special thanks to lan Sidaway for his expert and helpful advice, and for the use of his studio; Daler-Rowney, for advice and for providing materials and equipment; Mrs Smallman and the staff of the Daler-Rowney shop, Percy Street, London, for their help and patience. Street, London, for their help and	Cotman 28	Quayside Sketch 76-77	vv
hot-pressed 28 Hollingworth 28 I vorex 28 I vorex 28 Red Cabbage 86,89 Red Cabbage 86,89 Red Cabbage 86,89 Red Gabbage 86,89 Red Cabbage 86,89 Red Gabbage 86,89 Red Cabbage 86,89 Red Gabbage 86,89 Red Cabbage 8	Fabriano 28	Quill pen 66, 67	Water soluble crayon 49
Hollingworth 28 Ivorex 28 Ivorex 28 Kent 28 Reed pen 66 Reed pen 66 Refill strips 105 S S Sanguine 48 Saunders 28 special purpose 28 sugar paper 28 Whatman 28 Pastel 26, 78-101 blending 82 broken colour 82 cross-hatching 84 fixing 78 mixing colour 82 optical mixing 85 pastel pencil 98 Sarill-life with Vegetables 98-101 Sugar paper 30, 80 Studio strick 84 Special pencil 98 Special purpose 28 Sanguine 48 Scale 18 Scale 18 Special thanks to Ian Sidaway for his expert and helpful advice, and for the use of his studio; Daler-Rowney, for advice and for providing materials and equipment; Mrs Smallman and the staff of the Daler-Rowney shop, Percy Street, London, for their help and patience. All the artwork, demonstrations and step-by-step projects were done by Ian Sidaway. Special thanks to Ian Sidaway for his expert and helpful advice, and for the use of his studio; Daler-Rowney, for advice and for providing materials and equipment; Mrs Smallman and the staff of the Daler-Rowney shop, Percy Street, London, for their help and patience. All the artwork, demonstrations and step-by-step projects were done by Ian Sidaway. Special mixing 85 pastel pencil 98 Scale 18 Spattering 148 Spa	hand-made 28	technique 68	Water soluble pencil 121
Ivorex 28 Kent 28 Ret 28 Red Pen 66 Refill strips 105 S Sepiragmenta 28 rough 28 weight of 28 Saunders 28 sugar paper 28 tooth and texture 28 Whatman 28 Pastel 26, 78-101 blending 82 broken colour 82 cross-hatching 84 fixing 78 mixing colour 82 optical mixing 85 pastel pencil 98 Sribled texture 83 Side of stick 83 Sunders 28 Studio sticks 46, 48 Refill strips 105 S Credits The author would like to thank all those who have helped in the preparation of this book. Special thanks to Ian Sidaway for his expert and helpful advice, and for the use of his studio; Daler-Rowney, for advice and for providing materials and equipment; Mrs Smallman and the staff of the Daler-Rowney shop, Percy Street, London, for their help and patience. All the artwork, demonstrations and step-by-step projects were done by Ian Sidaway. Photography Studio photography by John Melville and Mac Campeanu. Pastel pencil 98 Studio sticks 46, 48 Pastel pencil 98 Studio sticks 46, 48 Watercolour concentrates 66 Watercolour pencil 121 Wax crayon 46, 49 Watercolour concentrates 66 Watercolour pencil 121 Wax crayon 46, 49 Watercolour concentrates 66 Watercolour pencil 121 Wax crayon 46, 49 Watercolour pencil 121 Wax crayon 46, 49 Watercolour pencil 121 Wax crayon 46, 49 Watercolour pencil 21 Wax crayon 46, 49 Watercolour pencil 21 Wax crayon 46, 49 Watercolour pencil 21 Wax crayon 46, 49 Watercolour pencil 21 Wax crayon 46, 49 Watercolour pencil 21 Wax crayon 46, 49 Watercolour pencil 21 Water about pencil 21 Water about pencil		_	
Kent 28 not 28 not 28 not 28 pergamenta 28 rough 28 weight of 28 Saunders 28 special purpose 28 sugar paper 28 tooth and texture 28 Whatman 28 Pastel 26, 78-101 blending 82 broken colour 82 cross-hatching 84 fixing 78 mixing colour 82 optical mixing 85 pastel pencil 98 Solution 28 Solution 28 Solution 28 Solution 28 Solution 28 Sille-life with Vegetables 98-101 Studios place. Red Cabbage 86,89 Red Cabbage 86,89 Red Cabbage 86,89 Red Cabbage 86,89 Solution 28 Solution 20 Solution 2	Hollingworth 28	R	Watercolour brush 66
Rent 28 not 28 not 28 not 28 not 28 rough 28 weight of 28 Saunders 28 special purpose 28 sugar paper 28 tooth and texture 28 Whatman 28 Pastel 26, 78-101 blending 82 broken colour 82 cross-hatching 84 fixing 78 mixing colour 82 optical mixing 85 pastel pencil 98 scribbled texture 83 side of stick 83 suders 28 Seded en 66 Refill strips 105 Wax crayon 46, 49 Wax crayon 46, 49 Wax crayon 46,	9000 BCH CHOCK (C. B.	Red Cahhage 86, 89	
pergamenta 28 pergamenta 28 rough 28 weight of 28 Saunders 28 special purpose 28 sugar paper 28 Socale 18 Syerial tooth and texture 28 Whatman 28 Pastel 26, 78-101 blending 82 broken colour 82 cross-hatching 84 fixing 78 mixing colour 82 optical mixing 85 pastel pencil 98 Soft pastel 46, 80 Soft p		0	
pergamenta 28 rough 28 weight of 28 Saunders 28 Saunders 28 special purpose 28 sugar paper 28 tooth and texture 28 Whatman 28 Pastel 26, 78-101 blending 82 broken colour 82 cross-hatching 84 fixing 78 mixing colour 82 optical mixing 85 pastel pencil 98 Spattering 148 Special with Vegetables 98-101 Special third would like to thank all those who have helped in the preparation of this book. Special thanks to lan Sidaway for his expert and helpful advice, and for the use of his studio; Daler-Rowney, for advice and for providing materials and equipment; Mrs Smallman and the staff of the Daler-Rowney shop, Percy Street, London, for their help and patience. Street, London, for their help and patience. All the artwork, demonstrations and step-by-step projects were done by Ian Sidaway. Special thanks to Ian Sidaway for his expert and helpful advice, and for the use of his studio; Daler-Rowney, for advice and for providing materials and equipment; Mrs Smallman and the staff of the Daler-Rowney shop, Percy Street, London, for their help and patience. All the artwork, demonstrations and step-by-step projects were done by Ian Sidaway. Special thanks to Ian Sidaway for his expert and helpful advice, and for the use of his studio; Daler-Rowney, for advice and for providing materials and equipment; Mrs Smallman and the step of the staff of the Daler-Rowney shop, Percy Street, London, for their help and patience. Street, London, for their help and equipment, Mrs Smallman and thelpful advice, and for the use of his studio; Daler-Rowney; by John Melville and Mac Campeanu. Other Photographs The author helpful advice,	Stringstein A Control Strategy (Strategy Control Strategy	and the second s	Wax crayon 46, 49
weight of 28 Saunders 28 Saunders 28 Saunders 28 Special purpose 28 Sepia 48 Scale 18 Scale 18 Scale 18 Special thanks to Ian Sidaway for his expert and helpful advice, and for the use of his studio; Daler-Rowney, for advice and for providing materials and equipment; Mrs Smallman and the staff of the Daler-Rowney shop, Percy Silverpoint 102 Street, London, for their help and patience. Soft pastel 46, 80 Special thanks to Ian Sidaway for his expert and helpful advice, and for the use of his studio; Daler-Rowney, for advice and for providing materials and equipment; Mrs Smallman and the staff of the Daler-Rowney shop, Percy Street, London, for their help and patience. Soft pastel 46, 80 All the artwork, demonstrations and step-by- step projects were done by lan Sidaway. Swimming Pool 90-93 Spattering 148 Spattering 148 Scribbled texture 83 Still-life with Drapery 54-57 Side of stick 83 Still-life with Vegetables 98-101 Studio photography by John Melville and Mac Campeanu. Pastel pencil 98 Studio sticks 46, 48 Pastel pencil 98 Studio sticks 46, 48 Pastel pencil 98 Studio sticks 46, 48 Age Campeanu.		Telm stripe 190	
Saunders 28 Saunders 28 Saunders 28 Sepia 48 Sepia 48 Sugar paper 28 Scale 18 Segraffito 53 Whatman 28 Pastel 26, 78-101 blending 82 broken colour 82 cross-hatching 84 fixing 78 mixing colour 82 optical mixing 85 pastel pencil 98 Scribled texture 83 Still-life with Drapery 54-57 side of Stick 83 Sunders 28 Studio sticks 46, 48 Pastel pencil 98 Studio sticks 46, 48 Credits The author would like to thank all those who have helped in the preparation of this book. Special thanks to lan Sidaway for his expert and helpful advice, and for the use of his studio; Daler-Rowney, for advice and for providing materials and equipment; Mrs Smallman and the staff of the Daler-Rowney shop, Percy Street, London, for their help and patience. All the artwork, demonstrations and step-by-step projects were done by Ian Sidaway. Photography Studio photography by Ian Howes. Still-life with Vegetables 98-101 Studio photography by John Melville and Mac Campeanu. Other Photographs technique 88 Pastel pencil 98 Studio sticks 46, 48 Pastel pencil 98 Studio sticks 46, 48 Mac Campeanu.		S	
saunders 28 special purpose 28 special purpose 28 sugar paper 28 Scale 18 Special thanks to Ian Sidaway for his expert and helpful advice, and for the use of his studio; Daler-Rowney, for advice and for providing materials and equipment; Mrs Smallman and the staff of the Daler-Rowney shop, Percy Street, London, for their help and patience. Sketchbooks 24, 76 sixing 78 soft pastel 46, 80 special thanks to Ian Sidaway for his expert and helpful advice, and for the use of his studio; Daler-Rowney, for advice and for providing materials and equipment; Mrs Smallman and the staff of the Daler-Rowney shop, Percy Street, London, for their help and patience. Sketchbooks 24, 76 street, London, for their help and patience. Street, London, for their help and patience. All the artwork, demonstrations and step-by-step projects were done by Ian Sidaway. Swimming 85 pastel pencil 98 scribbled texture 83 side of stick 83 suitable papers 30, 80 Still-life with Vegetables 98-101 studio photography by John Melville and Mac Campeanu. Other Photographs techniques 82-85 texture 84 Pastel pencil 98 Studio sticks 46, 48 Pastel pencil 98 Studio sticks 46, 48			Credits
sugar paper 28 tooth and texture 28 tooth and texture 28 Whatman 28 Pastel 26, 78-101 blending 82 broken colour 82 cross-hatching 84 fixing 78 mixing colour 82 optical mixing 85 pastel pencil 98 scribbled texture 83 side of stick 83 suitable papers 30, 80 technique 54 Sale 18 Special thanks to Ian Sidaway for his expert and helpful advice, and for the use of his studio; Daler-Rowney, for advice and for providing materials and equipment; Mrs Smallman and the staff of the Daler-Rowney shop, Percy Street, London, for their help and patience. Street, London, for their help and patience. All the artwork, demonstrations and step-by- mixing colour 82 optical mixing 85 pastel pencil 98 scribbled texture 83 Still-life With Drapery 54-57 Studio photography by Ian Howes. Still-life with Vegetables 98-101 Studio photography by John Melville and Mac techniques 82-85 texture 84 Pastel pencil 98 Studio sticks 46, 48 Mac Campeanu All the artwork, demonstrations and step-by- step projects were done by Ian Sidaway. Other Photography pol 10-12 Campeanu Other Photographs pp 27, Daler-Rowney; pp 130-133, Mac Campeanu	NAME AND ADDRESS OF THE PARTY O		
tooth and texture 28 Whatman 28 Pastel 26, 78-101 blending 82 broken colour 82 cross-hatching 84 fixing 78 mixing colour 82 optical mixing 85 pastel pencil 98 scribbled texture 83 side of stick 83 suitable papers 30, 80 techniques 82 stooth and texture 28 silverpoint 102 sgraffito 53 Shading 14 Daler-Rowney, for advice and for providing materials and equipment; Mrs Smallman and the staff of the Daler-Rowney shop, Percy Street, London, for their help and patience. Sketchbooks 24, 76 Soft pastel 46, 80 All the artwork, demonstrations and step-by-mixing colour 82 optical mixing 85 pastel pencil 98 scribbled texture 83 side of stick 83 suitable papers 30, 80 stipling 14 Campeanu. Pastel pencil 98 Studio sticks 46, 48 Pastel pencil 98 Studio sticks 46, 48 Special thanks to Ian Sidaway for his expert and helpful advice, and for the use of his studio; Daler-Rowney, for advice and for providing materials and equipment; Mrs Smallman and the staff of the Daler-Rowney shop, Percy Street, London, for their help and patience. Sketchbooks 24, 76 All the artwork, demonstrations and step-by-step projects were done by Ian Sidaway. Side of stick 80 Spattering 148 Photography Studio photography by Ian Howes. Studio photography by John Melville and Mac Campeanu. Other Photographs pp27, Daler-Rowney; pp 130-133, Mac Campeanu			have helped in the preparation of this book.
Whatman 28 Pastel 26, 78-101 blending 82 broken colour 82 cross-hatching 84 fixing 78 mixing colour 82 optical mixing 85 pastel pencil 98 scribbled texture 83 side of stick 83 suitable papers 30, 80 techniques 14 Shading 14 techniques 14 Shading 14 Daler-Rowney, for advice and for providing materials and equipment; Mrs Smallman and the staff of the Daler-Rowney shop, Percy Street, London, for their help and patience. Sketchbooks 24, 76 Street, London, for their help and patience. Street, London, for their help and patience. All the artwork, demonstrations and step-by-step projects were done by Ian Sidaway. Swimming Pool 90-93 pastel pencil 98 scribbled texture 83 side of stick 83 suitable papers 30, 80 techniques 82-85 texture 84 Pastel pencil 98 Studio sticks 46, 48 Shading 14 Daler-Rowney, for advice and for providing materials and equipment; Mrs Smallman and the staff of the Daler-Rowney shop, Percy Street, London, for their help and patience. Street, London, for help and patience. Street, London, for help	0		
Pastel 26, 78-101 blending 82 broken colour 82 cross-hatching 84 fixing 78 mixing colour 82 optical mixing 85 pastel pencil 98 scribbled texture 83 side of stick 83 suitable papers 30, 80 techniques 14 blending 82 Sheep's Skull 42-45 Silverpoint 102 Sketchbooks 24, 76 Sketchbooks 24, 76 Soft pastel 46, 80 All the artwork, demonstrations and step-by-step projects were done by Ian Sidaway. Swimming Pool 90-93 Spattering 148 Spattering 148 Still-life With Drapery 54-57 Side of stick 83 Still-life with Vegetables 98-101 Studio photography by John Melville and Mac Campeanu. Pastel pencil 98 Studio sticks 46, 48 Pastel pencil 98 Studio sticks 46, 48 Daler-Rowney, for advice and for providing materials and equipment; Mrs Smallman and the staff of the Daler-Rowney shop, Percy Street, London, for their help and patience. Street, London, for help and patience. Street, London, for help and patience. Street, London, for help and pa			
blending 82 broken colour 82 cross-hatching 84 fixing 78 mixing colour 82 optical mixing 85 pastel pencil 98 scribbled texture 83 side of stick 83 suitable papers 30, 80 techniques 14 blending 82 Sheep's Skull 42-45 Silverpoint 102 Silverpoint 102 Street, London, for their help and patience. Sketchbooks 24, 76 All the artwork, demonstrations and step-by-step projects were done by Ian Sidaway. Still-life With Drapery 54-57 Simm photography Studio photography by Ian Howes. Stidlo pencils 105 technique 108 Studio pencils 105 Other Photographs pp27, Daler-Rowney; pp 130-133, Mac Campeanu. Mac Campeanu Mac Campeanu			Daler-Rowney, for advice and for providing
broken colour 82 cross-hatching 84 fixing 78 fixing 78 Soft pastel 46, 80 All the artwork, demonstrations and step-by- mixing colour 82 optical mixing 85 pastel pencil 98 scribbled texture 83 side of stick 83 suitable papers 30, 80 techniques 82-85 texture 84 Pastel pencil 98 Silverpoint 102 Street, London, for their help and patience.		C. C	materials and equipment; Mrs Smallman and
cross-hatching 84 fixing 78 fixing 78 Soft pastel 46, 80 All the artwork, demonstrations and step-by- mixing colour 82 optical mixing 85 pastel pencil 98 scribbled texture 83 side of stick 83 suitable papers 30, 80 techniques 82-85 texture 84 Pastel pencil 98 Sketchbooks 24, 76 Street, London, for their help and patience. All the artwork, demonstrations and step-by- step projects were done by Ian Sidaway. Photography Step projects were done by Ian Sidaway. Photography Studio photography by Ian Howes. Still-life with Vegetables 98-101 Studio photography by John Melville and Mac Campeanu. Other Photographs pp27, Daler-Rowney; pp 130-133, Mac Campeanu Mac Campeanu Mac Campeanu			the staff of the Daler-Rowney shop, Percy
fixing 78 mixing colour 82 optical mixing 85 pastel pencil 98 scribbled texture 83 side of stick 83 suitable papers 30, 80 techniques 82-85 texture 84 Pastel pencil 98 Soft pastel 46, 80 All the artwork, demonstrations and step-by- step projects were done by Ian Sidaway. Photography Step projects were done by Ian Sidaway. Photography Step projects were done by Ian Sidaway. Photography Still-life With Drapery 54-57 Stmm photography by Ian Howes. Still-life with Vegetables 98-101 Studio photography by John Melville and Mac Campeanu. Other Photographs pp27, Daler-Rowney; pp 130-133, Mac Campeanu Mac Campeanu	The second secon	•	Street, London, for their help and patience.
mixing colour 82 optical mixing 85 pastel pencil 98 scribbled texture 83 side of stick 83 suitable papers 30, 80 techniques 82-85 texture 84 Pastel pencil 98 Sted Cabbage 86-89 Stemming Pool 90-93 Spattering 148 Photography Stond Photography Studio photography by Ian Howes. Studio photography by John Melville and Mac Campeanu. Other Photographs technique 108 pp27, Daler-Rowney; pp 130-133, Mac Campeanu Mac Campeanu			All the artwork demonstrations and step-by-
optical mixing 85 pastel pencil 98 Spattering 148 Scribbled texture 83 Still-life With Drapery 54-57 side of stick 83 Still-life with Vegetables 98-101 Studio photography by John Melville and Mac suitable papers 30, 80 Stippling 14 Campeanu. techniques 82-85 Studio pencils 105 texture 84 Pastel pencil 98 Studio sticks 46, 48 Summing Pool 90-93 Photography Studio photography by John Melville and Mac Campeanu. Other Photographs pp27, Daler-Rowney; pp 130-133, Mac Campeanu Mac Campeanu	_		
pastel pencil 98 Spattering 148 Photography scribbled texture 83 Still-life With Drapery 54-57 35mm photography by Ian Howes. side of stick 83 Still-life with Vegetables 98-101 Studio photography by John Melville and Mac suitable papers 30, 80 Stippling 14 Campeanu. techniques 82-85 Studio pencils 105 texture 84 technique 108 pp27, Daler-Rowney; pp 130-133, Pastel pencil 98 Studio sticks 46, 48 Mac Campeanu Mac Campeanu Mac Campeanu			step projects were done by fair sidaway.
scribbled texture 83 side of stick 83 side of stick 83 suitable papers 30, 80 techniques 82-85 texture 84 Pastel pencil 98 Still-life With Drapery 54-57 Still-life with Vegetables 98-101 Studio photography by John Melville and Mac Campeanu. Other Photographs technique 108 pp27, Daler-Rowney; pp 130-133, Mac Campeanu Mac Campeanu			Photography
side of stick 83 suitable papers 30, 80 suitable papers 30, 80 techniques 82-85 texture 84 Pastel pencil 98 Still-life with Vegetables 98-101 Studio photography by John Melville and Mac Campeanu. Other Photographs pp27, Daler-Rowney; pp 130-133, Mac Campeanu. Mac Campeanu. Mac Campeanu.		. 0	
suitable papers 30, 80 Stippling 14 Campeanu. techniques 82-85 Studio pencils 105 texture 84 technique 108 Pastel pencil 98 Studio sticks 46, 48 Mac Campeanu Mac Campeanu Other Photographs pp27, Daler-Rowney; pp 130-133, Mac Campeanu			
techniques 82-85 texture 84 Pastel pencil 98 Studio pencils 105 technique 108 pp27, Daler-Rowney; pp 130-133, Mac Campeanu			
texture 84 technique 108 pp27, Daler-Rowney; pp 130-133, Pastel pencil 98 Studio sticks 46, 48 Mac Campeanu		0	
Pastel pencil 98 Studio sticks 46, 48 pp27, Daler-Rowney; pp 130-133,			· .
Mac (ampeanii	Pastel pencil 98		
			Mac Campeanu.
Pen/Pen, brush and ink 30, 64-77 Lobster On A Plate 58-63 Layout and Artwork			Layout and Artwork
Circus Scene 72-75 optical mixing 51 Giorgio Moltoni	Circus Scene 72-75	optical mixing 51	Giorgio Moltoni